The
HEALING
SEASON
of
POTTERY

The
HEALING
SEASON
of
POTTERY

공방의 계절 by 연소민

Yeon Somin

Translated by Clare Richards

ALGONQUIN BOOKS OF CHAPEL HILL 2024

Published by
ALGONQUIN BOOKS OF CHAPEL HILL
an imprint of Workman Publishing
a division of Hachette Book Group, Inc.
1290 Avenue of the Americas,
New York, NY 10104

공방의 계절 by 연소민

This translated edition is published by arrangement with Mojosa Publishing
Co. c/o Shinwon Agency through Peters, Fraser and Dunlop Ltd.

Printed in the United States of America.
Design by Steve Godwin.

Cataloging-in-Publication Data for this title is available
from the Library of Congress.

ISBN 978-1-64375-675-2 Paperback
ISBN 978-1-64375-676-9 E-book

Printing 3, 2025
First Edition

CONTENTS

What's Hotter than Summer? 1

Just 60 Percent 16

The Moment Clay Becomes a Plate 27

That Person You Can't Avoid 47

Late Monsoon Season and the Cat 62

The One-Day Class Revival 90

Centering 109

Cobalt Blue Vase 129

Potter Wife, Florist Husband 142

My Sad Legend 152

Direction 165

Emerging from the Cave 182

First Snow 194

Wanting to Speak 206

Christmas Flea Market 217

Chestnut Burr Village, of All Places 238

Emerald Green Sea 254

Author's Note 263

The

HEALING
SEASON
of
POTTERY

What's Hotter than Summer?

LAST AUTUMN, JUNGMIN pricked herself on a thorn for the first time.

The moment stuck in her memory. Chestnut burrs were strewn all over the streets. Jungmin picked up a burr that was still intact, lucky enough to have dodged the soles of passersby. She brushed off the soil and opened up the shell. The inside was hollow, as if someone had run off with just the kernel. She scooped up a few more, when suddenly a needle dug into the flesh of her palm. In amongst the thorns, all alike, one lay in hiding: boiling with rage, it'd grown much sharper than the rest. Jungmin pushed down harder against the burr, wanting to punish her writer's hand for working with such indifference for so long. A drop of blood swelled on her skin. Next, a dull pain moved from her palm to her spine, right down to the tips of her toes.

From that day onward, Jungmin didn't set foot outside her flat. Only one season had passed since she'd first moved to Chestnut Burr Village.

SUMMER THAT YEAR, when Jungmin had first seen the flat, was unbearably hot. As the beads of sweat crept down her neck, traipsing round to viewings became even more exhausting. Fed up with having to move like this every two years, she felt no particular attraction—beyond practicalities—to whatever space she called home.

"Is this the last one for today?" Jungmin asked, her tone flat.

The real estate agent had dragged her here and everywhere across the district—making a big fuss about how "something good had come on the market"—but nothing had blown Jungmin away. Anywhere half-decent was way out of her price range, and otherwise the location made for a nightmare commute into Seoul.

"Hang on a minute! Let me show you just one more. I've got a flat perfect for someone living alone. Last one, promise!"

". . . All right. I'll take a look."

It was a battle of nerves waging between the agent, insistent on getting a deal done no matter what, and Jungmin, whose response was consistently indifferent. Jungmin had, however, vowed to herself that she would view every listing and make a decision today, without delaying until the weekend. For broadcast writers like herself, the boundary between weekdays and weekend was always blurred, making her time off on Saturdays and Sundays all the more precious.

As they turned into the alleyway that led to Chestnut Burr Village, out of nowhere the agent asked, "Do you like chestnuts?"

"Not especially."

"Apparently those are all chestnut trees, and in autumn, the streets are beautiful, lined with open chestnut burrs. I'm told the women in the neighborhood go round collecting the kernels . . ."

Jungmin didn't respond. Green clumps of leaves against brown trunks—trees in summer were all the same to her. Her eyes couldn't distinguish the chestnut trees from any of the others.

Of all the blocks of flats, Residential Complex Four was the furthest up the hill. The agent rapidly ran out of words to say as they hiked the long slope, and the two walked in silence. Jungmin stopped in her tracks as soon as she laid eyes on the building. The paint was peeling off the outside, but the arched windows with their balconies (a real rarity) and painted-orange frames, set against the ivory walls, gave it a European air. The easy cheer of the orange matched the summer heat well. It was love at first sight.

One of the second-floor residents had lined their windowsill with tiny potted succulents. On one of the third-floor balconies, socks every color of the rainbow hung from a washing line, welcoming summer. Tiny yellow baby socks dangled alongside the big ones. Through the window of the next flat, Jungmin could see a bookcase stuffed with thick volumes. Maybe a part-time lecturer lived there, busy teaching at universities all over the place. Jungmin could imagine day-to-day life in this building.

Flat 201. She gazed out of the window at where she'd been

standing just a moment before. The light, balmy breeze wrapped itself around her long hair strand by strand. Though the building didn't have many floors, being on top of a hill gave it a clear view as far as the mountains that surrounded the neighborhood. This was the first time Jungmin had ever felt like placing an object by a window as decoration. She stayed silent, lost a while in her thoughts, before snapping back to reality.

Turning to the agent, who'd been trying to gauge her reaction, Jungmin said without a hint of hesitation, "I'll take it."

This place was somewhere Jungmin could stay for a long time and never tire of. Like a bicycle going at speed with no need to pedal, she felt like life would be a breeze from here on out. For the first time ever, she genuinely loved her "home."

But all it took was a single gust of wind for her grand dreams to come tumbling down. Suddenly, that "bicycle" was racing downhill, and life was accelerating so fast that Jungmin lost control.

This was last autumn, when the building's orange morphed to a dingy brick red. At the office, Jungmin had abruptly terminated her contract with the broadcaster, midway through production of the documentary she'd been working on. She practically hurled her entry pass at them when she returned it, and loudly packed her belongings, a deadpan look on her face, before storming out.

In truth, Jungmin couldn't remember much of what had happened during that time. It wasn't until a colleague told her about it a few months later that she was able to fully grasp the events of that day. They told her everything in detail, right down to the

outfit she was wearing, but Jungmin was stunned to hear how she'd acted. She'd always been so passionate about her work. She couldn't believe she'd walked out of the TV station on her own two feet. In the passing of a single season, an inexplicable emotion, almost like a curse, had sunk deep into her heart—this was the only fact she was sure of.

Now, Jungmin no longer made small talk with the housewife next door who loved adorning her home with plants. She didn't wonder how much the third-floor family's baby had grown. She didn't borrow novels from the bookworm graduate student next door. Jungmin found no happiness in the small and peaceful neighborhood where the color of the buildings changed according to the sunlight. The window with the view that'd reminded her of Europe, always putting a smile on her face, became nothing more than a tool for ventilation. That fine autumn, it was as if the aquamarine skies were about to come crashing down on her home. Once the November chill seeped in, she simply left the blinds shut, obscuring the autumn sky from view. When the air in the flat sank and everything around her grew unusually quiet, she could only guess that the snow had arrived. Then when the spring showers came, at this height, she felt she could almost reach out and touch the grimy sky. Jungmin spent her time in a straight line, without fluctuations or jolts, and the days blended into one. She'd become trapped at that phase of life called Thirty—perhaps it was because she'd given up all hope of escape, but she couldn't see that she'd reached a dead end. Her prediction that life in this flat would be straightforward had flown nicely wide of the mark.

THREE SEASONS WENT by with Jungmin mired in self-loathing. Then one summer morning, nine months after the thorn had pricked her right palm, she shot up from her chair and screamed. The words she blurted out contained no sensible resolutions or goals. They weren't even sentences to begin with. Nothing more than an "exclamation," devoid of fully formed words. But her cry was loaded with an immense pressure, something she needed to act on. In truth, this scream had been building since last spring. As her life as a recluse went on, she started to believe she might never be able to return to society and would die there alone. Hundreds of thousands of won kept vanishing with the simple act of breathing. It was as if each month she was being charged just to carry on living. Living a life worthy of that sum was the only way to ensure her money wasn't going to waste.

The scream filled Jungmin's almost furniture-less one-bedroom flat. It was on hearing the echo that she realized how long it'd been since she'd used her voice. Once the sound hit the edges of the ceiling and faded away, she half-heartedly rinsed the stale taste from her mouth. Not even registering that it was summer, she put on long sleeves and trousers, and just like that, left the flat.

The August sunshine beat down with vigor. Jungmin staggered as the scorching rays struck the back of her head. It felt like she'd been locked up in a sterilized facility and lost her tolerance for sunlight. The sweat flowed nonstop. Clad in a long-sleeved black shirt and jeans that went past her ankles, she'd brought it on herself. Beneath her clothes, baggy from the weight she'd shed over the months, her bum and calves were squishy,

as if they'd lost all function. What little muscle she'd once had seemed to have disappeared.

Jungmin had been outside less than thirty minutes when she decided to seek refuge in a café. There were a few franchises with brightly colored signs outside. It'd taken her great resolve to leave the flat, and while she was about it, she wanted good coffee. Not an extra-large coffee to keep her from falling asleep, but a coffee made with love and attention. Hoping another café might show itself, she cut through an alley. She caught sight of a shop without a sign, which looked to be a café. One wall was floor to ceiling glass, but you couldn't see inside because of the endless potted plants blocking the view. It looked like the witch's house from one of the Western fairytales she'd read as a child. Most of the plants were cacti, and all their spines were razor-sharp. She'd never noticed this shop before. Trying her best to see this as one more challenge, she went inside.

The moment she stepped through the door, she was over-whelmed by the smell of clay flooding her nose, as well as the display shelves packed with pottery. There were two women, both in clay-spattered aprons. One, who looked to be in her twenties, was wrestling with clay on the pottery wheel. The other, some-where in her mid-forties, was staring absent-mindedly out of the window, and looked sick and tired of life somehow.

"I'm sorry. I thought this was a café."

Jungmin rushed to apologize, but seeing the pair entirely unflustered, she grew all the more flustered herself. It was almost as if her coming here had been planned.

"People do that all the time. You can't see inside properly

and the sign's so small. Alas, this here's a pottery workshop. I see you're sweating a lot, though." The woman in her forties, who appeared to be the owner, spoke without reserve.

"I came out for a stroll and ended up walking quite a bit."

Embarrassed, Jungmin fanned herself with her hand. She lowered her head slightly to examine her clothes, but thankfully the sweat hadn't seeped through.

"It's hot outside, have a coffee. Can't promise it'll be as good as you'll get in a proper café, but we have plenty of drip bags, or I can make you something sweet, too."

The younger woman stopped the wheel. "We were just planning to have a coffee break anyway," she said, before wiping her hands.

"Even so . . ."

Making a coffee for someone who'd stumbled in by mistake—was it kindness, or nosiness? Jungmin was wary.

"It's fine. Sit."

The younger woman hurried to pull out a chair from the back and smiled warmly. Jungmin felt suspicious of this unprovoked smile, but she didn't dislike it. Maybe the pottery of blues and whites, much like those found in nature, had already stolen her heart. She found it fascinating that these hard ceramics made by human hands could resemble nature's hues quite so closely. A few years before, at one of her hoobaes' stubborn insistence, Jungmin had reluctantly taken part in an interview entitled "Ask a Top Women's University Graduate about Her Career." At the time, to the clichéd question "Where do you find the inspiration for your writing?" Jungmin had given the equally clichéd

response of "Nature." It wasn't a lie. Jungmin did get inspiration from nature. Especially things blue and vast like the sea.

If it wasn't the mysterious blue that rippled across the ceramics' surfaces, then maybe it was how endearing the younger woman's pudgy hands had been as she pulled the chair out for her. No, more than anything else, the workshop owner had seemed genuinely delighted by Jungmin's visit, and so she'd been unable to refuse. Only a moment before, the woman had been staring into space, like someone who'd been abandoned—now, her face was glowing. Though perturbed by the sudden change in her expression, for some reason it put Jungmin in a good mood. She sat down on the chair as if possessed by magic.

"Would you like it sweet? Black?"

"I'd love a black coffee."

"Are you all right with a nutty taste? We're all out of the acidic. We have a secret recipe for our coffee here, so it'll taste good whatever your bean preference. Oh, and try it sweet next time. Sweet coffee is actually my speciality."

Next time? Was she asking her to come back to the workshop again for coffee? Out of courtesy, Jungmin smiled and replied with a brief, "Will do." The younger woman sitting beside her didn't say much, and Jungmin liked that. She couldn't stand conversations made up of vague attempts to suss the other person out.

Under the cool breeze of the air conditioner, Jungmin's sweat soon dried up. The coffeepot—the only thing in the workshop making a noise—blew out steam with great enthusiasm as if to make its presence known. As the coffee was served, its aroma

crawled in amidst the smell of clay that hung in the air. In an instant, the space filled with a scent that she couldn't describe in words. That harmony between the smell of clay and coffee. It was an aroma she'd never imagined before, but it wasn't bad. The physiological judgments of the nose—sweet, bitter, fishy—were preceded by an emotional judgment: "harmless." For Jungmin, highly sensitive to smell, it wasn't often she trusted her emotions over her nose.

"I made it iced for you."

One cup of hot coffee, two iced. The cups' designs were similar to those on display—perhaps they'd made them themselves. The woman who'd been at the wheel downed the coffee like it was beer. Her battle with the clay had looked pretty arduous, though Jungmin had only caught a glimpse. Having expelled a significant proportion of her body's water content through sweat, even the deep brown coffee looked refreshing. The coffee the owner had been so proud of was undeniably delicious. Though nothing special to look at, a distinct taste wrapped itself around Jungmin's tongue. She breathed in the aroma, and she could tell the beans weren't from a chain. Throughout her seven years in broadcasting, all-nighters had been the norm, so she was naturally well acquainted with the coffee giants. She calmly took another sip and thought hard, but nothing particular came to mind. After all, since quitting, Jungmin had done nothing but sleep for months on end, and so there'd been no need to drink coffee—it seemed her taste buds had dulled, too.

"It's delicious. Really. May I ask where the beans are from?"

"Actually, I'm not sure myself. They're ones I was gifted. I reckon they're probably from Yirgacheffe . . ."

Jungmin wondered what the secret to the coffee's taste was.

The owner watched Jungmin tilt her head and continued, "The reason our coffee tastes good, even when we make it with mediocre beans, is because of the cups. These are robust ceramics fired in a kiln at 1,250 degrees. If you serve coffee in a jade celadon cup, it tastes better. And the sweet coffee I mentioned earlier, you have to drink it out of glossy white porcelain. Maybe because it conjures up the image of sugar, but it's more delicious that way."

The younger woman weighed in to add credence to the "secret coffee recipe." "I didn't believe it at first either. I thought it was a placebo effect, like when Wonhyo-daesa drank dirty rainwater from a skull thinking it was a cup. But it's oddly different. The flavor, rather than the taste. I majored in chemistry, so I can't leave this kind of curiosity unsatisfied. I did a bit of research, and it seems that there's a chemical interaction that takes place between the surface of the ceramic and the components of the coffee. After all, they say pottery breathes, right?"

"That's fascinating."

As improbable as it may have seemed, the two women's words were strangely persuasive. *Maybe rather than beans, there really is a secret inside this vessel,* Jungmin thought, as she gripped the cup tight in two hands. Though it was of course full of ice, she was sure she could feel the 1,250-degree heat. She tried for the first time to picture a temperature higher than a thousand degrees. Instead of heat, a warmth traveled through the blood vessels in her palm right to her arteries. Unlike the instant refreshment of the air conditioner, it now felt like a warmth had burrowed deep into her bones, releasing her tension. A body

melting hopelessly away. The cold can't overcome warmth. She'd think of this coffee again. To be precise, she'd think of the flavor rather than the taste, just like the younger woman had said.

"Is the pottery back there for sale by any chance?"

"Of course. Feel free to take a look. Mugs and teacups like these are on the left-hand side."

Unlike the extortionately priced ceramics in department stores you'd find arranged neatly one by one, these had rough appearances. They were crammed in shoulder-to-shoulder, some piled up in stacks. Jungmin was concerned they might get chipped, but the setting felt familiar, like an ordinary family's kitchen cupboard. When she looked at a pure white cup, it naturally brought to mind a caramel macchiato. A cup with a jade and white ombré pattern made her think of milky tea. There was one with a jet-black glaze, which made her want to go out right away and buy some Excellent Ice Cream to make affogato. This was probably all down to the effect of the cup's "image" that the owner had spoken of. Writer Jungmin was quick to acquire this kind of imaginative skill. One by one, she picked up the cups with care, held them in two hands and felt the heat fill her palms. She wondered about the temperature inside the kiln, where these cups would have been until not long before. Just a moment ago she'd been sweating buckets, cursing summer. Her contradictory urge to look for something hotter than the weather was amusing.

"I'm a coffee lover myself. I had to pull all-nighters regularly because of my job. It'd be nice to have a cup like this."

"In that case, rather than buying, why not have a go at firing one yourself?"

The woman spoke in a similar tone and speed to when she'd suggested Jungmin stay for a coffee. She seemed to have mastered how to speak without making the other person uncomfortable.

"I'm useless with my hands. And terrible at anything to do with art. I won't be any good."

"Don't you worry about that. The lady next to you is one of our members, and she came in without any experience with craft whatsoever either. But now her work's good enough to sell at the Seoul Living Design Fair. If there's something you want to put in a container, that's a good enough reason to start."

Something you want to put in a container. Jungmin thought of the caramel macchiato, milk tea and affogato that'd come to mind just before. There were definitely other things she could put in a container, too. Warm and robust ceramics fired in a 1,250-degree kiln. Into these, surely, you could put even formless things with no smell nor weight.

"Do you live around here?" the owner slurped her coffee and asked.

"Yes. Chestnut Burr Village Complex Four. I've lived there a little over a year."

The woman's face lit up and her eyes widened. "That's really close to me. We've probably crossed paths a few times."

"We won't have done. I'm always at home." Jungmin smiled weakly.

"Me too. It actually hasn't been long since I was pulled out of my cave."

Jungmin bit down hard on her lip. *I'll pull you out of your cave.* A friend had said this to her a long time ago. *I'm doing this for you*—words that would make anyone uncomfortable. While

they professed to be the good-natured friend, to Jungmin it felt like a threat, that she needed to let that person in, even though she didn't have the slightest room to do so.

"But the cave isn't all that bad. Am I right?"

The woman's next words came unexpectedly. Without knowing why, Jungmin felt safe around her, and she nodded slowly, her hands still clasped around the cup.

SO THEY COULD decide on lesson dates, the workshop owner asked Jungmin about her schedule. Jungmin said she was off work most of the time. A nice way, of course, of saying she was unemployed. If you admitted you were jobless, people would then generally want to interrogate every last detail of the preceding events. Then, finally, they would act concerned and say, "Gosh, you really have been through a lot," having reached the conclusion that Jungmin was either someone with an uncertain future, or otherwise incapable of adapting to society. The owner, however, was sparing with her words and simply said, "Nice to be in charge of your own time." She didn't try and dig up her private matters, and so, Jungmin realized, there was no need to be nervous around her.

"How about Tuesdays and Thursdays, twice a week to begin with? For two weeks you'll do handbuilding with me, the goal being to get friendly with the clay. After that, we'll move one of the weekdays to the weekend, and put you in the Saturday class with the office workers. My name's Johee, and you can call me Seonsaengnim. This is Jihye-ssi, she's your workshop sunbae."

Once she'd finished speaking, Johee ripped out the August page from the desk calendar. She then circled the days Jungmin would come, and handed her the sheet. It was thanks to this square piece of paper filled with numbers that Jungmin came to understand just how long a month could be.

Just 60 Percent

"HOW ABOUT TUESDAYS and Thursdays?"

The words swirled around Jungmin's ears, like the afterimage of a strip light that flickers in the eye long after it's extinguished. She set an alarm before going to bed the night before. Looking at all the alarms saved on her phone, in five-minute intervals from 7 to 9 a.m., she was reminded of that intense period of her past life. At the same time, she felt a sense of relief that, despite her current state of inertia, there was no need to live like that anymore. She'd been given permission to rest again.

Her eyes opened to the sound of the alarm, and the first thing she remembered was what Johee had told her: to make sure she had a decent meal before coming to the lesson. For the first time in a long while, Jungmin ate a proper lunch before leaving the flat. She hadn't anticipated that learning something new would

send the blood pumping round her body like this. The sparkle of this golden light was unfamiliar. A color that Jungmin was sure she couldn't possibly possess.

In between each of Chestnut Burr Village's four housing complexes was a huddle of little shops. The ground floors were mostly Korean restaurants, convenience stores, and old cafés, while the floors above contained residential flats. The floating population was small, with the age bracket leaning toward the higher end, and so you could easily get the impression that there was nothing for young people to do here.

The workshop was down a street right at the far end, where the primary school and Residential Complex Two faced one another. Today Jungmin's clothes were weather appropriate, so this time she wasn't sweating buckets like she'd been caught in the rain. She carefully examined the outside of the workshop and found a sign hidden behind the ivy.

<div align="center">

소요 SOYO

ceramic art &

</div>

Letters in unfussy black type, set against a white background the same color as the building. Jungmin followed the smell of baking clay and opened the door. There were lots of people in the workshop today. A little kid and a high school student were messing around with the clay, and beside them was Jihye, the woman she'd drunk coffee with the time before. Jihye approached her first, her manner warm and welcoming, and introduced the members.

"This is Hansol, she's in our primary school class! Looks like

her friend didn't turn up today. . . . You never know when she'll make an appearance. I'll introduce you next time she's here. And this here's Jun, the future of our workshop. One syllable, Jun."

Hansol gave a slightly alarmed "Hello," while Jun's excuse for a greeting consisted of shooting Jungmin a perfunctory glance.

Jihye asked if she could call Jungmin "Unnie," older sister. Speaking on such familiar terms on the second, no, the 1.5th meeting? This was Jungmin, who'd insisted on calling her writer hoobaes who'd just graduated university the respectful "jak-kanim." Jihye, however, wasn't a work colleague, and so, deciding not to overthink it, Jungmin nodded gladly. She thought how pretty Jihye's smiling eyes were. She'd always struggled to get along with people who'd grown up in a loving environment, not experiencing any of life's setbacks, but she also couldn't help but be drawn to this kind of person, too.

Johee showed surprise that Jungmin had arrived at exactly 1:30 p.m., and half-joked that she didn't like perfect people. Before starting the lesson, as if according to set procedure, Johee first made coffee. This time it had to be the sweet hazelnut latte. Even without the usual thick milky foam on top, there was an honest flavor that allowed the original taste to shine through.

"I saw the sign as I was coming in earlier. The workshop's called Soyo?"

"Wow! The plants have encroached all over it but you still managed to find the sign. We hid it deliberately so only the observant ones could read it. I promise you it's not because it's a hassle to maintain."

The inside of the workshop was extremely clean for a place that dealt in clay, and so the words "it's not because it's a hassle" were most likely the truth.

"The plants outside are definitely a bit overgrown. I had no clue it was a workshop at first. Does it mean 'soyo' as in, to take time? Like the time it takes to make pottery?"

"Wrong answer. It comes from the hanja 'so' (塑), meaning to wedge clay, and 'yo' (窯), meaning to fire the clay in the kiln. Exactly what it says. But, as of just now, I've decided to include the meaning 'to take time,' too. A play on words. I think it's a great idea."

"It's a beautiful name. Easy to pronounce, too."

"Now we're clear about the workshop's identity, shall we get started?"

Johee led Jungmin to the back of the workshop. Beside the lockers for storing personal items, several aprons were hanging up. Johee, bubbling with excitement, was even more talkative than the first time they'd met.

"Whenever you come to the workshop, the first thing you need to do is get your apron from the back here. But . . . Oh dear, I'm all over the place! I completely forgot to order your apron. We'll borrow another member's for today. Don't tell anyone. He only comes on weekends so he has no clue what goes on during the week. Wouldn't say anything even if he did. He's a teddy bear."

Jungmin received the extraordinarily huge, clay-stained green apron. The initials G. S., presumably the man's, had been stitched clumsily on the front. The owner's cologne had seeped

into the fabric, and a sweet scent wrapped itself around her along with the apron. She reached into the pocket to place her phone inside, but her fingers brushed against a cold metal ring. Slim and made of silver. There weren't any initials or numbers engraved on it, but she knew immediately that it was a couple ring. It had scuff marks here and there, and so she guessed they were a longstanding couple—playing detective by herself like this, Jungmin was suddenly met with a strange sense of guilt. She shoved the ring deep inside the pocket. All she'd done was touch it, but it felt like she'd nosed in on the private matters of their relationship.

In the simple act of wearing the apron, she experienced a small thrill, as if she'd already become a potter. Even Jungmin, who'd always resisted the urge to get excited about anything, had decided this time to enjoy herself. She took a small bucket, two sponges, and a wheel, and went over to the large workbench where Hansol was sitting.

Johee came to sit beside her. "First things first, we have to decide what to make. Got anything in mind?"

"I'd like to make a mug, like the one you served coffee in last time."

"Aha. Mugs have handles, which makes them tricky. Usually we start off with a simple plate."

Jungmin quietly mourned the fact that she couldn't do a coffee cup straight away, and meanwhile scanned the plates on display. She had no idea what to make. All the plates looked far too technical for a beginner like her.

She held up one of the plates and asked, "Um . . . Would this yellow one be too difficult?"

Though the color had stood out, it was the simple design of the plate that'd pulled Jungmin in.

"That one cost more than five million won to make. It's meant for exhibition rather than for sale. You've got good taste, though."

Jungmin gasped in horror and hurried to return the plate. The gap between her and pottery widened once again.

"The first thing to think about is what you'll use it for. With ceramics, practicality comes before design and beauty. Though I'm sure they must look almost identical to you, all wide plates differing only slightly in size . . ."

Johee stood before the display stand and began to hold up each plate, one by one. "This one's nice and big, perfect for serving pajeon on a rainy day. This one's good for serving up dessert when you have friends over. Especially baked goods like cookies and madeleines. And this one with high sides is good for watery dongchimi. Right then, have a think about your kitchen. What kind of plate do you need?"

"Well . . . It's completely empty. If I'm honest, I barely ever use plates. I don't serve out food when I eat it—I just eat the banchan directly from the container. Desserts I don't really eat either. More than that . . . I don't cook."

"You've got all sorts of plates to make then, Jungmin-ssi. You'll enjoy working your way through them one by one. How about today we try making an all-rounder? One a little bigger than your hand. Just a plain and simple round plate. The in-between size will make it good for serving just about anything."

"Sounds good to me."

"Your first time working with the clay will be a shock. Don't try to be perfect, just think about getting sixty percent of the way there. No more, no less, just sixty percent."

Johee brought over some white clay. That this grubby lump would end up as a circular plate . . . Jungmin felt the unprocessed clay in her hands for the first time—it was soft and squishy, and colder than she'd expected. With a rolling pin, she flattened the clay for the base into an 8-mm thickness and placed it on top of the wheel. So far, everything seemed straightforward.

"Now's when you need to concentrate."

Johee took out a small knife. She spun the wheel and traced a faint circle on the slab to match the size of the plate. After the demonstration, she passed the knife to Jungmin, whose hand immediately began to tremble. The nail-biting first attempt. Jungmin's circle was perfectly . . . disfigured. She shot Johee a pleading look.

"It's all right. Give it another try."

Jungmin spun the wheel again, but the circle turned out even more mangled. By the third, fourth attempt, she'd managed to come up with something passable, but the clay was already a train wreck of knife marks.

"Should I roll out a new slab?"

"No need. Unlike wood, leather and metal, clay's soft, right? What I mean is, you can always salvage it. Let's see here."

Johee rubbed the spoiled clay with her fingertips. Like a wound as it heals, the traces faded, and had soon vanished completely, as if they'd never been there at all.

"Clay can be salvaged . . ." Jungmin whispered.

"Do you know why the circle kept warping? You're not being bold enough. Your hand keeps following the wheel as it spins, right? You need to hold the knife firmly in position. Okay then, go ahead and make as many mistakes as you like."

Johee rubbed out Jungmin's first half-decent circle, too, and told her to try again. The wheel spun at speed, as if to hurry her. She held the knife tightly in her hand at a three-o'-clock angle before lowering it. The shape turned out more of an oval, but this time her knife hadn't followed the wheel. When Jungmin lifted the blade, her hand was still right there at three o'clock. Then she rubbed out the line with her fingertips once more, like nothing had happened. She tried again. Finally, she ended up with a circle.

As she cut along the line with the knife, the texture of the clay felt new once again. It was almost like slicing through well-risen dough. When she wiped away the clay residue with the sponge, it felt as if she was touching the surface of a chewy, honey-filled ggul-tteok, slathered thick with sesame oil.

"Next, we'll move on to coiling. We're going to make the clay long and thin like garae-tteok, and then layer the pieces on top of the base."

Jungmin soaked her hands in water and rolled the slab with her palms, and her hands soon warmed the cold clay.

"When the clay warms, it's a sign that it's drying up. As the temperature rises, add more water. We need to communicate with our clay."

Once Johee had explained how to join the coils together, she went over to see how Hansol was getting on. Because Jungmin

now knew that, with clay, it was okay to make mistakes, she wasn't hugely afraid of working by herself. She wasn't an expert and there was no need for her plate to be anything near the standard of her teacher's work. Rather than the loftier idea of "wedging the clay," she could work in a way better described as "feeling the clay." All she had to produce was a practical plate you could serve food in, nothing more.

JUNGMIN LAYERED TWO coils and trimmed the surface to make it even. Once the sides had spread out at a 120-degree angle, it actually started to look like a plate. Only then did she relax. Maybe it was the nerves, but her shoulders had tensed right up. She stretched and took a look around the studio. At some point, her nose seemed to have got used to the earthy, muggy scent of the clay. She began to hear the sound of the radio. It was a channel that played upbeat, irreverent Britpop. Music from across the generations flowed out: The Beatles, Blur, Oasis, and Coldplay. She'd been so deep in concentration that she hadn't even noticed that the radio was on . . . Jihye and Jun were still at the wheels. Both had their AirPods in and were engrossed in their own work. Jungmin found it curious that she, too, was here in this highly solitary—yet at the same time surprisingly communal—space.

More than anything else, the noises that burrowed into Jungmin's ears were of exactly the right intensity—the sound level she'd been looking for. Locked away at home, she hadn't played any music at all. Her TV she'd ended up throwing away. She was afraid that she'd be channel-surfing and would land on

one of the programs she used to work on. Like a phone set on silent, she plunged her home into quiet. All the sounds from the world around her had felt like noise.

But the sounds in Soyo Workshop were different. Cogs in perfect alignment—not a single sound jarred. The ridiculous questions Hansol asked Johee, the teasing remarks Johee would make in response, the rhythmic hum of the wheels as they spun, the shrieks of irritation and strange exclamations Jihye would mutter to herself from time to time, the soft metal music escaping through Jun's AirPods, the muffled voices traveling through the glass window from outside, the radio that'd been switched on to a random channel, and the DJ telling terrible jokes—everything felt in its rightful place. She was sure that even if just one of these were to disappear, the whole place would feel empty.

Cracks were forming in the silence that Jungmin had been protecting for months. As they widened, it felt good, freeing. Like a tightly wound ball of string within her had started to unravel. Now, it felt okay not to be silent. She actually preferred to have the voices tickling her ears and to hear the thick and heavy sound of the clay.

JUNGMIN'S FIRST PLATE wasn't symmetrical, and the rim was uneven. The in-between size, however, really did seem right for serving just about anything. Johee said the plate was "marvelous." Jungmin later learned that she made this same comment out of habit to just about every one of her nervous students.

"Let's call it a wrap for today. We'll leave the glazing and

firing for next time. Think about which color you'd prefer, and whether you want a gloss. That's your homework."

When Jungmin looked at the clock, it was already almost 4 p.m. Time had flown by. She'd surprised herself yet again—it turned out she was still able to lose herself completely to a task.

At the end always came cleaning. *Wipe the clay from the wheel before putting it back where you found it. After washing up the buckets, sponges, knives, and wooden tools, leave them to dry in a sunny spot.* Jungmin began to tidy everything away in the order listed on the workshop rules.

Ding—

Suddenly, there was a sound of metal hitting the ground. Then a clattering that reverberated across the room. The tools left out to dry had scattered all over the floor. When Jungmin removed her apron, she'd managed to knock over the container with her arm. Johee laughed out loud and joked, "Looks like you've already mastered the art of imperfection, I see?" Jihye and Hansol, and even—unexpectedly—Jun, all came over and helped gather up the tools. Jungmin was starting to understand the meaning of 60 percent. She'd opened the door to the workshop at 1:30 p.m., but when she opened it once more, it was 4:07.

The Moment Clay Becomes a Plate

IT WAS A Saturday morning, and after a fortnight of weekday classes, today Jungmin was going to start glazing and firing. She was reflecting on the juncture between the weekdays and the weekend. Back when she was working, the days would go by and with each shift in the cycle—tensing, then relaxing—there was a noise, like something scratching at the inside of her ear. The hideous creak of an unoiled door hinge. If she wasn't careful, it'd be Monday again before she knew it. Seven weekdays in a row, of course, would be difficult for anyone to stand. A seven-day weekend, on the other hand, was a bottomless swamp of inertia.

For seven years, Jungmin had lived seven-day work weeks, and for the year just gone, it had been all seven-day weekends. Today, for the first time, she could feel a distinction between the

weekdays and the weekend. This was her first weekend visit to the workshop. Until now, she'd been lumped together with the school students on their summer holidays, as well as Jihye, who was—for whatever reason—there nearly every day. Jungmin felt her curiosity pique as she pictured the new people she might meet at the weekend class for adults, as well as the different sounds that might fill the workshop, but she felt an uneasiness, too.

Jungmin ate her breakfast as she stared out through the arched window, watching the world go by. By now she was in the habit of eating a proper meal before each class. You might call it an awareness of the line between breakfast, lunch, and dinner. This same awareness sharpened Jungmin's sense of time. The weekend lesson began at 10 a.m.—leaving just enough room in her stomach for coffee, she set down her spoon.

Johee welcomed Jungmin as if she'd been waiting only for her. Jungmin's apron had finally arrived. A shade of rich buttercream, with the letters J. M. on the front. Her initials had been embroidered the same as everyone else's. It looked like Johee had hand-stitched them herself, and much like G. S., Jungmin's letters were wobbly and had a life of their own. She was glad—now she had her very own apron, it felt like she'd been fully initiated into Soyo Workshop. She'd always drifted from place to place—a freelancer who belonged nowhere, not even at work—and so the fence of a community, no matter how loose and temporary, gave her a deep sense of stability.

Just then, a hefty man with pale skin opened the door to the workshop.

"Good morning."

Out of place with his large frame, he had big eyes and a

mouth that turned up at the corners. It was uncanny how his lips curved like that even though he wasn't smiling.

"This here's our weekend class's top student, and your super-sunbae, Gisik-ssi. This is Jungmin-ssi, the new member I told you about. Gisik-ssi, Jihye-ssi, Jungmin-ssi, from now on, the three of you will take lessons together once a week."

Gisik had been doing pottery for almost two years now and was planning to open his own workshop the following year. He'd made a promise to himself that once he reached an age of two identical digits, he would quit his job—as he said this, the corners of his mouth lifted even higher. He was thirty-three years old. Jungmin secretly scoffed at his idealism—the belief he could change careers and make a success of himself even in his thirties—but she was jealous, too. She envied his courage and willingness to step outside of his comfort zone. Though three years his junior, Jungmin didn't have the guts to start from scratch until she was pushed to. Gisik seemed to have the "clarity" she lacked.

Given his height and size . . . Jungmin was sure this man was the owner of the apron she'd borrowed.

"Gisik-ssi, this green apron is yours, right? I've actually been using it for the past two weeks. The apron I ordered only arrived today. I really appreciate you letting me use it."

"Oh, I heard someone was using my apron! Did you see a ring in the pocket, by any chance? I think it was about two weeks ago—I put it there and completely forgot. When I came last week, it was gone."

As Jungmin looked up at Gisik, who was fiddling with an empty-looking finger, she recalled the slender ring. As well as

the resounding *ding*. Flustered, she rushed to scour the floor. Thankfully, she found it glistening faintly at the bottom of the shelves where they kept the wheels. She dusted it off and handed it over.

"I'm sorry. I thought something had dropped when I took off the apron, but I had no idea it was the ring. . . . I'm so sorry. I wasn't paying attention."

"It's all right."

Gisik said nothing more and simply grinned. He was about to put on the ring, but at the last moment slipped it inside his trouser pocket. Rings had to be removed before working with the clay.

Late arrival Jihye was the last to step through the door. Even after the lesson had begun, Jungmin still couldn't shake the uncomfortable feeling. She'd been so focused on the tools she'd dropped that she hadn't noticed the ring—her face reddened at her own carelessness. As if it wasn't enough to borrow his apron, she'd almost gone and lost his ring, too. And what if it'd caused an argument between Gisik and his partner . . . ? She drew her thoughts to a close here, and resolved to apologize properly, if only to avoid a string of awkward Saturdays.

Though Jungmin was technically in the same class, Gisik and Jihye were already doing their own thing. Today she was once again the focus of Johee's attention. This was also going to be her first time glazing, and she spent the whole time carefully observing Johee's demonstrations. Johee took out Jungmin's plate, which she'd already bisque fired. Though Jungmin had definitely used white clay, after the bisque firing it now shone a

light pink. Though the exterior was no longer squishy but firm, the dish was still frail as glass.

Jungmin had decided to go with the shade Haneul Bori, named after the barley tea with its distinctive blue label. This had been Johee's recommendation to Jungmin, who'd still been struggling to imagine the clay changing color. When Jungmin looked at the example piece, it really did resemble the pale blue of the summer sky. She loved the sounds of the living clay—a gurgle as it sunk into the glaze, followed by a splish-splash. Her mind drifted, and as she watched the plate swimming back and forth in the tin of glaze, she began to feel like dipping her hand inside. The liquid had a concentration thicker and denser than milk, but it looked supple at the same time. Right now, the color of the glaze was close to white, but once fired, it would turn blue. No one could predict exactly what the final shade would look like, though, Johee explained—that particular fate was in the hands of the kiln.

"We can spend days working hard at the clay, but the problem is whether it'll survive the kiln. Oh, I still haven't shown you the kiln, have I? The one we use here is huge. It's probably the biggest one in all the workshops around."

The kiln was right at the back of the workshop where they kept the stacks of firewood. It really was the size of a double-door refrigerator, just as Johee had said. She beamed with pride as she explained that they didn't use gas, but a traditional wood-fired kiln. That made the process slower and more arduous, of course, but ceramics grew stronger the longer they were fired, she added.

"As I mentioned, the glaze firing temperature is 1,250 degrees. All we can do now is wait. There's no looking back."

BEFORE PLACING THE pieces inside, it was important to first wipe all the glaze from the bottom. Otherwise the base would stick to the kiln. Wedging the clay thoroughly wasn't enough. You needed to pay close attention to a whole range of things before making it as far as the kiln. Jungmin, Jihye, and Gisik sat in a line and each picked up a sponge.

Jungmin glanced over at the assorted cups with their smooth curves and asked, "Jihye, I see you make a lot of cups?"

"I mostly do little soju cups. Sometimes I make medium-sized ones for somaek, too."

Neat and tidy handleless cups with shallow stems. They'd been thrown on the wheel and had far more balance and symmetry than what Jungmin had built by hand. Given how many there were, it took Jihye a long time to wipe the glaze from all the bases. She filled the time with words.

Jihye was a long-term jobseeker, but she'd put that to one side for now while she was at graduate school. These days, she drank a lot. It felt so bleak drinking out of the chipped cups they had lying about at home, and so she'd decided to make some of her very own. Her first experience with pottery had been at a one-day class, but she'd really gotten into it, and had been coming to Soyo over half a year now. She'd found a hobby that allowed her a brief escape from reality, and with this, her mind—sucked dry by the endless slog of job hunting—had begun to clear little by little. The downside was that she'd developed a taste for drink and the weight was going right to her belly.

Despite looking cheerful as anything on the outside, Jihye had her own unexpected story to tell. She had a talent for softening things around the edges. Crafting her words to make them easier to swallow. It was clear she'd put her all into each and every one of these vessels, too, which she'd made for the sole purpose of cheering herself up. Even Jungmin, who was a lightweight herself, thought that a drink might really hit the spot if served out of one of these.

Just then, Jihye whispered to Jungmin, "*Pff*—Unnie, check out Gisik oppa. He does that sometimes—nah, all the time."

Gisik was wiping the glaze from the base of one of his ceramics, his eyes gently closed. He wasn't asleep, but maybe he was pretending to be? But then, why, all of a sudden . . . ?

"Oppa, seriously, can you 'feel' the ceramics or something? I told you so many times already. Pawing at them like that with your eyes shut is so creepy."

"It's not like that, Jihye-ya. You should give them a feel, too."

Gisik then started touching the piece even more creepily. There was a mischievous glint to his over-exaggerated movements.

"Do you think you're in *Ghost* or something? Gross! And in front of our brand-new member, too . . . Unnie, don't go getting any ideas from him!"

Gisik began furiously coating the base of Jihye's cups—the ones she'd wiped with such care—with glaze, calling it payback for making fun of him. As the two bickered, Jungmin found herself chuckling, too.

Johee had already cranked up the temperature of the kiln, and Jungmin could feel the warmth radiating from it. The heat

smothered the air around her with a force more terrifying than the sun outside, but it created a snugness like a sauna, too. Her clumsy plate was first to go in the kiln. Jihye and Gisik also brought over their pieces and began placing them inside.

You could tell at first glance that Gisik's creations had personality. Around half were plant pots and vases, and almost all had unusual, eye-catching shapes. The asymmetry of the vases had a charming "naturalness" to them. When she looked at the vases, Jungmin immediately felt the urge to fill them with slender-stemmed wildflowers. It was as if only flowers would give the vases balance, and a seat had therefore been left for them. There was also a flowerpot with a geometrical pattern in black glaze. To Jungmin, who was clueless about such things, his work looked like modern art. She wanted to express her admiration to Gisik—who was placing the vases so expertly inside the kiln—but then she recalled the ring incident, and as the kiln door shut, so did her mouth.

A PERK OF the weekend classes was that once they'd finished work and cleaned up, everyone ate a late lunch together. The rule was no deliveries, and usually they divided into two groups, each grabbing something to go from one of the neighborhood eateries. Today's menu was sandwiches, upon Gisik's recommendation. There was a really good place in Chestnut Burr Village, he'd explained, and as the new member, Jungmin just had to try it. By the look in Johee and Jihye's eyes, Jungmin could tell there was no getting between Gisik and his love for sandwiches. They'd have gimbap and tteokbokki along with them.

Jungmin had been paired up with Gisik, and she walked

awkwardly along the asphalt path, which sizzled in the heat. Despite the giant apron he'd been wearing, clay was still splattered here and there across his trousers. He'd been bent over the entire time he was at the wheel, and his shoulders must've been stiff because he kept swinging his arms and stretching. The image of the towering Gisik crafting those tiny vases—he was like a bear, crouched over as he reached a paw into the honey jar, fearful of being caught in the act. And then there were his enormous hands, which hardly gave the impression of dexterity. Though his appearance didn't align at all with her image of a potter, his calm and collected way of speaking and his generally unhurried movements were a perfect match.

Gisik was the first to speak. "We'll be seeing each other every week from now on, so you can speak casually with me, if you like."

Jungmin remembered how Jihye had called him Oppa without the slightest hesitation. As she tried to picture herself doing the same, Jungmin felt the hairs on the back of her neck stand on end.

"I'm an only child, so I find it weird calling anyone older than me Oppa or Unnie. I'm more comfortable that way. I tell anyone younger than me to call me whatever they like, though."

Perhaps Gisik had been hoping for a more affable response, but his eyes darted left and right as he struggled to locate his next words. It appeared that for him, dropping the honorifics was the first step to becoming closer to someone, but that wasn't the case for Jungmin. Silence fell once more. The only sound came from Gisik's sandals scraping across the ground as he strolled on ahead.

Unable to stand the awkwardness, Jungmin tried to reignite the conversation.

"When do you think I'll be able to start throwing?"

"Three to four months, they usually say. But adults can go much faster than that. It took me two months. You're doing this as a hobby, though, so there's no need to rush. I want to open my own workshop, so seonsaengnim sped things up for me. At the beginning, any weekends I wasn't in the office, I'd spend the entire time in the workshop. Seonsaengnim ended up just giving me a key. I fought a lot with my girlfriend over that, though."

At the word *girlfriend*, Jungmin's thoughts ground to a halt once more. Obviously she wouldn't feel comfortable until she apologized. She slowed her step.

"About the ring . . . I'm so sorry. I want to apologize properly."

"There's no need. I was the one who left the ring in the apron, after all. Don't worry about it, Jungmin-ssi. Honestly."

Watching the way Jungmin wavered in her response, Gisik could tell she was still bogged down by guilt. He repeated once more—and clearly—that it was okay, before quickly changing topic.

"Anyway, so how did you end up doing pottery, Jungmin-ssi?"

Jungmin's mouth twitched as she debated whether or not to tell him. Gisik waited in silence.

The Soyo Workshop members didn't seem overly close. Yet it wasn't a case of quantity over quality, either. It was enough for them, it seemed, to have ordinary relationships with one another, without a need to quantify "depth." *Share private matters only with those within a one-meter distance of your heart*—there were no self-help-y conditions like these in Soyo. Jungmin,

who'd always found forging connections with people to be a trial, actually preferred this kind of ambiguous relationship. She already felt like she was part of Soyo Workshop. And so, she began to tell her story, starting from when she left her career as a broadcast writer and became a recluse.

"It's not as if I had loads of money saved, but I was overwhelmed by emotion and just started screaming out in a fit of rage. Then I realized that inertia is the scariest thing of all. Now that I've calmed down and can look back on that period, I can't understand myself. I've begun to regain my strength, and I can't accept the person I used to be. The present me is left to pick up the pieces of what the past me has done. In the midst of everything, I ran out of my flat without thinking, and Soyo was where I happened to end up. I thought it was a café. There was no fateful turn of events, I never planned to pick up a new hobby. Not the grand story you were expecting, right?"

"Impressive. I'm always impressed whenever I see someone working hard at something. As for me, I need to get a move on and finally escape my life as a slave to this teleshopping company I work at. . . . Anyway, congratulations. You've put one step between yourself and inertia."

There was a sincerity to Gisik's words, though it could just have been his distinctive, unrushed manner of speech, of course.

"I've still got a long way to go, but I get the feeling that as long as I'm here working with the clay, things will get better."

"I like that mindset."

"But, Gisik-ssi, why come all the way here to learn pottery? You live in Seoul, right? It must be tiring to travel over an hour to Ilsan every weekend."

Every neighborhood in Seoul would've had its own pottery workshop. Why had he chosen Soyo, of all places?

"Do you know where Chestnut Burr Village gets its name from?"

"All the chestnut trees?" Jungmin remembered what the estate agent had said when she'd first told her about the flat in Complex Four.

"When autumn comes around, people gather the fallen chestnuts, taking only the kernels and leaving the shells behind. The discarded chestnut burrs are left scattered everywhere, hence the name. I fell for the neighborhood as soon as I heard the story. A lens focused on the things cast aside. That was why I started coming to Soyo. Nowhere else would do."

Okay, so why did you start pottery, though? Jungmin wanted to ask, but didn't. Everyone carries their own thorns. She herself hadn't been able to reveal her bare skin underneath the needles to anyone.

"Oh . . . That must be why I moved to Chestnut Burr Village, then," she said instead. Jungmin concealed the tangles in her heart, and instead smiled, as if everything was completely fine.

SANDWICHES FILLED WITH peaches and white grapes, planted in mounds of fresh cream: one for everyone, plus extra, packed to go. Jungmin promised she'd pay next time—Gisik had beaten her to the mark. By the time they reached the workshop, the air was already full of smells. Sweet-and-spicy tteokbokki and gimbap coated in toasted sesame oil. They served the food out on plates, and when Jungmin went to set the long hardwood table,

which was empty on one end, Johee stopped her. This one they didn't use, she said. Jungmin was ashamed that there were still rules and silent agreements within this community she wasn't aware of. Clocking this, Gisik quickly changed the subject, even though they still hadn't finished putting out the food. "How about we do rock-paper-scissors for the washing up?"

Gisik had clearly been waiting in eager anticipation for Saturday's fruit sandwiches and polished off two whole helpings, barely touching the tteokbokki.

Once he'd had his fill, he started up a conversation.

"Jungmin-ssi said she used to be a broadcast writer."

With her small appetite, Johee had already finished eating, too, and her eyes lit up at Gisik's words.

"Whoa, I had no idea. Do you write well, then, Jungmin-ssi?"

Apparently finding something off about Johee's question, Jihye interrupted. "You've got the order all wrong, Seonsaengnim. She writes well, that's why she's a writer."

The kind of "writing" they were expecting would be nothing like the kind of "writing" Jungmin used to do. . . . She'd unwittingly become the target of everyone's attention, and it looked like she had no choice but to clear up the misunderstanding.

"Broadcast writers explain specific scenes and write short pieces of text connecting different scenes together. Voice actors fill the gaps in the audio, which range from around four to sixty seconds long. It's different from writing subtitles and scripts, or the kind of writing that usually gets published. I don't write especially well."

Flustered, she'd ended up speaking a lot, which was unlike

her. Despite Jungmin's explanation, Johee sent her a hopeful look.

"I have a favor to ask. It feels a little odd saying this myself, but although I'm skilled at pottery, I'm useless when it comes to advertising."

As a potter, Johee had once been the main exhibitor at Gallery Hyundai, and her father was a famous artisan, Jihye whispered from the seat beside her.

"We've had an Instagram page for a while now, but no one visits it. My colleagues tell me that lots of young people come to their workshops through social media. . . . Both our online orders and offline footfall are closing in on zero. No one ever comes. There's definitely nothing wrong with the photos, so the text must be the problem, surely?"

Johee handed over her phone. Judging by the feed, the photos indeed weren't bad. Gisik pointed out that he was the one in charge of photography, and looked secretly pleased with himself. They would need more hashtags, however, if they wanted the posts to show up in searches, and much like the workshop's name, the writing was needlessly direct. *This is a sanbaekto clay plate, sturdy and of a timeless design.*

"The wording definitely leaves a lot to be desired."

"If I let you use the kiln for free, will you give it a go?"

Jungmin waved her hand. "I'm a broadcast writer, not a copywriter or a marketer." On top of that, it'd been over a year since she'd written anything at all.

"I'm not after anything as professional as that. All I need is some text that'll appeal to young people. In broadcasting, you

have to be sensitive to trends, right? I prefer working at a slow pace, so there won't be much to post. Once or twice a week, maybe. And of course, you can do it on days when you're at the workshop."

Gisik and Jihye both added their piece, saying that Jungmin would be the perfect fit. Though it was nothing more than a few lines for social media, Jungmin still felt incapable of overcoming this hurdle called "writing." She didn't feel like she deserved to write any more. Now, she had to confront it once again, here, of all places.

JUNGMIN HAD BEEN a subwriter for a documentary series that transformed ordinary individuals into the stars of the show. The summer before, she had cast a translator who'd made a success of himself after translating subtitles for famous films from across the world. The filming and editing processes went by without a hitch. However, when they ran through the rough cut in the editing room, the responses from her manager and the lead writer were lukewarm. The producer tapped away anxiously at the keyboard.

About halfway through the video, the translator suddenly burst into tears and began opening up about his mother. "I could never forgive my mother for abandoning me and my younger sister like that . . ." Jungmin froze. After the filming, the translator had called up and asked that the personal part about his family be edited out. Jungmin was sure she'd passed the message on to the producer . . .

"Bravo!"

Jungmin was the only one not to cheer.

"Now we're talking! This is our footage right here!" Their manager, apparently satisfied, rewound the video, and replayed the moment when the tears began to fall over and over.

The main writer, Gu, breathed a sigh of relief and slapped Jungmin on the back. "Makes you forget all about how dull it was at the beginning. And there I was worrying about how we were going to salvage this episode. I see you two had an ace up your sleeves?"

Overexcited, the producer began to blabber, fishing for a compliment, "I worked really hard to bring out the human element of the story. I even cried in front of him! I lied and said my father passed away the year before last, but that I hadn't been there when he died. It was only then that the guy started to open up." He was just like a dog wagging its tail.

Jungmin had expected the scene to be removed by the time she went to check the final cut. It was just a casual conversation that'd taken place between the translator and the producer during one of the breaks, after all. She'd never imagined they would edit it—and so expertly, too—to look like an official interview with the guest.

Their manager was in awe. "Wow . . . Lee PD, you deserve the award for best actor. We need that human touch to maintain the pace and keep things interesting. I was completely lost in the moment."

"Interesting, is it?" Jungmin was the one to kill the mood. "That it's fun to see people crying? PD-nim, I told you to take the part about his family out. The guest asked us to."

The producer frowned. "Yu jakka, you of all people know how broadcasting works—what's up with you?"

Jungmin didn't back down. "He's not a celebrity, he's just a normal person—we need to protect a certain amount of his privacy. It's our responsibility."

The producer's eyes shot daggers at Jungmin. "Then it won't be interesting at all, will it? You're saying we should cut the whole thing out? How are we supposed to fill the time? It was such a nightmare finding material after how dull his life turned out to be. . . . Actually, it was your fault for casting him to begin with! With all your years of experience, you should know what kind of person makes good television!"

At that moment, their manager threw the pen he'd been twiddling between his fingers down, and hard. As the pen hit the floor, everyone snapped their mouths shut.

"All of you be quiet. So, what you're saying is that there was a disagreement when the two of you did the final cut . . ."

"We need to remove it. This section can't be broadcast."

Jungmin hurriedly flicked through the preview notes, which described all the footage in detail, trying to find a replacement, but another writer, Gu, stopped her. Not a single person on the team was on her side.

"But Yu jakka, you like these kinds of family stories. Divorce, violent alcoholics, car accidents, poverty—stories about people who overcome life's hardships and make successes of themselves. It helps give the storyline its backbone, and gives you plenty of juicy buzzwords when you write up the draft, or am I wrong?" Their manager's voice was low and indifferent, as if

he were merely handing over a pile of documents. His words were far more menacing than the producer's loud and ignorant outburst. The icy atmosphere prevented Jungmin from uttering a word, and she was left with no choice but to nod her head.

The broadcast went out as planned, and Jungmin was restless. Ordinarily, she would've contacted the guest to say thank you. On this occasion, however, she was far too ashamed to make the call. A few days after the program aired, she finally plucked up the courage. The ringing was barely audible, hanging on by the skin of its teeth. Then there was a click, but the person on the other end said nothing.

"H . . . hello. Did you see . . . the broadcast?" Jungmin's voice cracked.

"Yes. I'd like to thank you and everyone else for their hard work."

"A . . . about your family's story . . . I'll try and make sure there isn't a rerun. And that the video doesn't go up on the website . . ."

"Everyone's already seen it. As you're well aware, it's a really popular program. My family, friends, acquaintances of my parents, and even my daughter, they all watched it."

His calm and collected tone sent a shiver down Jungmin's spine.

"I'm sorry. I'm so sorry."

"You packaged up my life in a few shallow words. Must have been nice and easy for you."

Despite being on the phone, Jungmin kept bowing in the air. She wanted to turn the blame on the producer but couldn't. After all, it was she who'd obediently written the narration to

go alongside the producer's video. The call cut off, and Jungmin received no forgiveness. It felt like part of her heart had closed off, too.

After that incident, Jungmin wrote robotically—the stories her manager, the producer, the viewers wanted to hear. She no longer felt indignation soar, and had no more pent-up frustration. Only inertia. Inertia latched on to Jungmin like a parasite deftly eating away at its host. Even the beating of her heart was painful; all that was left of her was an empty shell.

As summer drew to a close, Jungmin began to struggle to read the words on a page. She'd first noticed it while at work, when she was reading the preview notes as usual. Over and over, the same words and the same sentences . . . At first, she thought the producer had done several retakes. But Jungmin had been reading for a whole hour and still hadn't made it past the first page. She *couldn't* make it past the first page. As soon as the words reached her eyes, they bounced right back off with a twang. They scattered into syllables and floated off into the air. She couldn't read any of the shooting scripts and naturally couldn't understand any of them, either.

Jungmin tried to tell herself this was all because she wasn't feeling well. As soon as she got home, she took out a book and opened it. Amos Oz's *My Michael*, which she'd read a million times. It'd been her favorite book since university, and she could recite every word by heart. But she couldn't read a thing. "What does this mean?!" she exclaimed as she scanned the same sentence over and over. She couldn't find a single meaning hidden between the lines. Once she'd read more than five sentences, the contents would vanish from her mind—like a snowman

lacking shade, melting helplessly under the morning sunlight. She couldn't follow the plot. No matter how furiously she waved her arms from the stop where she waited, the bus called "the story" would always drive off without her.

Her concentration deteriorated so much that she couldn't appreciate the art at museums, let alone read books. Confronting words was so agonizing that Jungmin felt like giving up on writing altogether. *Who knows, maybe I've been granted permission not to write anymore?* As soon as the idea entered her mind, a weight lifted from her chest.

BACK AT SOYO, Jungmin's palm sweated as she gripped Johee's phone. She drew a deep breath and typed swiftly at the keyboard, all the while thinking to herself: you're okay, you're okay.

There is nothing more elegant than shapes born from nature. See for yourself how food tastes from your very own sanbaekto ceramic bowl, in a one-of-a-kind design.

Jungmin handed the phone back to Johee and showed her the edited text.

"It'd be a good idea to add a short explanation of what sanbaekto is, too."

Johee read the sentences carefully and beamed until creases formed around her mouth.

"I'm going to count on you, Jungmin-ssi."

The moment was drawing near: the clay in the kiln was about to become a plate. And for every person in the room, it really felt like the weekend.

That Person You Can't Avoid

ONE EVENING DURING the week, Jungmin went to the workshop to see how her plate had turned out, and arrived to find the place bustling. The busier the workshop, the more animated Johee became. Some people were born to harmonize, mix, and gather together with others—Johee was exactly that kind of person. The lesson would soon be over, she informed Jungmin, who then went and lingered awkwardly in the far corner while she waited. Her usual seat had disappeared, and the space was now occupied by a middle-aged man in a wheelchair.

While the class was still in full swing, suddenly Jihye appeared through the door, Jungmin's savior, accompanied by a man.

The man's sunny greeting seemed to transform the atmosphere in the workshop.

"Looks like everyone's having a great time! Just thought I'd stop by after work."

Jihye, pleased to see Jungmin, waved and strolled over. "I see you came to get your plate, too, Unnie?"

"Yeah. But looks like there's a group class on at the moment."

"It's a program they run in partnership with the local Welfare Service and Adult Education Center. The workshop is at its noisiest every Tuesday and Saturday at six p.m. It's partly because of the number of people, but mostly because of Hyoseok over there. He talks enough for ten."

Jihye quickly shielded Jungmin's eyes, which were pointed at the man chattering away at one of the tables. His radar had apparently already detected her, however, and he bounded right over.

"You must be the new member! I'm Lee Hyoseok, the social worker. I'm in charge of this class. I always stop by after work so I can take some photos for the report and check on how things are going."

Hyoseok chattered/blabbered on. "I heard a lot about you from Jihye." Jihye, meanwhile, shook her head in resignation with a look that said, *Here we go again*. She and Hyoseok grew up in the same neighborhood and had been friends since middle school. Their relationship seemed to work as follows: he would mouth off, and she would shoot him down.

Hyoseok brought a folding chair out from the back room and made Jungmin sit, before taking the seat beside her.

"Noonim, I'm looking forward to seeing plenty of you from now on!"

"..."

Calling her "noonim" like that, familiar yet overly respectful, when they'd only just met—it was cringey. Jungmin was struggling with how to respond when Jihye came over and squeezed her bottom between them.

"This guy . . . Unnie, just go ahead and ignore him."

Jihye put a stop to Hyoseok's chatter, so thankfully Jungmin could wait in peace for the lesson to end.

ONCE THE LESSON was over, all that was left on the tables were the students' creations. Each one was unique. Jungmin picked up one of the pieces and examined it a while; it belonged to the man in the wheelchair who'd been in her spot.

Just then, the man in the wheelchair—after saying goodbye to the other students—came back in, a look of irritation on his face.

"Excuse me, miss. That's not finished yet . . ."

"Oh, I'm sorry. Here you go."

Jungmin smiled awkwardly and set the piece down again. That man, had she seen him somewhere before? She tilted her head—there was definitely something familiar about him.

The pieces were cold to the touch, as if they'd forgotten all about the 1,250-degree heat. In amongst them was one ugly and especially uneven plate. Jungmin sighed, recognizing her work. No matter how much effort you put in, perhaps anything made by a messed-up person was doomed to turn out a mess, too. In that case, this plate represented how Jungmin saw the world.

"On your first attempt, design, aesthetics, beauty, and detail

all come second—if there are no cracks and it's stayed in one piece, you've done a marvelous job."

At Johee's reassurance, Jungmin's disappointment shriveled away, like candy floss dunked in water. "That's a relief, then."

"Lots of people get scared, believing that ceramics are like glass, but they're actually safe to use in the oven and microwave. Don't just use this to serve out shop-bought banchan, but try cooking something for yourself. You're as skinny as anything— make sure you eat properly." The way Johee spoke, it was as if she were pleading with her own daughter.

"No way—surely it'll break if I put it in the oven?"

"I use ceramics as lasagne dishes all the time. I sometimes make pound cake on Sunday afternoons, too. These pieces have survived a 1,250-degree kiln. Have some faith in them."

"I better do some food shopping on my way home today. I definitely feel like paying more attention to what I eat."

Johee beamed. "Right? I knew the instant I saw you that you were someone who needed pottery, Jungmin-ssi."

Once Jungmin had sanded down the underside of the plate, she wrapped it carefully in newspaper. She felt a pleasant thrill in performing these motions. Two weeks of time and effort hadn't vanished into thin air—it was all stored within this dish.

A WOMAN WITH cropped hair, dressed in a blouse and black suit trousers, stepped through the workshop doors.

"I'm so sorry. I'm late again, aren't I?"

Jungmin's excitement over her first plate was squashed in an instant. Although the woman's voice wasn't completely familiar,

she was the same girl who'd always been a handspan shorter than Jungmin—her face, voice, build were all just as they had been ten years before. Her short hair was the one and only difference.

Hyoseok, who'd been wiping down the tables, lifted his head and greeted the woman warmly.

"Juran noona, you're late out of work! Your father still hasn't finished, anyway."

Juran scuttled over to the man in the wheelchair and crouched down beside him.

"Appa, what did you make today?"

He was missing part of his left leg from the calf down. Why hadn't she recognized Juran's dad? Seeing the warmth between the father and daughter pair, Jungmin felt her heart plummet. What were the chances of running into her—the last person she wanted to see—here, in this tiny neighborhood in Ilsan? It was as if she'd been walking down the street and a flowerpot had fallen from a windowsill above, right on top of her head.

Juran looked up and saw Jungmin. Unlike Jungmin, who was desperately trying to avoid eye contact, Juran was completely unfazed—her eyes curved into a smile, and she came over and grabbed Jungmin by the hands.

"Jungmin-ah! Wow, it's been so long. Are you taking lessons here, too? Or do you work with Hyoseok? My dad's here every week for his class."

Juran and Hyoseok had attended the same university. Hyoseok had found out about her father and recommended the class to him, Juran explained. Juran never needed to be asked

anything—her words always came spilling out anyway. She was acting as if nothing had ever happened, as if they'd gone back to how it was before. *Does she not hate me? Or is all this fake?* Jungmin was convinced that she was deliberately trying to make her feel guilty—there was no way she'd be this happy to see her. The blood-soaked white shirt was still vivid in Jungmin's mind.

JUNGMIN AND JURAN went to the same primary school, but they ran in different circles. They were simply students in the same year, just about aware of each other's existence. Their class numbers were determined by height—Juran was always right at the front, and Jungmin right at the back. Then Jungmin went on to the neighborhood girls' middle school, and Juran to the mixed school in the city, and at that point the two more or less forgot about each other. However, when Jungmin later joined the same mixed high school as Juran, their paths crossed once again. After all that time, Juran was still short, but she seemed to have matured somehow. She'd been in a mixed environment since middle school, and so was already used to having boy-friends, which was perhaps a big part of why. It was also a boy who'd brought Jungmin and Juran together. Juran always had a horde of at least five or six guys with her wherever she went, while Jungmin always went around on her own—but Juran went over to talk to her.

"Dongjin says he likes you."

"So what?"

"What do you mean, 'so what'? Are you going to go out with him or not?"

"Not interested."

"Did you know? Everyone calls you a hermit. An endangered species. You've never had a boyfriend, have you? Your life must be so boring."

This didn't put Juran off Jungmin. The opposite: she was intrigued. Juran told Jungmin she'd help drag her out of that dark cave she was hiding in. At first, Jungmin wasn't too keen on this girl, acting like she was going to be her savior or something. However, Jungmin's dad was a taxi driver, while Juran's dad was a delivery driver, and both of them were only daughters—these two points of common ground quickly brought them closer together. It felt like they could stay up for nights on end and never run out of things to talk about.

However, in the early hours of one winter's night, when fat flakes of snow were falling, all the conversations they'd shared disappeared in a puff of smoke. There'd been a traffic accident. When a baffled Jungmin entered the police station clutching her mum's hand, Juran was there sobbing, her tiny body trembling. A taxi driver had been drunk behind the wheel and had run into a delivery van. Jungmin couldn't ask a thing. But from the way that Juran was looking at Jungmin's dad, she could tell everything she needed to know. There was no question about who was at fault.

Jungmin's dad had always been this way. Whenever he drank, he used to beat her and her mum. Then, in the blink of an eye, the blows would cease and he'd be out like a light. A few hours later, he would be out drinking again. He cared a lot about what other people thought, and so his fists, at least, he

reserved for his family. But someone else had been hurt this time. Jungmin wanted to believe it had been an accident, but there was no shadow of a doubt: it was planned.

If Jungmin had known what would happen, she would've stopped Juran when she started coming by her mum's jokbal restaurant. On weekends, Juran often brought her own dad along and they'd have dinner together. After that, he came alone on several occasions for a bite to eat, late at night on weekdays. Sometimes he'd insist on clearing his own plate, and Jungmin's mum would try to stop him, there was some subtle physical contact. But there was nothing to their relationship—they just chatted about their kids. But in the eyes of Jungmin's pathologically jealous father, a spark had ignited between the pair. In the end, he drank, and then he accelerated full pelt toward the delivery van.

When a wailing Jungmin clutched at the hem of her dad's blood-stained shirt, he pushed her away. The glint in his eyes was clear. He'd been drinking, but he was fully in his right mind. It wasn't a drunken accident: it'd been perfectly planned.

Though Juran thankfully got away relatively unharmed, Juran's dad, Gyuwon, lost his left leg. Obviously, that meant he lost his job, too. After the incident, Jungmin and Juran's friendship shattered like a sheet of glass. Jungmin felt guilty, for the simple reason that her dad was family. At school, the kids whispered about her behind her back. Daughter of a washed-up drunk, daughter of a would-be murderer. The kids had found their ideal prey, and went around mouthing off, inflating Jungmin's story as they pleased. Once the visible violence at home had stopped, the invisible violence at school would begin.

Jungmin was back in the same position she'd been in before she met Juran, and had to spend the rest of her school days as an outcast. This time, though, it hadn't been her choice to go back inside the cave.

JURAN WHEELED HER father over to Jungmin.

"Guess you've already said hello to my dad? Appa, you should've told me. It would've made my journey from work way more enjoyable."

Jungmin pulled a reluctant look. *Enjoyable? Is us meeting like this supposed to be enjoyable now?*

"Nah. Don't think either of us recognized each other. Jungmin, you sure have grown."

Gyuwon had seemed just as reluctant, but he spoke with warmth. Still, no words came from Jungmin's mouth. *If it hadn't been snowing that night, if Appa hadn't drunk that night, if I hadn't run into you at the police station, would things have turned out differently between us?* Now that Jungmin was face to face with Juran once more, she knew the answer. *No, we should never have become friends to begin with.*

Quick-witted Hyoseok, who'd clocked the blatant look on Jungmin's face, inserted himself between the two women.

"Do you two know each other already? Wow, what are the chances? It was a long class today. Juran noona, you must be tired, too, coming all the way here straight from work."

Hyoseok then rolled up his shirt sleeves and boomed, "Okay, everyone, it's time to close up the workshop, so Jihye and I'll help tidy things away. Let's get a move on!"

Juran's mouth was twitching, but she kept it shut and left the workshop. The look on her face seemed to say: *I guess you're still trying to avoid me, Jungmin, still hiding away in your cave.*

JIHYE AND HYOSEOK suggested to Jungmin they go shopping together in one of the big supermarkets in town. Hyoseok had his car, so they could take Jungmin's stuff, too. Jungmin placed her plate carefully inside the carrier bag Johee had given her and went outside.

Jihye left the passenger seat empty and went to sit in the back next to Jungmin.

Hyoseok pouted. "Am I your taxi driver or something?"

Nonchalant, Jihye replied, "Step on it, driver!"

Jungmin was going food shopping with one person she barely knew, and another she'd literally just met—the situation felt so alien. The most unnerving thing to her wasn't these unfamiliar people, but that she wasn't uncomfortable around them in the slightest.

Jihye—perhaps she'd noticed that Jungmin had calmed down a little—didn't stop speaking the entire journey. Mostly about variety shows and TV dramas that were popular lately. Naturally, televisionless Jungmin was oblivious, and the majority of what Jihye said went in one ear and out the other. But here and there when Jihye slapped Jungmin's arm and let out an animated laugh, she found herself chuckling, too. With her unique gentleness, Jihye softened those around her. It wasn't just because she was younger than Jungmin. Jungmin couldn't help but be drawn to her, and she liked that feeling. And she simply wanted to laugh along with her jokes, no matter how terrible

they were. Thanks to her, the heaviness in Jungmin's heart after seeing Juran had noticeably lifted.

She may have been living with her family, but even then Jihye certainly didn't hold back on the food. Breakfast bagels, spicy ramyun, pork for making jjigae—all of it went straight into the trolley, and in large quantities. Jungmin, on the other hand, carried a basket, and even that she hadn't filled half of. Regardless, she found enjoyment in thinking about what she would put in the dish she'd made.

"What's on the menu for dinner tonight?" Jihye asked, carefully inspecting Jungmin's basket.

"I still haven't decided. I don't cook and so I'm not sure what to buy. To be honest, I can't cook. Whatever I make never tastes any good."

"For your plate, how about curry? A curry packed with tinned tuna, carrots, potato, and broccoli on top of steaming white rice. Wow, just the thought is making my stomach rumble."

"Curry. That's not a bad idea."

Jungmin picked up her usual "three-minute curry powder mix," but Jihye quickly batted her hand away. She'd never seen her move with such speed.

"Unnie, curry has to be made with curry roux cubes."

"Aren't the powder and roux both ready-made mixes though?"

"No, they're different. Roux cubes give a richer flavor as you cook the curry. Have you never made it with roux cubes?"

"Never. The three-minute mix is just more convenient. . . . I didn't realize you were so into cooking, Jihye."

"I'm not so much into cooking as I am into eating. I drink to

relieve my stress, but I can't drink without something to snack on, can I? I'll take my time choosing a pretty plate and serve up the food however I like, and I cook, too. That was how I started to become a bit of a foodie. I learned that the act of eating delicious food that I put my heart into making is the best and most definitive way of loving and caring for myself. When I eat, my stomach warms and the blood goes pumping round my body."

Jihye placed the curry roux cubes in Jungmin's basket and continued.

"Unnie, put your all into this curry and see how it tastes."

Jungmin promised she would.

With Jihye now fully absorbed in shopping, Jungmin and Hyoseok fell behind. "Noonim, I wanted to ask, how do you and Juran noona know each other?"

"Hmm . . . It's similar to you and Jihye. I guess you could call us old friends."

Hyoseok wasn't oblivious—he knew. The look on Jungmin's face when she'd seen Juran that day at the workshop wasn't one of someone glad to run into an old friend.

Jihye's trolley was soon full to the brim. "Hyoseok-ah, Unnie, that till has the shortest line. Let's go join the queue." She parked the trolley, after which she came over, grabbed Jungmin with her left hand, Hyoseok with her right, and dragged them along to the till. Her fleshy palms were just as warm as they looked.

Now that Jungmin had only ended up with one measly bag— after claiming she was going to do loads of shopping—she felt guilty about making Hyoseok give her a lift. For some reason she hadn't wanted to be alone today, and besides, even if she'd

tried to refuse the lift, Jihye would've forced her into the car if necessary. Jihye and Hyoseok lived in the same apartment complex, so Hyoseok drove to Chestnut Burr Village and dropped Jungmin off first. She thanked him for the lift and stepped out of the car. Jihye said she'd cook her a proper meal soon and waved from behind the window. The car soon disappeared into the distance.

ROUX CUBES, TINNED tuna, potato, carrots, onion, broccoli . . . Curry could, conveniently, be made in a single pan. Though the rice was the Hetbahn kind you heat in the microwave, Jungmin had still made a proper meal. Curry made with roux cubes did indeed taste different to what she was used to. Unlike the instant powder, which easily ended up as a big clump in the water, the roux gave a richer taste, maybe because of how the blocks gradually dissolved. There was an oily, nutty aftertaste. Thanks to this, the walnut-size lump of words that'd been clogged in her throat all day seemed to slip down nicely into her stomach. Jungmin chomped away at the big chunks of carrot and potato, which had a subtle sweetness to them. The more she ate, the more her appetite grew. She began to understand why Jihye had recommended curry.

Jihye had told her to buy fruit in season—more of an insistence than a recommendation—and so Jungmin had even bought peaches, which she almost never ate. She decided to allow herself to be fooled by the shop assistant's sales pitch—that these were the last glut of peaches this summer, and therefore the sweetest—and grabbed an entire box. Without a dish to

serve the peaches on, she washed up the same one she'd used to serve the curry. Her knifework clumsy, she hacked away at the fruit. The plate was jagged, the peach slices were jagged. A pretty good match.

Jungmin arranged the peaches on the plate and went to sit on her favorite wooden chair in front of the arched window. She cracked open the window slightly and placed a slice of fruit in her mouth. It was sweet. So sweet it made her tongue tingle. How could a single plate change a person quite so much? Jungmin couldn't articulate the changes that had been taking place within her that summer. Instead of continuing to roll the word *change* here and there across her tongue, she decided to accept the fact as it was. Jungmin traced the movements of the people bustling back and forth beneath the glow of the neon signs, and focused on the taste of the fruit as she filled her stomach. Self-care wasn't as hard work as she thought. The simple act of eating a proper meal was enough to feel that she was looking after herself.

That same person who used to see music as just noise was today, for the first time in a while, listening to nostalgic pop on her speaker. They might've been the same songs that were playing on the workshop radio the first time she'd handled the clay. She found a joy in feeling something lift within her. There was no need for a huge stimulus, one that would send her emotions soaring in the air or crashing to the ground. Even a small stirring could easily make her happy or sad. And how about right now? She wanted to say the feeling was closer to happiness, but she kept recalling Juran's smiling face. The empty left leg of

Juran's father's trousers. Jungmin hugged her knees to her chest, buried her head, and screwed her eyes shut. These overwhelming things were coming at her so fast.

It would soon be a year since she'd moved to this flat. She should sit here and gaze out of the window more often, Jungmin thought. Autumn was loitering just a couple of steps ahead. While she fired clay in Soyo Workshop, she gained back time, and as she watched the members' outfits change, she gained back the seasons. For Jungmin, who'd finally caught up with the passage of time and the seasons, this pace was perfect.

Late Monsoon Season and the Cat

JUNGMIN NOW HAD three dishes in her kitchen. There was already a crack forming in the base of one. She'd also had another two duds that broke apart in the kiln. That her first plate *hadn't* was a prime example of beginner's luck. Jungmin liked being a novice. Day by day, she became more attuned to the feel of the clay, and she could sense herself drawing closer to it. It was a raw enjoyment beyond the reach of experts.

In contrast to the fuzzy sensation she felt inside, outside it was September, and monsoon season was in full swing. There was no point using an umbrella. Jungmin tugged on her Wellington boots, and in the short time it took to reach the workshop, the rain had left patches all over her button-up shirt. Gisik and Jihye, and even Jun, who'd run off to evade his parents' nagging—all

their T-shirts were mottled, and it made Jungmin smile. The first smile of the day was important. It determined how the dozens of others that day would turn out.

The weekend workshop awoke to the whir of Jun's wheel. Jungmin, who still hadn't made it to throwing, was having a one-on-one lesson with Johee. Today, she would attempt for the first time to come up with her own design. Up until now, she'd copied the plates on display, or otherwise worked off one of the basic designs used for practice. She was about to level up. For the past two days, she'd been hunting for ideas on the Pinterest app Johee had told her about. She'd saved pictures of a few pieces that caught her eye.

"This one's much too difficult. Next.

"This one you'd need to throw on the wheel. Won't work with coiling or slab building.

"This one isn't practical at all. It's more like a piece of modern art you'd see in a museum. We're not modern artists—let's not be so ambitious."

Like this, Johee's comments were a continuous fire of "That won't work." *What a surprise.* Jungmin didn't let the words pass her lips, but inside, she felt deflated. In the end, she went for a relatively simple coffeepot. Even this, however, was above her skill level, and so she couldn't make it as in the photograph. Johee told her to strip back the design. Jungmin had no idea what she meant.

"Strip back the design?"

"Try, and you'll see."

She wanted to hurry up and get to work with the clay, but all

she was given was a pencil and a sheet of paper. Johee told her that she'd feel much more affection for the piece if she designed it herself. She then smiled and patted Jungmin on the shoulder, before disappearing off behind her.

At a loss, Jungmin was soon staring out of the window, deep in a daydream. Everyone was at their respective wheel, and in front of each of them was a steaming cup of coffee. Until last week, everyone had been drinking it iced, but now the beverages had suddenly become hot. It'd been raining all week and the temperature had plummeted out of nowhere. Only Jun, who didn't drink coffee at all, had a peppermint tea bag in his cup.

Jun wasn't wearing his AirPods today, perhaps so he could hear the patter of rain. Jungmin wondered what he was working on. She turned her gaze to the shelf with his name on it and couldn't help but be amazed. There was a teapot of such high quality it looked ready for sale, and while the other members' pieces were generally small, he had lots of large ones, too. There was even a broad hangari jar that reached knee height. *That kid must be some kind of prodigy.* To Jungmin, he had the aura of a genius who'd secretly infiltrated the workshop, his true skills concealed by his lack of words.

Jungmin shone her eyes at Jun, who'd returned to his table carrying a sketchbook.

"Jun-ah, do you mind if I take a look at your sketchbook? It's my first time designing is all . . ."

"If you want."

Even the sketches looked like they'd been done by a

professional. So this was what you called drawing? His parents were famous designers, after all, so he must've inherited their talent. Anyone could tell from the detail and expression of the pictures that they had been done exactly by the book.

"How do you draw like this? This is incredible."

"I just do it, I guess."

"It's really impressive, though. Look at mine, it's so unexciting."

"Yours is better. I'm just doing this because my parents told me to. All of mine are boring."

"But if you keep doing something you're good at, don't you naturally start to enjoy it?"

Jungmin reflected on herself in her early twenties: there was one thing she'd wanted to do but didn't have the talent for. Only a minority were lucky enough that what they were good at also happened to be the thing they enjoyed. For anyone else, coveting this was a gamble. Rather than doing something you liked but weren't good at, wasn't it both easier and more effective to try and grow to like something you *were* good at? And if you truly did come to like the thing you were good at, wouldn't that make you happy in the end?

"Just because you're good at something, doesn't mean you'll like it."

Jun spoke with cynicism, but examined Jungmin's sketchbook nonetheless. She'd copied out the coffeepot just as it was in the photograph, but something was still lacking. When making pottery, there was a good chance the piece would crack as it dried or as it was fired inside the kiln, and so you had to make

two, like a set of twins. Without much thought, Jungmin had gone for a 20-cm height for one and 18 cm for the other.

"Try reducing the height a bit. To around seventeen and fifteen centimeters. Right now, the proportions are off. Also, isn't the spout way too narrow? You'll need to make it a centimeter wider. Plus, if you make the handle fancy like this, you won't even be able to fit two fingers inside. Beauty comes second—you have to think about grip first. Also, the pot is chunky but the handle's flimsy, which looks unstable to me. It could break really easily."

Here and there, Jun scribbled measurements with his pencil. He was basically telling her to redo the entire thing. Jungmin guessed this must've been what Johee had meant by stripping back the design. Lowering your ambitions and thinking about practicality. And without giving up on stability and beauty, either. Maybe this was what you'd call innate artistic sensibility. She was in awe.

Johee, who'd just been to look at Gisik's design, came over to Jungmin and Jun's table. "I thought I told you to do the design yourself! Using Jun is cheating."

Jungmin smiled gently with her eyes. "Seonsaengnim, can you let me off the hook this once? I was only planning to get a few ideas from Jun's sketchbook, promise."

Jun shrugged and returned to the wheel. Johee said she'd let it slide this time, before taking a look at Jungmin's coffeepot and calling it "marvelous." Next, Jungmin needed to take out a small bucket, fill it with water, get a sponge, and then some clay. The last of the previous batch was now on top of Gisik's wheel,

and so Jungmin went to the back to collect some from last night's delivery.

MEOW, MEOW—JUNGMIN HEARD a yowling. A black-and-white cat with green eyes met her gaze. It wore black socks on its front paws, and white socks on its hind ones. Judging by the cat's clean and glossy coat, someone must have been feeding it.

Chestnut Burr Village had its own vagabonds: the sassy cats. There were plenty of empty ground-floor commercial lots, as well as underground car parks, in the villa complexes, making the area an ideal place for strays to set up home. Most important, they had happy lives here thanks to the local grandmas and grandpas—on sunny afternoons, they sat in pairs and trios on the benches in the neighborhood's little park and fed the cats. Rumor of Chestnut Burr Village's warm generosity must've made its way round the feline world. This cat, too, had probably moved in after hearing that same rumor, before ending up at the workshop. The cat with black patches gazed up at Jungmin and continued to wail, and when Jungmin approached, it didn't run away. Jungmin pulled back, then edged one step closer, before repeating the same process again.

Hoya. Once nearer, Jungmin could see a tiny name tag hanging from its neck. Was it someone's lost pet? She went to stroke Hoya's head, when all of a sudden the cat let out a vicious meow and bit the back of her hand. She leapt back in shock.

"He doesn't like it when you suddenly act friendly like that."

Jungmin flinched when she heard a voice scolding her. A young girl appeared from behind her and began stroking

Hoya's back to reassure him—he would've been more scared than Jungmin, after all. Big eyes, dark skin, a long silhouette: the child was distinctive. Before Jungmin knew it, the kid was scooping Hoya into her arms and whizzing him off into the workshop. She felt her face redden. Shaking herself out of her daze, Jungmin shot up and followed the child inside.

Soyo Workshop was feeding the cat. Johee had wanted to take him in, but there was a high chance he would treat the many shelves of pottery as his personal cat tower and wreak havoc. Which would be dangerous for Hoya, too. Johee reached the conclusion that a workshop wasn't a good environment for a cat. Yet she always spoke of her disappointment that she hadn't been able to adopt him.

Apparently it was Hansol's friend, Yeri, who'd first brought Hoya in. Yeri insisted they weren't friends, though. Just as Hoya seemed to be half-stray, half-domestic cat, Yeri seemed to be half-workshop member and half-not. She would turn up with Hoya whenever she felt like it, make plates or mess around with the clay, then leave. And usually on the weekends, too. She said she hated coming on weekdays, because that was when the loud, rude, and annoying kids like Hansol, who spent their whole time staring at themselves in the mirror, came. Despite the fact that she was a primary school student herself. The way Jungmin saw it, Yeri was trying to act older than her years. She generally liked children, but she wasn't too fond of precocious kids like this one.

Thankfully, Hoya wasn't a cat that actually bit humans. Rather than biting per se, he'd been afraid and nibbled Jungmin

as a warning: *Don't come any closer.* Even so, things were a little awkward with Hoya after that. And that included Yeri, who'd found a seat on the opposite side of the table to Jungmin. Based on the glances she shot her from time to time while she worked, Yeri wasn't too fond of Jungmin, either.

Hoya, quite oblivious to Johee's nerves, padded around the workshop, his eyes brimming with curiosity, inspecting every nook and cranny. Whenever he rushed to climb the shelves, it was Johee, not Yeri, who shouted out a firm "No!"

"Seonsaengnim, Hoya doesn't have anywhere to shelter from the rain. Can't he stay in the workshop for a bit?" Yeri was staring up at Johee with Puss in Boots eyes.

"It's not that I don't want him to . . . What if he smashes something when he's all alone here at night and hurts himself? It's far too dangerous. Also, though thankfully everyone here today likes cats, some of our members are scared of them. And there are people like Gisik who've got allergies, too."

Johee looked over at Gisik, who'd been scratching at his arm for a while now. Yeri looked extremely cross. Everyone knew just how much she loved Hoya, but what else could they do?

Jungmin tried to reassure her. "Hoya must have family—brothers and sisters—right? Looks like the cats round here spend monsoon season in the underground car parks."

Those poor Puss in Boots eyes from earlier were no more—Yeri glared at Jungmin and snapped back, her tone prickly and piercing. "Hoya doesn't have parents. They got run over down one of the alleys. And he was abandoned by his brothers and sisters because he's small and weak. Hoya won't make it if he ends

up in one of those underground car parks where there's lots of cats. But what would you know . . ." Yeri topped her words off with a snide snort.

"Really . . .? I didn't realize . . . I'm sorry."

Jungmin felt really bad—the words "run over" touched a nerve.

It was the end of Jungmin's third year at high school. She'd been waiting for the results of her university application, when she saw a black-colored bird that'd been run over by a car. Innards were spilling out, bits of flesh spattered everywhere, and its body had already started to decompose. The night before, so it seemed, the bird had left this world all too easily, on top of the cold asphalt. Seeing this, Jungmin thought to herself, *If I see three dead animals, then I'll get into university.* She had no idea what had led her to think such a thing. She'd probably believed that screwing her face up at the sight of gruesome animal corpses was the price she had to pay for later good fortune. Funnily enough, that same week she saw another roadkill, a brown bird this time. That set her superstition in stone. Just one left. Three days before the results were announced, she finally saw a gray cat that'd been hit by a car. A neighborhood stray that'd liked to follow people around—she knew it well. Its body was more intact than the other roadkill she'd seen. No splaying entrails or crushed bones—instead, it looked as if the cat might spring up at any moment, which made the sight all the more chilling.

And as it turned out, Jungmin got into university first time around. She'd gone and done it. It was quite a while later that she

learned the truth. The gray cat hadn't been hit by a car; it'd been kicked to death by a drunk old man. She struggled with that guilt for a long while. Jungmin was convinced she was responsible for the cat's death. Wasn't it true that she'd been fretting in case she didn't see that third and final corpse?

Jungmin believed that she'd inherited the foul, violent instincts of her father. And so she clung on even harder to her guilt. She needed to prove she was nothing like her father: that repulsive human being, who didn't feel a shred of remorse for almost killing someone. From then on, whenever she saw a stray cat, her heart would ache. And so she vowed never to keep one as a pet. She'd concluded that she was the kind of evil person who could kill a cat with only her mind.

JUNGMIN DECIDED TO go out at lunchtime and buy some snacks for Yeri and Hoya. She'd seen the hurt on Yeri's face when she talked of how Hoya had been abandoned. A scar in the shape of a tiny thorn seemed to reveal itself beneath that ferocious expression. Yeri was a primary school student, after all. These layers of herself she'd tried to conceal were blatantly obvious to thirty-year-old Jungmin.

JUNGMIN HEADED OUT with Gisik to buy lunch for everyone. Trying to have a conversation across two umbrellas made her throat sore. As Jungmin's words blended with the drumming of the rain, Gisik kept edging in to try to hear her better. Each time, their umbrellas collided, and droplets pitter-pattered over Jungmin's transparent parasol.

Yeri, Gisik explained, sometimes got prickly about the most unexpected things. He'd been on her blacklist ever since the time he'd shooed Hoya away because of his allergy. Jungmin noticed that he was clawing at his arm more furiously than before—his allergy was clearly severe. If there was one tip to staying on Yeri's good side, he said, you had to be good to Hoya. Jungmin bought the most expensive can of cat food they had, some salmon-flavored snacks, as well as an XL strawberry smoothie. Meanwhile, she wondered whether there was some kind of sticky thread connecting Yeri and Hoya.

"Wow, is this all for Yeri and Hoya?"

On the lookout for an opportunity to repay Gisik for the sandwiches, Jungmin swooped in. "Gisik-ssi, is there anything you want? I'll get it for you."

"Really! In that case, I'd love some ice cream!"

His response was so rapid that Jungmin suspected he'd prepared it in advance. Gisik softly grabbed the rim of Jungmin's umbrella and pointed to a place called Gromit at the end of the alley. Like a black-and-white screen shifting to color, his face came to life. It was no surprise—when it came to food, this guy meant business.

"Their ice cream is top-notch. I haven't told the other workshop members about this place, but I'll make a special exception for you, Jungmin-ssi. Let's have some before we head back."

"Right now?"

"Quick! This way."

Gisik waved at the speechless Jungmin to hurry up and follow him. He was through the door before she knew it.

In a single breath, Gisik recited his order.

"I'll have the chocolate chip cookie dough frozen yogurt."

He needn't have said it because the café owner knew his order by heart. Judging by the way the two spoke, Gisik was a longtime regular.

Meanwhile, creases formed on Jungmin's forehead as she struggled to decipher the menu.

"What kind of flavor's got a name that long?"

"It's their secret, and most delicious flavor! Try it—trust me on this one. We need to eat as much of it as possible before it gets discontinued."

Ignoring his recommendation, Jungmin went for the most basic flavor of all: vanilla. Gisik didn't hide his disappointment, but no matter what anyone said, plain and simple vanilla was Jungmin's all-time favorite.

"What happened to Wallace . . ." Jungmin muttered and gazed vacantly at the ice cream as it was scooped into perfectly round balls. The café had naturally made her think of the *Wallace and Gromit* animations.

"The eccentric inventor Wallace is our owner here. He's always coming up with unique flavors," Gisik replied, and held out two hands, taking both his and Jungmin's ice creams from the owner. There was a rhythm to his words.

The seating area was upstairs. Jungmin and Gisik perched side by side and picked up their spoons. Contrary to Jungmin's expectations, the vanilla was exceedingly sweet. If the vanilla was this sugary, she couldn't imagine what the chocolate chip whatever-you-call-it was like. Gisik was scarfing down his ice

cream, loaded to the brim with chocolate and cookie dough (and with a dash of yogurt in there for good measure). How could something that sugary slip down so easily? But seeing him in such a state of bliss, Jungmin felt her own mood lift, too.

"Why's the flavor being discontinued? It must be popular with anyone with a sweet tooth like you."

"Apparently a lot of people are against the pairing, saying that yogurt and chocolate chip cookie don't go together."

Jungmin couldn't help but burst out laughing. What was he being so serious for?

"The taste is one thing, but the reason I like this café is right here."

Gisik pointed at the wall. There was a poster with a neat line of tombstones displayed across it. On each grave was a different flavor of ice cream. Beneath each tombstone was an explanation as to why the flavor had left this world, as well as a brief note honoring the departed. The dates of birth and dates of discontinuation were also recorded in full.

"The flavors that've performed their duty and departed this world are buried in graves like this, never to be forgotten."

"It's unique, that's for sure."

"Good thing you like vanilla—it'll always be there. There's no need for you to fret. I still hope that true love will come one day for Mr. Yogurt and Mrs. Cookie."

Gisik held his hand to his chest and spoke as if reciting a fairytale. Jungmin, meanwhile, quipped back, "Yes, but Mrs. Cookie is awaiting an imminent death sentence."

"Eh? Jungmin-ssi, that's harsh! You've got a heart of stone . . ."

Jungmin and Gisik broke into laughter. What would become of sour Mr. Yogurt and sweet Mrs. Cookie? This friendly café, which made graves even for its unpopular, so-called "failed" flavors—Jungmin rather liked it.

LUNCHTIME'S TOPICS OF conversation were, of course, the "late monsoon" and "Hoya." The typhoon would be sticking around at least a week. Hoya needed somewhere to stay in the meantime. Johee had two dogs that she referred to as "mongrels." Jihye lived with her parents, and her mother regarded cats as "pests"—it wasn't just that she disliked them, she had a phobia. Gisik seemed to want to help, but his allergy was far too severe. Jun, meanwhile, had been the first to make his position clear— he'd never been fond of Hoya to begin with, and resolutely refused to take on such an inconvenience, particularly when he was preparing for the university entrance exams. That left only Jungmin. She lived alone, and her flat was nearby, so she could return Hoya to Chestnut Burr Village as soon as the rain eased off. Yeri didn't seem best pleased, but Jungmin fulfilled all the requirements for Hoya's temporary guardian.

For her whole thirty years, Jungmin had never once owned a pet. She had no idea how to relate to animals. And, of course, she'd vowed never to get a cat. She was convinced that Hoya would never take to her, either. Jungmin said there was no way and waved her hand in dismissal, but Hoya's bright green eyes were already gazing up at her.

"Oh . . . just one week then."

Jungmin trusted in the weather forecast—that by the

following week, the front of the monsoon would have left the peninsula. She agreed to spend seven days with Hoya: no more, no less. Late that afternoon, when they'd finished work for the day, everyone went to the supermarket together. Here, they bought enough food for Hoya for the week, a cat scratcher, and a box and cushion for him to use as a bed. Though he'd be staying with Jungmin, they were all in this together, and shared out the responsibility between them.

Hoya looked at home in Yeri's arms. The pair accompanied Jungmin to her flat. This was mainly because Hoya refused to let Jungmin touch him, but Yeri had also stubbornly insisted on confirming for herself whether the home was "suitable."

It'd been a long while since she'd had guests. She'd had her now ex-boyfriend over to her previous place a few times, but they'd had a nasty breakup not long after she moved to Chestnut Burr Village. That was one of the curses of this place. One by one, the people around her had disappeared without a trace. To be honest, though, she rarely met up with her friends. She didn't get excited about hosting housewarming parties, and found the whole culture surrounding them uncomfortable, so she'd never invited her colleagues over, either. She was unconcerned how it looked to others. Her sole aim was to live life maintaining a minimal level of decency. The flat was neat and tidy, without a single ornament on display. Actually, maybe "deserted" would be a more accurate description. So, when Yeri announced she was coming over, Jungmin didn't have the common worry of *The place is a mess—what do I do?* Instead, she was more concerned about being berated: "Are you *sure* someone lives here?"

"Do you live here on your own?"

"Yeah, I do."

"Unnie, are you rich?"

"Not especially."

"In my family, four people live in a place the same size as this, so you're definitely rich."

An ordinary one-bedroom flat. The home of an ordinary unmarried woman in her thirties, with the bare minimum furniture and clutter. Yeri said that having less furniture made it safer for Hoya, and she awarded Jungmin "temporary permission" to be the cat's one-week guardian. *Yeah, yeah, thanks a lot.* By now, Jungmin was well used to Yeri's busybody nature. Still unfamiliar with his new home, Hoya showed no signs of leaving his box. Yeri said Hoya would come out when he was ready, and in the meantime instructed Jungmin not to disturb him. She'd had no intention of disturbing him to begin with, of course, but acquiesced and said no more. Jungmin watched from afar as Yeri poked her nose into every corner of the flat. She was tall and slim, and at first glance easily mistaken for a middle school student—or, at a stretch, even a first-year high school student. The saucer eyes and button nose, however, soon gave her away.

"Can I have dinner here?"

"Don't think I've got anything to eat—we can order in?"

Yeri stared in resigned dismay at Jungmin, and went straight over to inspect the fridge. All that was inside was spinach, tofu, and some eomuk on the brink of its use-by date. Yeri was already filling the pan with water when she asked if she could use the kitchen. What exactly was a primary school student going to

cook? Jungmin didn't let her true feelings show, and instead perched nervously at the dining table and followed Yeri's hands meticulously with her eyes. With deft movements, Yeri washed the rice and pressed the "quick cook" button on the rice cooker. Judging by how she sliced the tofu and trimmed the vegetables, she was used to this. Jungmin was an only child, and she wasn't close to her relatives. And so, whenever her friends referred to "the feeling of becoming an aunt or uncle," she could never relate. Was Yeri the kind of "stubborn tomboy" her friends had spoken of? Though Yeri was definitely stubborn, she didn't quite fit the cool tomboy image.

It had been so long since Jungmin had heard the hiss of steam escaping the rice cooker. Exceptionally, her plentiful stock of Hetbahn microwave rice hadn't made it to the table. Today's menu was spinach doenjang stew, fried eomuk, and white rice. There were three dishes, so thankfully they could serve up the two portions of rice as well as the eomuk. Jungmin's mouth was watering at the mere sight of the piping hot rice. She scooped up a great spoonful and swallowed it down plain.

Jungmin was so over-excited that she couldn't help but gush. "This is delicious! It's so long since I've had freshly cooked rice like this, not from the microwave."

"Unnie, can you not even make rice by yourself?"

"Thing is, back then I was busy with work . . . You know, it's a hassle, for all kinds of reasons. Is cooking your hobby?"

"It's not a hobby, I have no choice. No one cooks for me, so I have to do it myself."

"Guess your parents must be busy?"

"You could say that. Even though my dad doesn't work, he must be *so* busy because he's almost never at home."

For a moment, Jungmin set down her spoon and stared intently at Yeri. What was she supposed to say at times like these? She tried to find some words of reassurance, but in the end said nothing. With her own body so cold, she usually felt that trying to comfort another would send an even greater chill through theirs. Such a half-baked consolation would be no help at all. In this moment, however, she regretted never having learned how to encourage someone properly.

They'd finished eating, but Yeri didn't show any intention of leaving. She dangled a cat toy in front of Hoya—a stick with a fish hanging from the end—and scoured the house from top to bottom. It was already past sundown, but no one rang Yeri's phone. Jungmin quietly peeled the final peach. By the time she'd scooped out the bruised parts, there was barely any left. She placed some chocolate-coated vanilla ice creams on the same plate and went to sit beside Yeri. Exhausted, Hoya was soon sound asleep on the snug ondol-heated floor. An unusually luminous moon turned the sky from black to a deep purple. Such relentless rain felt at odds with such a radiant night.

"My dad was sometimes a bad person, and sometimes he was scary."

Without concern for how Yeri might respond, Jungmin said what she had to say.

"He was a bad person because he was incompetent. Ever since I was young, my mum made a living running a jokbal restaurant at a market over in Seoul. My dad, meanwhile, lived without a

care in the world. He was never a scary person, though. He was just a free spirit. He was too interested in himself to take care of a family. But there were times when he changed from a bad person to a scary person, and that was when he drank. When he drank, he suddenly became someone completely different. Without warning, his eyes instantly changed."

Yeri peeled open one of the ice creams and shuddered. "Just like my dad."

The fact that she was talking about this with a primary school student made Jungmin's heart heavy. She hadn't done it to push Yeri to open up—she'd simply wanted to share about her own family.

Then Yeri spoke. "I used to think all dads were like that—wastes of space that scare their families and are completely broke—but my friends' dads are different. One day I was going home with my friend after school, but her dad came to pick her up. He'd taken the day off for her. He was going to take her to the amusement park to have churros. At first, I doubted it. Are most dads warm and kind like that? I felt like my friend had betrayed me."

Jungmin guessed it was Hansol she was referring to. Hansol's parents always drove to the workshop to pick her up, and the family had a warmth you could feel a mile off.

"I really, really hate going home. Actually, I hate the word 'home.' Isn't it so weird? 'Home.' It's one syllable and so empty. Unnie, you're a writer. Come up with a new word."

"I'll have to give some thought to that one."

It bothered Jungmin that, even in this situation, Yeri was trying to keep the mood light. Stories she'd never told anyone,

the feelings she'd kept tightly bottled up—it couldn't have felt natural to share such things.

"That's why sometimes I feel jealous of Hoya. I know I shouldn't say this but, it's because he has no parents. I wish I was an orphan instead, like Hoya."

Jungmin gazed at Yeri's profile. It felt odd to be looking at a smaller version of herself.

"Whenever you feel like that, you can come over here. You know I'm unemployed, right? You can play with Hoya, too. . . . I'll cook for you next time."

"I don't trust your skills, Unnie. I can tell from your fridge that you never cook. . . . I'll take care of the cooking; you just take good care of Hoya."

"I'm not going to complain. Dinner today was so good."

Yeri told her to look forward to next time's menu and got ready to leave. Her step seemed a little lighter.

Before Yeri left, Jungmin rested her hand on her shoulder and whispered, "I don't like my parents . . ."

Yeri, eyes startled like a rabbit's, gazed up at her.

"That's between you and me. I'm thirty years old and still haven't made peace with my parents. With families, there'll always be things you clash on, and some things you can't understand. Just because you're related, doesn't mean you have to love each other. If you don't like them, you can say so, even if you just say it when no one's around. Or to me."

"What do you mean? What's the point in talking to yourself?"

But despite this, Yeri turned around. Then, in a just about audible voice, she repeated Jungmin's words.

"I don't like my parents."

The two burst out laughing.

Then, suddenly Yeri asked, "By the way, Unnie, what's going on between you and Jun oppa?"

The topic had come out of nowhere.

"Huh?"

"I saw you two talking this afternoon. Jun oppa doesn't usually talk so long to girls."

". . . Do you have a thing for Jun?"

Yeri's face flushed a deep scarlet. Her great big eyes, unable to settle in one place, kept darting this way and that. She insisted it wasn't true, that she was just a fan of his, but she was all lovey-dovey, in the way people were when they had a crush. Jungmin was unable to stifle her laughter—even as she assured Yeri there was nothing going on between her and Jun, and that besides, she was far too old for him. A primary school student falling for a high school student. He must've felt like a celebrity to Yeri. Yeri couldn't stand the embarrassment and slammed the door with a bang on her way out. Through the window, Jungmin watched Yeri prance home like a pebble skimming the surface of a lake.

JUNGMIN WAS NOW alone with Hoya, and it was awkward. She questioned her own good nature and all sorts of thoughts crossed her mind: *What if I'm in a bad mood and take it out on Hoya? What if I'm drunk and leave him out in the rain in a fit of rage?* For owners, their animals were more than just pets—they loved and cared for them like family. When the animals were in pain, they felt pain, too. They spent a fortune in vet bills, not to

mention forking out extra for the fancier food and giving them every kind of nutritional supplement imaginable. *Am I capable of treating a cat with as much care as I treat a person? I never properly loved any one of my exes even.* Jungmin had so many doubts, but it was the "one week" that reassured her. She simply needed to play the role of Hoya's guardian for that fixed period of time. Whether there was any love behind her care or not, she didn't see it as all that important.

What reassured her more, though, was the weight of Hoya when Jungmin opened her eyes in the morning. Jungmin would always toss and turn throughout the night. She almost never exercised, and instead it was as if she was warming up the muscles in her sluggish body while she slept. At the beginning, Hoya would sleep beside her for a while before retreating to his box in the early hours. Gradually, however, he began to stay in silence at the ever-restless Jungmin's side. One night, Jungmin's bottom landed on Hoya's front legs. Jungmin jolted awake to see an unstartled Hoya, who quietly removed his paws and shifted a little to the side. He then set down his chin and closed his eyes. Jungmin's arm was the next to land, this time on Hoya's head. Hoya extracted his head from her hefty limb, readjusted, and leaned on her arm instead. Sleep must have escaped Hoya, and he simply blinked his green eyes drowsily. Still, he remained by Jungmin's side.

It was on the third morning that Jungmin opened her eyes to find Hoya curled up beside her. And so, without notice or warning, he had come bursting into Jungmin's life. She lay with him in bed and stroked his head as the cat let out tiny,

hot breaths, and felt a comfort she found hard to describe in words. Whenever Jungmin felt something warm, she held on to it. Just as when she'd held the ceramic cups on display on her first visit to the workshop and felt the temperature seep through her veins. Once Jungmin let this warmth into her heart, she could never let it go. She'd believed she could take care of Hoya without getting attached, but within three days, she'd become his natural guardian, bursting with love.

Hoya was the same in that respect, watching over Jungmin, too. In taking responsibility for Hoya's meals, Jungmin started paying better attention to what she ate. She swept away the fallen clumps of Hoya's fur and cleaned her flat top to bottom. With the arrival of a living creature in this dwelling, which hadn't homed so much as a houseplant before, little changes sprang up here and there. Jungmin was forgetting all about the stray cat that died. She felt that, through Hoya, she was receiving forgiveness—forgiveness for her misplaced desire to see an animal's death as a sign of good fortune.

Jungmin had thought Yeri would be over all the time, but she only visited twice that week. Apparently she was too busy and tired on the days when she had six classes. Jungmin began sulking to everyone at the workshop. She'd thought a week was a long time, but it turned out to be far too short. She was making a wide, shallow food bowl for Hoya; but she knew, too, that before the dish went inside the kiln, Hoya would leave her.

By her fourth day with Hoya, the sky had begun to clear. The weather forecast, which had promised the monsoon would last another week, now seemed like a cruel joke made at her expense.

The menacing dark clouds that'd once cloaked the peninsula drifted away, until the sky was a perfect blue.

Tuesday. Jungmin gave Hoya his would-be final breakfast and headed over to the workshop. She was going to finish work on his bowl.

"You didn't eat before coming today, did you?"

"How do you know?"

"You're not being aggressive enough with the clay. Your disc is supposed to be just seven millimeters thick, how are you going to ever get there like that?"

As if she was left with no other choice, Johee took a cinnamon roll, which she'd made in the sleepless early hours, out of her straw basket. The sight of the ballooning dough had put her in a good mood, and she'd brought the rolls to work telling herself that she must let the workshop members try some. She could see Jungmin was struggling to concentrate and told her to have the roll before carrying on. Johee then went to fetch water for coffee. Steam billowed. Only then did Jungmin realize that something was bothering her.

"Honestly, I think I'm a bit depressed that Hoya is leaving."

"I never thought this day would come around so quickly, either. I can't tell you how relieved I was when you said you'd take Hoya in. I always felt so guilty that we couldn't keep him here. The alleyways in the neighborhood are really narrow, and so much traffic passes through, too."

For the first time in a while, both the front and back doors were propped open, and fresh air without a spot of dampness wafted inside. The roll released a rich aroma as it warmed

through in the oven. Johee must have been generous with the cinnamon powder and almond slices.

"I'm scared I'll get greedy and won't let Hoya go. I'm worried I'll be forcing him into being a domestic cat when his previous life was much better. That I'd be taking away his freedom under the pretense of a safe life . . ."

"Then you need to be that much better to Hoya. The problem is, Yeri."

Johee had hit the nail on the head. Jungmin was concerned what Yeri would think. Hoya may have been a stray, but Yeri was her de facto owner, after all.

"Yeri probably won't like it if I keep Hoya, right?"

"You'll have to ask her yourself."

"Before I do . . . do you think I'll make a good owner?"

"I think I can pretty much guarantee that. You've brightened up so much since you met Hoya. I might say the same for him, too. Judging by your KakaoTalk profile picture, I can see his fur is getting softer and fluffier by the day."

Johee served the warmed cinnamon roll on a dish and ordered Jungmin to hurry up and eat. A pleasant sweetness coated the inside of Jungmin's mouth.

"Eating something sweet, I feel invigorated."

"You're not just imagining it. Positive thinking isn't possible on an empty stomach."

YERI AND HANSOL arrived at the workshop together. Though Yeri claimed she didn't like Hansol, she certainly seemed to enjoy hanging out with her. She may not have expressed her

feelings in so many words, but Yeri was a kid who wore her heart on her sleeve. Johee handed them each a cinnamon roll. It was 4 p.m., and after running around all afternoon, it was the perfect time for a snack. Johee had advised Jungmin to broach the topic once Yeri had something in her stomach and the sweetness had lifted her mood.

"Listen, Yeri-ya."

Jungmin had finally plucked up the courage, but Yeri immediately cut her off.

"Unnie, can you keep on looking after Hoya?"

"Huh?"

Jungmin instantly breathed a sigh of relief—all that agonizing had been for nothing.

"I think Hoya will be happier at yours. And then I don't need to worry about him getting bullied by the other cats at night."

"You don't mind?"

"I'd take him if things were better at home, but they aren't. I'm just leaving him with you until I have my own place. When I'm older, I'm going to buy a way better home than yours. That's when I'll come for Hoya."

"Thanks. Come over whenever you want."

"Of course. I'm still his original owner. Make sure you don't forget."

"Obviously. Hoya needs you."

In small ways, no matter how insignificant, all the members of the workshop were coming to need one another. Jungmin was worried that, now Hoya wasn't there, Yeri might stop coming to the workshop. But her concerns didn't last. She could see it in

Yeri's eyes whenever she stole glances at Jun. As long as he was here preparing for the entrance exams, Yeri would continue to turn up unannounced.

"CONGRATULATIONS, JUNGMIN-SSI! IT finally came out in one piece!"

On any other occasion, Jungmin would've told Gisik not to get carried away, but this time was different. Lately, none of her dishes had stood up to the heat of the kiln. Her confidence had taken a knock, so this plate meant a lot to her. Hoya's food bowl; a bowl for her new family member. As she gazed at the immaculate dish, free of a single crack, Jungmin felt once more that she wasn't alone.

Thankfully, Hoya seemed to like his new bowl. The weight of the ceramic stopped it sliding all over the place like the plastic ones. Thanks to the dish, Hoya seemed to find eating a whole lot easier. Jungmin took a photo of him enjoying his meal and uploaded it to the workshop group chat.

—His claws need to be cut.

The message stuck out amidst everyone else's cooing. Yeri's nitpicking. This was just her looking out for Hoya. Jungmin wasn't annoyed. Quite the opposite. It was Yeri's endearing way of regaining everyone's attention.

Hoya was adjusting so well, it was as if he'd never lived anywhere else. Jungmin was both proud and thankful. It was

obvious what she needed to do. To make Hoya the happiest and most carefree cat in the world, until the day when Yeri came for him.

Meow—

Once he'd finished his meal, Hoya came and rubbed his head against Jungmin's ankle. *Better trim his claws this evening, like Yeri said.* Thanks to Hoya, the tasks Jungmin had to do each day increased one by one, and she was moving around more and more. She realized that there was no miracle cure for inertia better than responsibility. Her body, once heavy and waterlogged, grew light like a towel dried crisp in the sun. That feeble voice that'd echoed round her ears, questioning her right to take responsibility for another life, gradually faded away. There was no need for Jungmin to writhe or plead—the tightly-wound balls of yarn that suffocated her seemed to be unraveling of their own accord, one after another.

The One-Day Class Revival

THE SEASON OF torrential downpours had passed, and change was underway at the workshop. One-day classes were making a comeback. "I've decided. I'm starting them up again." At the beginning of Saturday's lesson, Johee had made the sudden declaration. Not unlike how Jungmin had started screaming out of nowhere a few months before.

It'd been almost a year since the one-day classes were put on temporary hold. Jungmin had noticed an old post herself while going through the Soyo Instagram account. *We are not currently taking enquiries for one-day classes.* Gisik and Jihye met Johee's resolution with applause. Jungmin quickly followed suit and stood up to clap alongside.

"Didn't you say you first came to Soyo for a one-day class, Jihye-ssi?" Jungmin asked.

"Exactly. Back then, the one-day classes were buzzing. Sometimes as many as six or seven people came."

"Then why were they stopped?"

"Um . . . Seonsaengnim had some things going on. She took a break from the workshop entirely for a while. Thankfully it's open again now, but I guess she didn't feel up to one-day classes."

"I see."

Johee's voice was animated and her footsteps were light. For whatever reason, Soyo was full of life. As Jungmin imagined throngs of people turning up at this little workshop—a place she wanted to keep all to herself—she felt a pang of disappointment. But she'd also never seen Johee so energized, and wanted to help with the "one-day class revival project" in whatever way she could.

"Gisik-ssi, guess we better lend a hand? Let's advertise on Instagram that the one-day classes are back on!"

"Great idea!"

"But how . . . ?"

The two looked at one another.

THAT DAY, GISIK and Jungmin ate their lunch of strawberry sandwiches in front of the laptop as they snooped around at how other workshops ran their one-day classes. The strawberries weren't as sweet as before—perhaps the café had switched to frozen ones. Though Johee said there was no need to go to

all this effort, Jungmin was still keen to help out. If not for the workshop, she wanted to do it for herself.

"Every workshop seems to have its own signature selling point. Whether that's painting or making designs out of all different types of clay. Marbling looks to be a recent trend, too. I think if I was a customer researching which workshop to go to, I'd choose based on the design or feel of the dish I wanted to make. That means we need to come up with a curriculum based on the techniques that'll be taught in class."

Mouth full of sandwich, Gisik mumbled, "In that case, we'll need something to set us apart from the other workshops . . . Something that'll make people feel like this is a dish they could only make at Soyo."

"Yes. Exactly that!"

Jungmin examined the pieces on display. So few had been sold that the shelves were almost identical to the first time she'd come. These plates were a far cry from the cutesy colorful look that was so popular lately.

Johee seemed to have lost all of the morning's spark. "I've always stuck to traditional methods . . . I won't stand a chance against the workshops run by all those youngsters."

Concerned that Johee's self-esteem would hit rock bottom, Jungmin quickly fired back. "Turn that to your advantage. A sophisticated, traditional workshop. A workshop that makes elegant plates to keep for years to come—not the kind that may look pretty on the surface but start to crack before you know it."

Then, Gisik's huge hand was hovering in front of Jungmin's face. Jungmin just stared back at him, till he grabbed her hand

and lifted it into position for a slightly off-kilter high five. "Nice!" he exclaimed.

Everyone banded together to come up with the new Soyo Workshop One-Day Class, which would be divided into "Course A" and "Course B." A was handbuilding, and B was throwing. Students could choose based on the kind of plate they wanted to make. Handbuilding was for those who wanted to make ornaments, or rustic plates with handprints still left on the surface; throwing, meanwhile, was for those after a more traditional design. Course A students could imprint leaves and flowers into their dishes. This had been one-day class graduate Jihye's idea—she'd gather the flowers and leaves before the lesson began, then the students would press the shapes into the clay before drying it. Johee grew sentimental as she reminisced about her university teacher, who used to give a class on engraving every year as soon as the leaves began to fall. Nobody wanted to interfere with Johee's trip down memory lane, and she was left to chatter on uninterrupted.

Capture the season in a plate.

Throughout the conversation, Jungmin would note down on the laptop any phrases that popped into her head. The next thing she needed was photographs. She'd hoped they could use images of the existing plates, but they were all far too technical for demonstrating that "you too can make something like this!"—especially for a one-day class. Some cost as much as five million won, after all. When Jungmin explained they needed something simple as an example piece, Johee happily announced that she'd have one ready by the following week. Thinking about

it, Jungmin realized she had never once seen Johee at work. She'd watched her helping the other members or giving demonstrations, but that was the extent of it. Though it was difficult to imagine Johee as a potter rather than a teacher, Jungmin was sure she'd be bursting with charisma.

Gisik suggested photographing students taking the class, as well as their creations. Rather than Johee making everything herself, it would be more convincing to include pieces made by the students. He then whispered to Jungmin that they should try and water down Soyo's undeniably dated image by showing young people taking the class, too. Startled by Gisik's sudden physical proximity, Jungmin's ears grew hot. But with his next words, they instantly cooled again.

"Should I bring my girlfriend along? She's always wanted to give pottery a go. I think she's around next Saturday."

An animated Jihye also put in a word. "What about Hyoseok, too? He always says what a shame it is that class is over by the time he gets here each week."

Jungmin dipped her fingers in the syrupy slip, a mix of clay and glaze, and traced out the letters on the workbench.

Soyo. Where the kiln will fire your heart.

"Guess it's full steam ahead for the soft launch!"

Everyone nodded in agreement with Jungmin. Excitement was one of the most infectious emotions.

"Seeing you so enthusiastic, I reckon you're a cheerful person at heart, Jungmin-ssi. Maybe you were a bit shy at first?" Johee asked, having recovered the morning's energy once more.

"It's similar to when I used to plan TV programs. . . . Guess I got a bit overexcited."

"You seem to be enjoying yourself. Thank you."

Jungmin believed she'd been born gloomy. She never smiled like her peers, and she had a maturity that didn't suit her years. Put next to her friends, who'd grown up in loving households, they were like chalk and cheese. If it were possible to quantify "lovability" on a scale, then she saw herself as well below average. As a result, she had to be constantly hooked up to a "lovability IV drip." As she got older, she gladly agreed to go out with guys she had little interest in, and sent pining messages to friends she didn't miss at all. From time to time, she needed to wear uncomfortable dresses and sparkly accessories. It was then, she believed, that she'd move a little higher up the lovability scale.

Then, one day, someone she'd been friends with throughout university said to her, "I get depressed just being around you." With these words, Jungmin was content. *I don't need that lovability drip any more*, she told herself. *No matter how hard you try, Jungmin, you'll always be stuck under the shade of an unlit lamp.* Jungmin accepted her innate temperament and was left to be her gloomy self.

Johee was the first person who'd ever called her "cheerful at heart." Like a boat released from its anchor, pressing ahead as it sliced through the waters, ripples began to spread across Jungmin's heart.

MID-LENGTH HAIR THAT fell to her collarbones, white dress and lemon flats. Gisik's partner, Ara, worked at the Paju City Community Center. She had that well-mannered nature particular to the staff at the local district office, who Jungmin had come across once or twice, and there was a lightness to her. Jungmin,

who almost never wore makeup, stood out in even starker contrast to Ara, and she felt herself shrink against her radiant aura. Though even she had worn a thin coating of lipstick today.

Distinct from his usual slick appearance, Hyoseok had meanwhile turned up in a baggy old tracksuit.

"At last! The day I get to lay my hands on the clay has finally come. By the way, I've brought someone else along with me, hope that's all right?"

Hearing there'd be one more guest, Johee clapped and rushed to put on a second pot of coffee. "Everyone's welcome. The more the merrier."

A woman in a smart short-sleeved blazer poked her head out from behind Hyoseok. It was Juran.

Juran greeted the members awkwardly. "Hello. I've always wanted to try a one-day class. And then Hyoseok suggested I come along. Sorry to turn up out of the blue."

"What a nice surprise, right? What's better than receiving a gift you didn't expect?" Conscious of Jungmin, Hyoseok attempted to lighten the mood. He tried to subtly block her from Juran's view. Despite his best efforts, however, Juran was already making her way over to Jungmin with a huge grin on her face. Jungmin couldn't begin to guess what lay beneath that suspiciously friendly look.

"I didn't realize you'd be here, too, Jungmin. Great to see you again." She turned to the rest of the group. "Jungmin and I went to the same high school. We ran into each other the other day when I came to pick up my father. Meant to be, right?"

Jungmin had turned as white as a sheet but was saved by

Johee chiming in. "Who would've thought? So the two of you were friends! I was right, the more the merrier!"

The members were amazed by the Jungmin–Juran connection and flipped their gaze back and forth between the two, as if watching a game of table tennis. Jungmin didn't want to dampen the mood, especially when everyone was feeling so good about the one-day class comeback, and so strained a smile before bolting from the table.

Johee handed out the six cups of coffee and announced the beginning of class. Hyoseok, Ara, and Juran all chose throwing, or Course B. Jihye, who'd gone out and picked wildflowers in preparation, tried her best to promote Class A, but each one of the students refused in a roundabout way, talking of how they'd dreamt of using the wheel. A sullen Jihye called this all a "fantasy created by the media."

Jihye had no choice but to join Gisik as a helper. Johee watched Gisik tie Ara's apron. "We've never seen such beautiful clothes in our workshop. Don't look at me, though, when your white dress is all caked in dirt."

"Gisik and I had a date planned for after class. He told me he'd be taking pictures for Instagram, so I guess I dressed up a little."

Everyone else was in either gray or black, making "visitor" Ara in her white outfit stand out all the more.

Ara looked to be having a blast shaping her clay on the wheel. Even the slightest shift in the position of her fingertips had an immediate effect. She made nonstop remarks. "How about this?" "Not bad, huh?" "I'll try what you're doing." Everything she said

was with affection. Gisik gave her little bits of advice. "When you do this, try that." "When you do that, try this."

Jihye sat beside Hyoseok and helped him to center his clay. From where Jungmin was standing ten steps away, it was hard to believe they weren't a couple. Of course, as soon as you got a little nearer and listened in on their conversation, you'd discover a mix of 90 percent joking around, and 10 percent bullying. *At this rate, they might start to hate one another.* Jihye's hand landed casually on Hyoseok's. *That's the twenty-first-century version of* Ghost *right there. Only with the gender roles reversed, of course. Everyone apart from them can see it. . . .* Jungmin stretched her thumbs and index fingers to right angles and made a frame. Inside this silent rectangle, the image of Jihye and Hyoseok was a tender one. Jungmin wanted to bet Gisik an ice cream that it wouldn't be long before the two started dating. Gisik, however, was far too busy helping Ara. As she observed the members huddled around their wheels, Jungmin found herself letting out little sighs. Being the only one handbuilding, away from everyone else, was lonely somehow. And though she could feel the clay on her hands drying up, she didn't add any water. As it splintered, the clay felt coarse against her skin.

Perhaps her exhales had been a little on the loud side, because before long, Johee appeared beside her.

"Well, forget the chemistry of ceramics and coffee, I think Jihye'd be better off researching the chemistry between her and Hyoseok."

Jungmin was a little startled, and Johee wiped her clay with a damp sponge on her behalf.

"You're telling me. They look . . . good together."

Then, off the cuff, Johee commented, "You're jealous, aren't you?"

Jungmin had been stealing glances at Gisik and Ara for a while now. She was worried Johee had seen right through her.

"Sorry?"

"Come on, there's no use pretending! You want to have a go at throwing, too, don't you?"

Oh, that *was what she meant?* Jungmin breathed a sigh of relief.

"Me, jealous? Of course not."

"I can see it all over your face. That's the benefit of a one-day class. Members who haven't been able to so much as touch the wheel even after three months can try it all in just one day. You've been coming more than two months now, so I think you're about ready."

Jungmin didn't put up a fight. "Guess I was itching to get at the wheel."

What was she going through all this effort to do things step by step for? Couldn't she have fun and give something a go if she felt like it? She wasn't dreaming of setting up her own business like Gisik was. And unlike Jihye, she'd never considered this a lifelong hobby. At her age, she wasn't exactly going to go back to university and study ceramics. Then what was she so focused for?

Johee gave Jungmin, who was lost in thought, a gentle pat on the shoulders. "Are you not feeling well? You don't look too good."

"It's not that. My mind was just elsewhere."

In truth, Jungmin's head had been throbbing since earlier. Every time she saw Gisik and Ara together, she felt a needle-like pain in her heart. And always at the back of her mind was Juran, who, unlike the others, had no one to help her. *What's that blank look on her face about? It's almost like she's forgotten everything that happened. And then there are the pottery-related worries, which I tried to bury . . .* Jungmin shook her head back and forth. As if, by this, she might shake off her concerns, too.

"If so, that's a relief. How about today we have a go at throwing together? The seat next to Juran-ssi is free. You're her pottery sunbae, though, so once she's finished you can help her with the trimming."

Juran was working at a snail's pace. She never had been good with her hands. It was true that people never changed. This gave Jungmin even more reason to keep her at a distance.

At Johee's suggestion, Jungmin waved both hands in dismissal. "It's fine. I'm going to finish what I was working on. I'll give it a go at another one-day class." She felt awkward, of course, but someone at her level certainly wasn't in the position to help anyone else.

"All right then. Whenever you like, just let me know. I'm sure this is more than just a hobby for you, though. Maybe there's something else you want to try?" And then she added, "Later on, you should take part in the Living Design Fair or enter a competition, like Jihye."

". . . I'm not sure about that yet. To be honest, all I want to do is work with the clay—without any grand goals, just to prove that 'I'm doing something right now.'"

"You're right. I think the fact that there's somewhere you need to be at the same time each week, and that as the seasons and weather change, there'll always be a piece requiring your attention—all this is reason enough to keep learning. Forget what I said earlier. It's been a long time since I've had such an earnest student, and I think I got ahead of myself."

"It's no problem. But it's all right to not take pottery too seriously for the time being? Just until winter."

"Sounds good to me. Winter's cold, after all."

ARA'S LITTLE VASE was complete, and aside from being perfectly symmetrical, it looked just like Gisik's work. Hyoseok's piece resembled Jihye's kitsch teacups, too. Jihye had probably done more than half the work for him, of course. Juran had made a cylindrical tumbler with a wave pattern across it. She'd stayed faithful to the example demonstration piece, which Johee had created for those stumped for ideas of what to make.

Jungmin and Gisik joined forces and started uploading content to Instagram. Beneath the photos Gisik had taken throughout the class, as well as the images of the three students' finished products, Jungmin typed out the text she'd prepared. For the first time in a while, she felt a pride and sense of accomplishment, the kind she used to feel at the end of a big work project.

All pumped up, Jungmin wanted to discuss future promotional plans with Gisik. Unaware of this, Gisik was already getting ready to leave for his date with Ara.

"Gisik-ssi, your girlfriend's come all the way here, make sure you don't take her to the sandwich shop," Jungmin joked to Gisik, who'd just removed his apron.

"What sandwiches?" Ara asked, at which Gisik rested his hand on her shoulder and appeased her with a smile. Jungmin was glad Ara didn't know about the strawberry and fresh cream sandwiches.

Jihye and Hyoseok went to eat, just the two of them, and while Jungmin was tidying away, she asked Johee what was on the menu for lunch.

"I'm going to eat alone today."

"Oh? Then I'll . . ."

"Seeing that lovely couple, and that adorable soon-to-be couple, too . . . On a day like this, for some reason, I feel like basking in my loneliness. Anyway, I'm sure the two of you have lots to catch up on, so leave the tidying up to me and go have your lunch."

Johee motioned with her chin at the spot where Juran was standing. She'd apparently been waiting for her, and wrinkled her nose as she waved Jungmin over. While Jungmin dithered, Johee urged, "Quick, quick!" and swung her arm, almost as if herding cattle.

"KNOWING YOU, YOU won't feel much like eating if I'm there. Know any cafés round here?"

Jungmin changed direction without a word. Juran seemed unsurprised by Jungmin's iciness and simply followed on behind. The only café Jungmin could think of in Chestnut Burr Village was the ice cream place she'd been to with Gisik. Jungmin and Juran sat opposite one another at the spot by the

window upstairs. Not knowing where to look, Jungmin fixed her gaze on the rim of Juran's ear. Juran, on the other hand, looked Jungmin straight in the eyes.

They had each other's numbers. They could've got in touch any time during the past ten years if they'd wanted to, but neither had made the first move. Juran's KakaoTalk profile picture was always a photo of her and what looked to be her boyfriend. She hadn't the slightest reserve about making her relationships public knowledge—that was *just* like Juran, Jungmin thought to herself. Jungmin had opened up the empty chat window with Juran more than once, but she'd never sent a message. She guessed this was what people called a "strained relationship." The person was right there in your contacts, but when you actually went to write them a message, the words didn't come out.

At this point, Jungmin didn't mind if their relationship stayed forever as a brittle piece of sandpaper. She had accepted that Juran couldn't forgive her, so why was she dredging up old wounds?

Juran spoke first. "I finally get to say hello properly. How've you been? I wondered if I'd done something wrong—you didn't get in touch all that time."

Jungmin's response was peppered with resentment. "It's not as if you contacted me, either. And what did you ever do wrong? I'm the wrongdoer here, aren't I?"

Juran did her best to ignore her. "Anyway . . . I work near Seoul City Hall. As a PA for a finance firm. You're a broadcast writer, right? Hyoseok told me."

The fun-loving high school student was no more, and in her place was now a respectable member of society. Two years before, she'd married a dentist and left her hometown for Seoul.

"So, you're already married, then?"

"You know me. I was always obsessed with boys, and my dream was to become the poster wife and mother, always saying how I wanted to get married young."

When they were at school, Juran was forever switching boyfriends. Jungmin found it odd that she'd settled down so soon. There was plenty she could've said, but she bit her lip, and Juran carried on talking.

"Once I got married, Appa sold his place in Seoul and moved to Ilsan. I thought he might be a bit bored, what with being unemployed and living alone. So I signed him up to the pottery class via Hyoseok. Never dreamt I'd see you there. It was weird running into you in Ilsan, not in the neighborhood we grew up in. This area's unfamiliar."

Jungmin felt a creeping disgust that, even while discussing her father, Juran was still acting like nothing had happened.

"Why did you come to the workshop today?"

"The main reason was to talk to you. The more I thought about it, the guiltier I felt. As if I'd left you all alone in that deep, dark place."

"But Juran-ah, it was you. You were the one who drove me there."

A pair of sensitive kids could easily become friends, but it was just as easy for them to drift apart, too. At that age, the look in a friend's eyes, a moment's hesitation, a shift in physical

contact, the pitch of their laughter, and each and every word they spoke became something to be analyzed.

At some point, before the accident, whenever Jungmin suggested they hang out at her mum's restaurant after school, more and more often Juran's response would be lukewarm. Was it because Juran had seen her dad get drunk and aggressive when she was there? Each time Jungmin asked, Juran's eyes would flicker, and she would pick nervously at her fingernails. Jungmin began to feel like she possessed a useless superhuman ability to grab time by both ends, stretch it out and slow it down. In slow motion, she watched Juran hesitate, and witnessed each second in crystal clear detail. The brief time she waited for an answer felt like an eternity. The moments piled up like dust and made Jungmin more and more pathetic. A kind of weightless space formed between her and Juran, a gap that neither of them knew how to address. They thus became trapped inside the definition of "friend."

Less than a week before the incident, Jungmin and Juran's relationship had gone beyond the point of repair. Winter vacation was approaching, and on that day, they received their performance assessment grades. Someone from Juran's friendship group had given Jungmin an absurdly low score on the peer review. Outraged, Jungmin went over and grilled the kid, but all that came back was a snort. Jungmin's fists were trembling. Just then, Juran grabbed her hand. "What do you think you're doing?" Jungmin jerked herself from Juran's grip and stormed out of the classroom. And not because Juran hadn't taken her side. It was the contempt that'd tinged Juran's words. Juran's

fear that, if left to her own devices, Jungmin could've hit one of her friends. Jungmin's feeling of being shunned. That she wasn't fully accepted. She didn't go to see Juran during break times any more. Worried she might come and find her instead, Jungmin went and hid in one of the bathroom stalls. Within the confines of that tiny box, she imagined a long, stretched-out runway. She felt a suffocation in her chest, and wanted to run and run until she was completely out of breath. Jungmin was seventeen when she learned just how long ten minutes could be.

That day, it'd been Jungmin's turn on the film club's cleaning rota. She was tidying up the storage cupboard when the door to the clubroom burst open and Juran and her friends crowded in. They were members, too. Jungmin immediately crouched down so they wouldn't see her. It hadn't been her intention to eavesdrop, but the clubroom was small, and their voices were loud. After a few rounds of nasty backstabbing, one of the kids turned to Juran and started to badmouth Jungmin for squaring up to her over a few lousy marks. Juran pretended to defend Jungmin, saying she wasn't a bad kid. When Juran's friends asked her about the stench of pigs' feet coming from Jungmin's jacket, she lowered her voice and spilled the details. And finally, when they asked about the bruise on Jungmin's calf, she scanned around the room before whispering, "Here's the thing, so Jungmin's dad . . ."

"YOU PUSHED ME away, even though you pretended like you didn't." Juran twiddled her chin-length hair round and round her finger as she spoke.

Juran's mum left home when she was four years old. She

left her husband—claiming she didn't love him any more—for another man, leaving her daughter behind, too. Jungmin knew that Juran had felt abandoned, and because of that, relationships became her fixation. She'd wanted her dad to remarry so she could have a new mum, and she was extremely possessive of her friends. She'd said that her first experience of maternal love came from Jungmin's mother, when she'd taught her how to use sanitary pads. By the time Juran had memorized the entire menu of the jokbal restaurant and could wait the tables with prowess, she had stopped calling Jungmin's mum "Ajumma," and started calling her "Umma." Watching Juran call her mum "Umma" with such tenderness made Jungmin sick to her stomach. Juran was growing too close for comfort. She, too, had clocked the way Jungmin looked at her.

"At that age, friends drift apart for all sorts of reasons. They do just one thing to annoy you, and you come up with every kind of excuse to hate them."

"You never could be honest," Juran remarked, her tone cold.

The way Juran pounced on every little thing she said made Jungmin's insides wrench. *There's probably no point digging things back up now, but might as well finish what we started. Are you sure you never did me wrong? Can you really say that you were never, even for one minute, repulsed by me?*

"I was there that day. In the clubroom."

An unveiled look of horror swept across Juran's face, and she froze. Her jaw dropped ever so slightly, and it was as if her consciousness had slipped out through the gap. Juran always had been an open book.

"If it'd been anything else, I wouldn't have cared. But you

shouldn't have told them about the bruise. You should've made something up. Or at least said it out of earshot from me . . ."

"I said I was sorry. I didn't know you were there. I'm sorry for going round telling people about the accident. Maybe I really was the one who drove you into the cave." Juran's voice was hoarse.

"I can't do this any more."

Jungmin stood up from her chair. She couldn't bear to look at Juran any longer. Being around her was agonizing, and forced her to delve deep into her own thoughts. Like drinking rancid milk—it was no surprise it gave her a stomachache. Maybe it was better to go ahead and pour it all down the drain.

Long after Jungmin had left, Juran remained behind, alone. Her ice cream, untouched, had already thawed into a tepid gloop.

Centering

OCTOBER HAD ARRIVED, and the leaves began to drop one by one. Now that the trampled chestnuts and their burrs lined the streets, the time had finally come for Jungmin to face the wheel. When Johee had told her she was ready, Jungmin was surprised to discover she'd been neither waiting, nor hoping, to hear these words. She was, in fact, a bit fed up—it'd taken her so long to pick up the basics, and to consider pottery a proper hobby. When she first started, she'd done it casually, but at this point she needed a reason to keep going. With her passion fading, learning a new technique would provide a breath of fresh air.

Jungmin sat before the wheel and watched Johee demonstrate once, and again. Up until now, Jungmin's clay had always been soulless. Its shape remained unchanged unless she touched

it, and she had to trim it carefully by hand before it just about earned its new name of "plate." The clay had always been passive—now, the wet lump spinning of its own accord on the wheel felt awkward and unfamiliar.

"From now on, your left and right hand will work together as a single moving team. When your left is on the outside and your right is forming the shape inside, both hands need to be at the same height. You carry on like this, and then when you move both hands to the outside, they need to be in the same position. You're slimming down the clay by applying pressure only from the top."

Jungmin was frozen stiff. Johee told her to feel the texture and moisture of the clay. The prospect of handling the lump as it danced round and round terrified Jungmin. She'd felt a similar fear as a primary school student, when she went to a friend's house and reached out to stroke their tiny white Maltese dog. For some reason, she shrank away from anything that was alive and moved with vigor.

Once she'd plucked up the courage, Jungmin gripped the clay gently to form a cone. A jolt of anxiety shot through her—the wet clay felt completely different from what she was used to. The sloppy lump contorted so easily. With even the tiniest pressure, in a flash, the cylindrical clay would have widened at the bottom and narrowed at the top. It was as if Jungmin and the clay were doing the tango, and Jungmin had suddenly pierced her partner's foot with her high heel. Timing, pressure, speed—if any one of these was slightly off kilter, dancing with the clay became impossible.

"Right, we'll worry about shaping later. That was just a practice. What we need to focus on today is centering. You'll know this from looking over the others' shoulders as they work, but the first thing you need to do is center the clay so that it stays in position. You cone it, flatten it again, cone it, flatten it again, and through repeating this process you're aligning the clay particles. Until you've centered, you can't start throwing."

"How do I tell when the clay is centered?"

Johee's explanation was short and sweet. "It's a feeling."

What a surprise, Jungmin thought once again. Completing a "quest" in pottery was never as simple as mastering a new technique. She gazed down at her palms, smeared with watery clay. These blunt hands had a real challenge to overcome.

THE CLAY, IGNORANT of what was on Jungmin's mind, kept irritably losing its balance. And then it abruptly came tumbling down. She coned the clay once more, but it swayed left and right, ending up with a middle like a flattened pillow. Jungmin was beginning to doubt whether by repeating these actions she was really centering her clay. Was a simple process of stretching and squashing really enough to align the particles? Though the texture of the clay wasn't visible to the naked eye, there was no doubt it was all uneven. No matter how many attempts she made, the clay would always escape her grip and let out an exhale as it collapsed.

The clay caved in yet again, resembling the hollow left by an exploded landmine. Despondent at her own ham-handedness, Jungmin could stand it no longer and flung a timid fist at the

clay. The sluggish pace of "ceramics time" had grown unbearable. Not even two seasons had passed—Jungmin was annoyed at herself for losing interest so soon. She always had been indecisive and unable to stick at anything. Even in relationships, she could never make it last. Remembering this, everything she felt now made complete sense.

Forget dancing—Jungmin hadn't even managed to get a hold on the clay yet. She was utterly exhausted. What's more, she'd been crouched over the wheel, her neck and back crooked, for two hours now. The posture put even more strain on her shoulders than hunching over her computer at the office. Jungmin straightened her back and swung her arms. Before she knew it, Gisik, who'd been at the wheel beside her, was gazing upon her sunken clay and pulling a gentle smile.

"Not easy, is it? The first time throwing takes a lot of patience. As obvious as it sounds, practice is key."

He must've witnessed her punch a moment ago—realizing this, Jungmin felt ashamed, as if the voice inside her heart had leaked out. Ever since meeting his girlfriend a few days earlier, she'd felt oddly uncomfortable around Gisik. Whenever she saw him, she was reminded of that sprightly woman.

"I used to think I was a patient person. But I guess not, even though I used to always power through no matter the situation. It's so frustrating."

"When the clay wouldn't do what I wanted, I'd sometimes just go and punch it, too. I was that annoyed. But clay's so soft that it doesn't hurt a bit. Whenever you're in a bad mood, go ahead and pummel it as much as you like."

Jungmin looked at the distinct fist-print stamped in the clay. A hand disproportionately large for her build. "A born pianist," the adults always used to say when they saw her hands. Or otherwise, "She'll make a brilliant artist with hands like those." Unfortunately, Jungmin had zero talent in such fields. Though with her long fingers she could tap away at a keyboard faster than most, what she wrote vanished just as quickly. *What did it feel like to love what you do . . . ?* After the documentary team incident, Jungmin drew the line: she knew now that pouring everything she had into her work was toxic.

"Gisik-ssi, do you really love pottery that much? It takes so long to master the basic techniques, and just because we're good doesn't mean we get results. And you're rushed off your feet with your day job as well . . . To be honest, I was surprised when you said you were opening your own workshop."

"I was never inspired by abstract words like 'art.' But the first day I felt the cold clay, straight away, I knew. That I'd be doing this for a long time to come. I knew that I could spend my whole life doing this and never get bored. It was different from a sense of 'This is fun.' Unlike the electric thrill you get from enjoying something, it was a peaceful feeling. If the work calms me, it's something I can do long-term."

"Work that calms me . . ."

What could that work be for Jungmin? Most of her numerous options either triggered her anxiety, or otherwise did more than calm her and simply bored her to death.

"To be honest, I'm not sure what pottery means to me at the moment. There's nothing wrong with seeing it as a casual hobby,

but I keep getting my hopes up and believing that it'll be a way of transforming myself."

Gisik, like a doctor, diagnosed her condition. "Looks like you've found why you can't center the clay. Maybe you're in too much of a rush. You're trying to get your zest for life back by doing something, anything, as quickly as possible, but clay is such a slow material. Maybe it's this gap in speed and expectations that's made you lose your way."

"What are we supposed to do when we lose our way, though? I want to match my speed to the clay's, but today I got bored, even. And now I've acknowledged that, I can't concentrate. I'm a mess."

"In that case, look at it this way: don't do it for yourself, but for others. Pottery has a different charm when you think about the people around you as you do it. That was how I picked myself back up again whenever I got into a slump. Other people know how much time and effort I've put in, so even if the shape is slightly off or the piece has become fragile inside the kiln, they're always glad to receive what I've made."

"Guess you can show off a bit by giving gifts, too?"

Gisik pulled a playful smile. "Of course. Let's be honest, my pieces are worth keeping, right?"

When it came to centering, maybe you had to start by looking at the edges. This whole time, Jungmin hadn't once examined her surroundings. Instead, she sat alone in the remote exhibition room where her many hearts hung on display, and didn't let a single person in. Here the hearts—out of sight and unsold—rotted away.

"I don't know who to give it to."

"I don't think about it in advance. While I'm making something, there are words that keep coming to mind. If I follow those words, I see a name. That's when I know. Oh, this piece belongs to *you*. And so I get in touch with them, ask how they're doing, then meet up face to face and give them the piece. Maybe it'll feel awkward at first. It's embarrassing giving such a heartfelt gift. But try it anyway."

"I've got enough dishes in my kitchen now, and plenty of bowls for Hoya."

"Whoever's going to get a gift from you is a lucky person."

"Most of my pieces are all distorted though."

"They're like that because you wanted to make them look better and kept trying to fix them with your hands. You can see the heart that went into them."

Jungmin could sense the warmth in Gisik's tone. She gazed at him, bewitched by his voice, before hurriedly averting her gaze. Both her clay and her heart had been thrown off-center. She cooled the fire inside her, sprinkling water over her clay, which had dried up while she was speaking with Gisik. As the clay swallowed the liquid, its color grew brighter and softer. In the end, the clay dancing on the wheel was nothing. Only once it'd made it through the 1,250-degree heat of the kiln to come out nicely as a plate and, finally, been set down in someone's kitchen or on their dining table, did it get a name. A piece needed to reach someone, who'd then place something inside, giving the clay its glittering life force, like a sprout bursting through the rigid earth. Jungmin therefore decided to let go of

her silly fear—of the clay that still refused to be centered. Soon, she would take a slow look around her; it was then that the clay would find its center, and the piece's owner would float to Jungmin's mind.

Jungmin took the clay in her grip once more. As she held it in her hands, one by one she threw out the self-portraits that hung in the exhibition space of her heart. Applying force, she pulled the cone out long, and spring-cleaned the gallery. Next she pressed the cone down flat, opening up the door. Now, rather than portraits of herself, it was time to bring in ones of those she cared about.

"I think you've got it pretty well centered by now?"

As Gisik's words wrapped quietly around her ears, Jungmin could tell a new thing was underway. Learning something new didn't mean your day-to-day life would transform instantly by magic. She didn't have grand aims for a hobby to change her life. Her only assignment now was to find who the piece belonged to. At times, nothing brought reassurance. Today had felt like one of those days to Jungmin, but Gisik had gifted her an exception. It was as if a relentless, pounding headache had been unexpectedly cured by a single tablet from the first aid kit. In her mind, everything had become clear.

THIRTY. THE NUMBER of pieces Jungmin had thrown in the space of two weeks. She'd decided to practice by making as many as her years. This decision had been inspired by Gisik, who set all sorts of goals based on his age. Her creations had, of course, turned back into clay again, before being thrown into

something new. Like this, the thirty blocks of clay were lumped together over and over, until all that remained were two pieces. With Johee's help, Jungmin had pinched in the end of one and actually made it look like a vase. The other was a wide, shallow bowl. Though they could never compare to Jun's perfectly molded works, or Gisik's creatively designed ones, Jungmin was satisfied. She was beginning to find her center.

"Have you thought about who you'll give the vase to?"

"I'm thinking about giving it to my mum."

An unexpected response had passed Jungmin's lips. She certainly hadn't had her mum in mind, but the words came flying out nonetheless.

"I'm sure she'll love it."

In truth, the throwing process had been so arduous that she hadn't given any proper thought to the matter. However, judging by her own response, it was as if she'd been waiting for Gisik's question. Without her noticing, a particular face had popped up over and over in her heart.

Gisik pointed to the wide, shallow bowl. "What about the other one?"

"Not sure yet. I'm wondering if a person might come to mind out of nowhere, like a clueless student showing up late to class, so I'm putting it to one side for now."

"You're very considerate of that late student, too, Jungmin-ssi."

Gisik tidied away his things, and said he needed to stop by the estate agent. On the weekends leading up to his workshop opening, he divided up his time in such a way. He made a show of acting incredibly busy as he prepared to leave, but when he

was actually at the door, he dawdled. Then, he walked over to Jungmin, and suggested they grab dinner.

"I'll be right back. Won't keep you waiting long."

Gisik, oblivious to the meaning and possibility each of those words held to Jungmin, strode out of the workshop swinging his arms. Jungmin couldn't concentrate on her work anymore. She was like a puppy waiting excitedly for its owner to return. When the message arrived from Gisik to say he was waiting in front of the workshop, she typed straight away at the keyboard with clay-smeared fingers, not feeling the need to judge the timing of her response. Thanks to her eagerness, her phone screen got filthy, too.

"I'M VETOING SANDWICHES. After all that hard work today, I'm starving."

Jungmin gave Gisik firm instructions as she slid into the passenger seat. She was confident she could eat *a lot* this evening. Gisik said there was no way sandwiches would fill his stomach, either. He grabbed the wheel; the ring finger on his left hand was empty. Instead, there was a pale strip where it'd once been. Jungmin had got in the habit of checking his left hand. Whether he was wearing the ring when he arrived at the workshop, whether he'd put it back on before he left . . . She realized she'd probably been paying attention to his finger since the very first time they'd met.

"I see you keep forgetting to put your ring on?"

"Oh no, I did it again. It's almost as if I'm going out of my way to get scolded."

Gisik turned the wheel with his left hand, obscuring his ring finger slightly from view.

Jungmin gave him directions to the suyuk gukbap restaurant, where she often used to come alone after a live broadcast. It was somewhere she'd really wanted to take Gisik when he was drained and needed an energy boost. She hadn't been back since quitting her job, making this her first visit in almost a year. The same run-down sign and door. This place was a refuge, where office workers drank to drown the absurdity and humiliation they'd had to face throughout the week. Then, amongst them, the fresh-faced pair: Jungmin and Gisik were the youngest people there.

"This place is the real deal. Only Ilsan locals know about it, but I'm making a special exception for you. They're open twenty-four hours, and suyuk gukbap is their speciality. The gopchang hotpot is just as good, but it's huge, enough for three or four people. Sadly I guess we'll just have to stick with the suyuk gukbap for today."

"Suyuk gukbap is great. We can always save the gopchang hotpot for next time."

The soup was packed to the brim with offal—meat that didn't belong to the mainstream—and the earthenware stewpot was heavy. A thick, rich meat stock made up the broth. Jungmin preferred eating the soup plain at the beginning and then adding the marinade halfway through to spice it up. Gisik, on the other hand, plopped in the gloopy marinade right away, dyeing the soup a deep crimson. After the exhausting day they'd had, they were fully immersed in eating. All they exchanged were a

few brief noises. It was only once Jungmin started adding the spicy marinade to her soup that Gisik spoke.

"Actually, the reason I went to the estate agent earlier wasn't to do with the new workshop. I've put my flat up for sale, and I needed to let someone in to see it. My workshop's going to be in Goseong. I'll be finding somewhere to live there, too."

"Goseong?" Jungmin spluttered as the now fiery soup stuck in her throat.

Gisik handed her a glass of water and continued.

"It's my hometown. My parents were always so busy, and so me and my younger brother lived with our grandfather until I finished primary school. It's always been my dream to do what I love while looking out over that same sea I grew up with. I think I'm better suited to the quiet of the countryside, rather than the energetic and bustling city, with its glaring lights. Oh, and I'm planning to run a little café alongside. Rather than espresso-dessert pairing, I'm hoping to do espresso-cup pairing. Johee seonsaengnim gave me the idea. I wonder if I should be leaking my business ideas like this . . ."

Those final words, Gisik whispered as if to himself, and took a moment to catch his breath.

"Things got delayed after I decided to do the café, but I think it should be ready by December. I'm planning to open in March, but I want to head over a bit early and rest. The real problem's my girlfriend."

Gisik opened up his empty-looking left hand. Jungmin didn't particularly want to hear about Ara, but she did her best to keep her cool and listen to what he had to say.

"I asked Ara to come to Goseong with me. I suggested she take charge of the café. I know it was selfish of me. Ara is a civil servant, and I witnessed with my own eyes what she went through to get where she is now. Unsurprisingly, she flat-out refused. To be honest, when I first said I was going to quit my job and start my own business, Ara wasn't too thrilled. It was only after the one-day class that she started to accept how serious I am about pottery, even though I've been doing it two years now."

Jungmin didn't know whether to be pleased or saddened by this news, but she set her confusion to one side and managed to get out her next words. "Couldn't you . . . go long distance?"

"We've got no other choice, and I suggested we stick it out until we get married, even if it's hard. But she said there was no way. We're not talking about a short trip to Gyeonggi Province here, it's several hours to Gangwon. One of us needs to back down, but we've found ourselves in this tense situation where neither is showing any intention of giving in . . . No, it's gone beyond that. I guess you could say we're slowly heading our separate ways." Gisik hung his head.

"It looked like she was really rooting for you at the one-day class . . ."

"I guess there are some things that no matter how hard you try, you just won't get."

They'd been friends for six years, and dated for no less than four. When he returned to university after completing his military service, Ara was the first friend he'd made. The two saw each other as good friends, but without making it obvious,

Gisik had always kept the door open for things to develop into something more. Ara, however, saw things differently. You were either friends, or dating, there was no in-between. Then, when eventually one day Ara burst into tears, lamenting, "All men are the same!," Gisik persuaded her to take a chance on him. Despite Ara's fear of losing a friend, she didn't hesitate in her response to his confession. She grabbed his hand and, matter-of-fact, said, "Sure, why not?" And so, Gisik always put the work in. Even when out of the blue Ara started studying for the civil service exam, Gisik had completely trusted her. Why she'd made the decision so suddenly didn't matter.

It took Ara three years, but she finally passed the exam, and the two went on their first trip overseas together. In Sapporo, the whole world was a blanket of snow. On day one of the holiday inside that impossibly perfect ryokan, however, Ara admitted that she didn't feel the spark any more. The next day, Gisik went to a nearby drugstore and bought a disposable camera, which he used to photograph Ara throughout the trip. Alongside the pictures, he wrote her a letter, like someone confessing their love for the very first time. "Let's be together. Let's be together again. Like it was the first time." Gisik always made the effort to come up with new ways to win his girlfriend's heart.

Three out of their four years Ara had spent consumed with studying for the exam, and the remaining one year had been spent in boredom—despite the time they'd had together, their relationship turned out to have weak foundations. Perhaps because of that, it took only a matter of days for them to drift apart. The car called "breakup" gained speed the instant the

word *Goseong* had passed his lips. It seemed that the car had been waiting there all along, pulled up in a parking spot inside their relationship. At one word, the vehicle lurched forward, and though neither party was at fault, the breakup process naturally began its course.

Cautious, Jungmin asked, "How are you feeling now?"

"Surprisingly fine. Cracks were showing in our relationship ever since Ara got her official posting a year ago. But now I've realized how quickly we fell out of love with one another, I can't help but feel empty."

When it came to longstanding couples, there was no precise mathematical formula for a split. The pair took slow steps, until each of their lines stood in perfect parallel—all this was part of the breakup process.

"Suyuk gukbap was an excellent choice for today's menu, right?"

"It was incredible! It feels like my whole body is warm and full—from my belly right down to my toes. Thanks for bringing me here."

"I'm no big eater, or a food connoisseur, but when it comes to data on where to eat, no one can top me. As surprising as it may be, one of the TV programs I worked on was a show that toured round delicious restaurants. I have an Excel file on my laptop with a list of the best places to eat in each of the eight provinces, their signature dishes, as well as their contact details. Pretty solid, right?"

The change of subject was Jungmin's way of giving Gisik no room to feel empty. And by laying out every detail of her

unemployed life, she was doing her best to prove what a driven and impressive individual he was by comparison. If she had to use self-deprecating humor to do it, she wanted to let him know he was fine just as he was. Gisik appeared cheery on the surface, but behind that smile, a deep and dark emotion shone through.

Jungmin continued to keep Gisik occupied. Jihye was right—the simple act of eating delicious food was the fastest way to fill a void in your heart. After dinner, Jungmin escorted him straight to the waffle place. One banana and Nutella whipped-cream waffle and one blueberry gelato waffle. Gisik ordered obediently, based on Jungmin's suggestion. After that first bite of waffle, even Gisik—who knew a thing or two about desserts himself—promised never to doubt her restaurant recommendations ever again.

Seeing Gisik munch away at his waffle like an innocent child, Jungmin could finally breathe easy. Before long, she had joined him, and a smile formed at the corners of her mouth. After sharing their memories today, she felt their smiles had become remarkably alike, but that they now had a sell-by date. Despite the dejection she felt at this brief time frame, Jungmin hoped they would keep pulling similar smiles. An urge she was yet unaware of was growing: to make the most of her remaining time with Gisik.

GISIK DROVE JUNGMIN to her building. She thanked him and was about to get out of the car, but the door wouldn't open. Jungmin turned to face Gisik, who patted his stomach. "How about a walk to help the digestion?"

After parking, the pair meandered through the dimly lit Chestnut Burr Village. It appeared the chestnut-poaching was already in full swing, as empty shells and thorns kept stabbing the soles of their shoes. Gisik went to rummage for chestnuts, but Jungmin stopped him. Did he know how painful it was to prick yourself on one of the thorns? she asked. He asked if it'd ever happened to her, and she told him about the autumn before. With this as their starting point, they strolled the streets and began to unpack their pasts together.

As they passed the primary school, Gisik spoke of his time back in Goseong. He'd been a hot-tempered kid, but also a romantic, one who'd looked at the ivory Catholic church next to his school—one of the "top three most beautiful churches in the country"—and decided he wanted to get married in a place like that one day.

Next, walking by the independent bookshop that ran creative writing classes, Jungmin spoke of one of her favorite authors, Kaori Ekuni. She'd been a bookworm as a teenager, and after reading *Between Calm and Passion*, she'd sheepishly confessed to her English conversation tutor how much she liked sad love stories. She told Gisik how she couldn't understand *Falling into the Evening*'s protagonist even now, and how—embarrassingly—she used to dream of becoming a giant of romance novels, Korea's own Kaori Ekuni . . . "You should publish your own work, Jungmin-ssi," Gisik sighed, and it was only then that Jungmin realized how giddy she'd been the whole evening. Blaming the cold, she buried her trembling hands deep into the pockets of her puffer coat.

At the homeware shop, Jungmin learned that Gisik's parents ran a similar store of their own. His mother and father were all about adornments—they loved to brag about their children's academic success and careers. Making ostentatious comments in such a way was like doing up a run-down property and scrubbing until it was sparkling clean. Gisik admitted that he'd felt like just one out of many tiles illustrated in a home décor brochure. So-and-so tile studied at so-and-so university in Seoul, got a job at so-and-so big company, drives so-and-so car . . . Every detail had to be etched out. Despondent, he shook his head and recounted the lengths he'd gone to—all to become an expensive, alluring tile that his parents could boast about.

After a moment's silence, he suddenly asked, "What color comes to mind when you think of the sea? On three. One, two, three."

"Green."

The two answered in unison. Then, like always, they high-fived. By now, they knew exactly which position, which hand, to use. A seaside resort was the first thing that came to Jungmin's mind, and so she'd said green, but Gisik's response had been unexpected—he was, after all, used to the blue East Sea.

"To me, the sea isn't all that cold. It's warm, somewhere that holds lots of memories. That's why I think of an emerald green."

Gisik's explanation was succinct. Rather than try and understand, Jungmin simply accepted what he'd said.

As they walked by a jokbal takeaway place, Gisik found out about Jungmin's mum's restaurant. He told her that he'd once been such a fan of jokbal and makguksu that they were basically

his soul foods, but then he got a terrible stomachache one time after and hadn't been able to eat them since. Jungmin chimed in flatly that she was sick of jokbal, too.

While they were piecing together these unknown parts of the puzzle, before they knew it, they'd arrived at the workshop. The "&" still hadn't been removed from the sign.

"I did like the aroma of fresh flowers in the old workshop, but I like how it is now, too."

"Flowers . . . ? Soyo used to sell flowers, too?"

"Yes, and they did flower arranging as well. That's all in the past now, of course."

As Gisik spoke, a look of great sadness fell over his face, and he became almost unrecognizable to Jungmin. So many questions came to mind, but she didn't ask any more.

"I'm intrigued by what your workshop will look like."

"I can't picture it yet, either."

Gisik still had reservations about his workshop. He believed it was thanks to the other members that he could continue to enjoy pottery. Would he manage without them? A secret worry spread, like liver spots across an old man's wrinkled face.

The night was long, and it felt as if they could walk on endlessly, but Chestnut Burr Village was too small for their conversation to continue. Once they'd explored the alleyways' every nook and cranny, finally they climbed the hill path and found themselves back in front of Jungmin's flat.

Gisik looked embarrassed, and confessed that he felt like a bit of a blabbermouth—today, for some reason, he'd wanted to tell his story to anyone who'd listen. Jungmin's right eyebrow

raised a little at the words "anyone who'd listen." She wanted to ask why, out of all of the potential listeners, he'd chosen her. Gisik's attitude may have been a bit off, but she was much worse. When she'd heard that he and Ara were on the verge of breaking up, she'd childishly and selfishly tried to calculate her own chances. In the midst of this complex bundle of emotions, she let out an audible groan.

"Is something wrong?"

Seeing the warmth in Gisik's eyes, the emotions Jungmin had been bottling up all day came flooding out. At last, she thought, *To hell with it.*

"Do you remember when I first came to the workshop, the thing with the ring?"

"Of course. You were so apologetic about it."

"At first, when I saw the ring, I thought, if it were me, I would've gone for a different design. I would've gone for something that suits us both better."

Gisik looked perplexed. Jungmin then realized what she'd just said—she felt as if she were drunk and had been smacked by a sobering cold wind. She flung open the car door and raced inside the building. Her ears were hot. It was too late now, so if nothing else, she hoped Gisik would go home and think of her.

Cobalt Blue Vase

DRESSED IN THE cool yet mysterious blue of the cobalt glaze, the vase came out the kiln even more beautiful than Jungmin had hoped. Gisik's idea of adding vertical stripes to remove some of the weight was, to quote Johee, marvelous. Engraving the pattern had given the vase the vintage feel Jungmin was after, and at the same time it felt sturdy in her grip.

Once Jungmin was home, she unwrapped the vase, which Johee had packaged in newspaper for safekeeping. Next, she placed it inside one of the gift bags that were lying around in her flat. She'd briefly thought about buying wrapping paper and a proper box, but she wasn't that much of a devoted daughter. Deciding to avoid such cringeworthy behavior, Jungmin went

and sprawled out beside Hoya instead. Hoya acted as if he both knew everything and knew nothing at the same time. He licked Jungmin's hand, coarse from a day handling the clay. Jungmin dozed off as she gently stroked Hoya's warm fur. The spot Hoya licked had soon dried and hardened once more.

JUNGMIN AWOKE FROM a deep sleep and flung some clothes on. Though she knew Saturdays were the restaurant's busiest day, she left her flat and headed straight for Seoul regardless. She hadn't left the villa complex for long when she realized she'd forgotten the gift, and had to turn back round again. Jungmin reflected on her withered generosity—was she so unused to giving presents?

The journey to her mum's jokbal place involved transferring from the subway to the bus, and took just over an hour. Though it wasn't particularly far, Jungmin rarely went to see Yunjae. A huge eatery inside the market, her mum's restaurant was famed for its good food, meaning it was permanently crowded. As time went on, business boomed, and she'd expanded and renovated multiple times.

Jungmin hated this pristine restaurant, which didn't fit in at all with its surroundings. Though part of the reason for its popularity was its longevity—it'd been around since Jungmin was in primary school—the fact that it had been featured on the food tour program she'd produced a few years before had played a bigger role. Yunjae boasted to her customers that she'd appeared on her daughter's show, but it wasn't purely a reflection of her work. Jungmin had been in urgent need of restaurants to

feature—that was her job—but it had also been her way of trying to be a good daughter.

The logo of the program Jungmin used to work for was displayed on the restaurant's front, and "Featured on NBC's *Happy Dinners!*" was written conspicuously in a tacky font alongside it. Underneath was a still image from the broadcast, showing Yunjae making her top-secret jokbal medicinal water. Jungmin did her best to ignore her mother beaming in the photograph and pushed open the restaurant doors.

In a husky and grating voice, Yunjae's boyfriend was the first to greet her. "Oh, Jungmin, it's you? Long time no see."

"Hello. I completely forgot to let you know I was coming. I just stopped by. Can't stay long."

Thankfully he was the same guy she'd seen a year before. Whenever Jungmin made her yearly visit to the restaurant, Yunjae usually had a new boyfriend. Her boyfriends always had a ruddy complexion, short hair, and wore a black belt pulled tight, as if to accentuate their scrawny frame. Yunjae's type never changed. She'd gone through at least ten men; only their names and faces were different.

At first, Jungmin had struggled to understand her mother, who'd been a serial dater ever since she split with Jungmin's dad. It hurt her, but she couldn't make her feelings known. When she'd tried to bring the matter up, Yunjae had looked distraught and pounded her chest, lamenting that even her own daughter didn't understand her. Yunjae's horrendous marriage had left her isolated, and she would've needed someone to rely on when her only daughter wasn't there. Jungmin had taken a part-time

job and left home in her early twenties, which would've only made things worse. She resolved not to blame her mum's dating habits any longer.

Jungmin brushed past Yunjae's boyfriend—who was rushed off his feet with the swarm of customers who'd flooded in after the break in service—and headed silently to the staff room behind the private dining area. Piled up were boxes of peppermint candy and green toothpicks ordered in bulk, and there were low tables and spare floor cushions stacked up in two rows. As a young girl, this tiny room was where Jungmin used to do her homework. The staff would act as her teachers for the day and look over her work from time to time. Every couple of months, or sometimes as much as every week, they would change. From the sixty-year-old woman, who was an excellent cook, to the twenty-year-old, who was just out of high school and paid far too much attention to what the customers thought—one by one, they all passed Jungmin by. While they looked through her homework, they would lament over their wearying lives, and occasionally badmouth the young owner, Yunjae, too.

These comments about her mum didn't make Jungmin angry, exactly. She felt sorry for the staff. While she was there listening silently to their stories, it seemed like they were doing all they could to be pitied. They each believed their own life more pitiful than the rest, and they'd battle it out to see who had it worse. In the end, was everyone living just to be pitied? "Pitiful" definitely described them better than "sad." Even so, once service was over and they'd gather at the table for a very late dinner, it was smiles all round. Seaweed stems, stir-fried anchovies, and

alcohol. The women, claiming they needed to cut down on the carbs, would laugh off the day's exhaustion with a cold beer and three spoonfuls of rice served in a tiny dish used for dipping sauce. Jungmin couldn't stand the sight of those absurd grins, but all she could do was sit there in silence. She gave up on finding any logic in their inconsistent words and stayed on her best behavior. Even once dinner was over and it seemed they might never stop talking, Jungmin fidgeted, her legs numb—beneath the table, Yunjae would squeeze her hand tight.

Today, Yunjae was nowhere to be seen in the hectic restaurant. Jungmin waited for her mum and attempted in vain to smooth out the recycled gift bag, which had crumpled in her grip on the way here.

The staff-room door was flung open, and Yunjae popped her head out from behind. Despite how long it'd been, she greeted her daughter as if it were only yesterday.

"Have you eaten?"

"Yeah. You went out somewhere?"

"We were running low on medicinal herbs so I popped to the market. We're closed Mondays, if you'd come by then we could've eaten together . . ."

"Don't worry about it. I just came to give you something. I can't stay long."

After all this time, Jungmin left no room for niceties and cut straight to the chase. Even so, Yunjae didn't once show disappointment.

"What's all this? What could my daughter have to give me?"

"I've started learning pottery. I made this in the workshop."

Jungmin dubiously held out the gift bag. She felt too awkward to meet Yunjae's eyes.

"You made it yourself?"

"Yeah."

Yunjae simply stared at the piece. Outside, it was clamorous with the clinking of plates, hum of the television, scraping of chairs and people chattering—this room, however, felt separated from all that, like being inside a time capsule.

"Did you know I trained in flower arranging? Before I got married, when I used to work at the magazine, I loved flowers and took classes every weekend. I promised myself that when I got old, my life would be all about flowers. But now I'm spending day after day cutting, not stems, but piping hot pigs' feet. Life never does turn out how you expect."

"I'd no idea you had a hobby like that."

Yunjae's love of flowers was news to Jungmin. And a qualified flower arranger at that. It reminded her that her mum was indeed a woman, too, and this blatantly obvious fact broke her heart. There were so many conversations they'd neglected to have. The air was pungent with the scent of peppermint candy seeping through the boxes. Maybe that was why Jungmin's eyes stung.

"I sure did. These days my hands are stiff and covered in sores—hardly fit for flowers, are they? But from time to time I imagine myself as a florist being interviewed by the magazine I used to work for. I wonder what it would've been like. Selling jokbal isn't bad, though. That was what allowed me to raise my daughter right."

"I raised myself right, you mean."

As she uttered the insensitive words, Jungmin's gaze fell to the floor. With a delayed pang of regret, she murmured, "Guess I should've bought some flowers, too. You've got nothing to put inside."

Yunjae pulled a wry smile. "Get me some next time. At least that'll give you a reason to stop by more often!"

Just then, there was a *knock knock*. A middle-aged staff member cracked open the door and handed over two mugs of instant coffee.

"I heard your daughter was here! Gosh, she's pretty, just like her mother."

Yunjae beamed and began to sing Jungmin's praises. *Broadcast writer daughter* . . . That was all in the past now, but Jungmin missed the chance to correct her mother and smiled uncomfortably with her eyes. Just as she was getting sick and tired of Yunjae's boasting, the staff member left for the kitchen to prepare for the evening service. Thanks to her mum, who dished out brags about her daughter like side dishes, humiliation was Jungmin's portion.

"Business okay lately?" Jungmin asked, sipping her coffee in an attempt to swallow her embarrassment. She flinched at the sweetness of the milky instant coffee.

"Same as always. How's your work?"

Calmly, Jungmin replied, "I quit. A year ago now."

"Funnily enough, that was exactly what I was going to tell you to do. Seems like people in your line of work are forever pulling all-nighters."

Yunjae was surely aware that Jungmin had stepped down from the program. It was a well-known documentary series, whose audience was mainly middle-aged viewers. When the end credits started rolling and most people would reach to switch channels, Yunjae would ensure the customers stayed well away from the remote. *Listen here, my Jungmin's name's about to come up.* She couldn't have failed to notice the disappearance of her daughter, replaced by the three characters of another writer's name.

"Maybe I should take over your restaurant?"

"Why you! Not a chance. I'll keep you from working in a restaurant if it's the last thing I do."

Though Jungmin had only meant it as a throwaway comment, Yunjae's response was furious. *I could always work in the restaurant* were the words her mum most loathed to hear. Jungmin quickly backed down.

"Thinking about it, I got sick and tired of jokbal ages ago anyway."

"You should be working writing at a desk."

"I can't even do that now. My legs go numb."

Yunjae smiled bitterly at Jungmin's lukewarm response. The same smile she'd pulled when her daughter had given up on applying to literary contests as a university student.

Jungmin had always dreamt of being a novelist. As a primary school student, books had been her refuge, and her secret wish was to become a writer. Based on her grades, she'd decided to study Japanese at university, but a few terms in, she took a break. For a whole year, she wrote tirelessly. Sometimes there was a

consistent thread to her writing, and at others, it was made up of incomplete paragraphs and sentences, or fragmented words. But she'd had no luck at any of the literary competitions. Why she failed—there were too many reasons to count. Her biggest problem was that the stories had only one character. The protagonist, oblivious to the passing of the seasons, wore long sleeves and long trousers even in summer—Jungmin's novel was terrible, filled with nothing but the main character's thoughts and monologues. Her writing back then was no more than a record of the conversations she'd had with her clumsy, naïve self.

With zero prospects as a novelist, Jungmin met reality halfway. She decided to become a broadcast writer: she could continue to write, but without the need to write about herself. All she had to do was convey other people's stories through other people's mouths. Later on, she realized that—much like the staff members she'd met at the jokbal place as a young girl—she'd chosen this work to become pitiful, but she didn't care. Rather than getting hung up on her insufficient talent and living in false hope, she was more at ease becoming someone overworked, someone to feel sorry for.

THE VASE HAD simply been an excuse, she realized now that she was there. Jungmin had needed to tell her mum that she'd seen Juran and her father.

"Umma, I actually saw Juran and her dad a while ago."

Yunjae was taken aback. "How did that happen?"

"It was at the workshop. Her dad goes to the adult education class there. He sold his place in Seoul and moved over to Ilsan."

"I wonder how he's getting on . . ." Unsettled, Yunjae trailed off at the end of her sentence.

"He seemed to be doing well. I didn't recognize him, and he didn't recognize me either."

"Guess a lot of time has passed."

Yunjae was far away, as if she'd forgotten Jungmin was right there in front of her. Her daughter's words had transported her to the past. For Jungmin, seeing her mother like that was like looking in a mirror, and it sent her hair on end. She resembled her father in appearance, but her expressions were much more like her mother's, the person she'd grown up with.

After spending a while rummaging through her memories, Yunjae snapped back to reality. "Oh, do you know Juran's married?"

Jungmin frowned. "How did you know that?"

"She stopped by once, a couple of years back, just before the wedding. Her husband's a dentist, nice-looking and a decent man at that. I know you get sensitive at any mention of Juran, so I didn't bring it up."

Jungmin was hurt. Her mum had hidden it from her. Their conversations had always turned ugly whenever Juran came into the picture.

"How can we show our faces in front of Juran?"

"I didn't go to see her, she was the one who came to see me. Looks like she wants to apologize to you. Said she'd done you wrong. I don't know what she was referring to, but given you've seen her now, why not air out your old guilt and get it all off your chest?"

Jungmin was firm. "I don't want to apologize just to ease my own guilt, and I don't want to receive an apology like that either."

"So you're planning to carry that guilt with you your whole life?" Yunjae shuddered in frustration.

"How can I forget? How can I live like nothing happened? Someone needs to remember, it's not as if Appa's going to. It's only right, Umma."

"No one ever told us we did wrong. Jungmin-ah, it's okay to let go. When you wear all those spikes like a hedgehog and keep everyone at a distance, in the end it's only you who suffers."

"I can't let go of my guilt. I know."

Jungmin had bound the memories of that day to a pillar in her heart, and had punished herself ever since. Cracking the whip on herself little by little was the only way to take the edge off her guilt. To lessen that pain, she had to inflict a pain even greater.

Yunjae's voice clogged. "There must be things you want an apology for, and things you want to apologize for, too. Next time you see Juran, tell her what's really on your mind. After I saw Juran that day, I felt a whole weight lift off."

What would it feel like for the pain pressing down on Jungmin's chest to lighten? Would she feel like a newborn child, who opens their eyes each morning without a care in the world? Or perhaps it was more like regaining your true laughter, laughter that no longer required strain or pretense. Cautiously, Jungmin imagined the freedom she'd forbidden herself for thirteen years.

". . . I think I'm going to head off."

Jungmin massaged her tingling legs and stood up to leave, then she turned back to face Yunjae.

"Listen, I haven't asked anything from my family for a long time now, but there is something."

"What is it?"

"Find a man who'll really love you and then build a life with him."

Yunjae scoffed in resignation. "I'll try my best. In return, do one thing for me. Don't forget that I raised you on proper food. Precious foods, the kind made with broths simmered for hours, food that takes lots of preparation, and ones that you have to eat raw to get their nutrients. Looks like you've forgotten."

It seemed that Yunjae had believed that by giving her child three square meals a day, she'd performed her duty as a mother. That as long as her daughter ate food so painstakingly made, she'd turn out just fine. By the time she realized, it was too late.

"How could I forget? Thanks to that, I grew up nice and tall, unlike you," Jungmin said, shrugging off her mum's appeal. But upon greater thought, it occurred to her that her mum's request might be a more difficult ask than her own. After all, whenever Jungmin had hit a bump in the road, the first thing she did to lighten her burden was cast aside the memories of her family.

YUNJAE'S BOYFRIEND GRABBED Jungmin as she was leaving and urged her to stay for dinner. Jungmin forged an excuse—she needed to work tomorrow, even though it was Sunday—and brushed his hand away. Though she was well aware her daughter

was lying, Yunjae didn't stop her. Instead, she sent her boyfriend on a fruit run to the shop next door before loading it all into Jungmin's arms. Two bags bursting with green persimmons and bright red apples.

Arms crossed, Yunjae called out to the back of Jungmin's head. "Stay for dinner next time."

Jungmin nodded without looking back. In Jungmin's eyes, she and her mom were more like comrades than family. Battle companions who'd braved it out together. And so, the distance between them was just right.

ON THE SUBWAY home, out of nowhere, Jungmin handed a red apple to the old lady sitting beside her. Though the woman looked suspicious of this unorthodox behavior, Jungmin pointed to the crimson fruit and said, "Now's the perfect time to eat them." After placing the apple carefully inside her small cloth handbag, the lady smiled and thanked Jungmin. The green persimmons would need to ripen a bit more before eating, so Jungmin saved them for later.

As the subway train poked its head back above ground, Jungmin uploaded Gisik's photos of the vase, alongside a brief caption, to the workshop Instagram. A story of "the heart of gifting pottery." Through the window, she could see the Han River, and soon the smell of jokbal had gone from her trench coat, leaving only the sweet aroma of fruit. Yunjae still didn't have anything to put in her vase. As Jungmin pondered what flowers might suit its blue glaze, she stared a while at the ripples of evening light as they bobbed across the autumn Han River.

Potter Wife, Florist Husband

JUNGMIN WAS ON her way to the workshop, having picked up some coffee to go from a café that'd newly opened nearby. On weekday afternoons, Johee and Jihye were usually the only ones in the workshop, and so Jungmin was carrying three cups including her own. One of the café's signature Einspänners, one ordinary black coffee, and finally one drip coffee, which the owner—who'd studied as a barista abroad—particularly prided himself in. She hurried her step, concerned the gently sloshing coffee would go cold. Jungmin had pled with Johee in advance not to make any today—she'd promised she would bring some from the new café instead. Soyo's coffee was good, too, but exploring the delicious cafés dotted here and there across Chestnut Burr Village had become yet another pastime of hers.

From a distance, Jungmin could sense a boisterous presence

inside the workshop. Even against the bracing wind, the count-
less potted plants lined up outside seemed to burst with life. The
doors were already wide open, and she could see there were cus-
tomers inside. Two men she'd never seen before.

Johee welcomed Jungmin with a huge grin. "Jungmin-ssi,
you came just at the right time!"

"There's a lot of people here today. Is there an event on or
something?"

"No, the owner of the new Japanese place down the alley
came to buy some dishes."

"Really!" Jungmin clamped her mouth shut, slightly alarmed
by how loud her voice had become.

"Jungmin-ssi runs our social media account."

The restaurant owner, Seungho, was counting the bowls
inside the box. At Johee's words, his eyes lit up and he greeted
Jungmin.

"I follow the workshop Instagram! I'd been wondering where
to buy dishes and that was when I came across it. I particularly
enjoyed the recent 'Heart Series.'"

"That's kind of you to say so."

Jungmin struggled to respond. This was her first time meet-
ing someone, other than the workshop members, who'd read
her posts. She was both mortified and delighted.

"Your posts are charming. It was the words, 'put your heart
into a plate,' that brought me to the workshop. You've success-
fully moved the heart of one consumer at least."

"I only got the idea because Johee seonsaengnim's ceramics
were so good to begin with." Jungmin glanced out the corner of
her eye at the dishes in the box. There were scorched ocher soup

bowls, square plates for sashimi, as well as sharing plates with a blue pebble pattern against a background the same color as the other dishes.

"Out of all Seonsaengnim's work, this line goes particularly well with Japanese cuisine. You've got a good eye."

"They were all so beautiful I didn't know what to choose."

Seungho said he'd invite them all over to the restaurant once it opened later in the month and left the workshop. Johee pointed to the empty space on the display stand and thanked Jungmin over and over. Even Jungmin struggled to believe that her regular "Heart Series," which had begun with "the heart of gifting ceramics," had actually produced results.

Jungmin's takeaway coffees were already cold. Everyone gulped them down thirstily to calm their excitement, however, and so in the end they were appropriately tepid. There were three cups of coffee, but four people. The second unfamiliar man, who Jungmin hadn't yet been introduced to, sat nearby.

"Goodness, what am I doing?!"Johee exclaimed. "This is Souta—we went to graduate school together. He first came over from Japan as an exchange student, and he's now working as a designer for the Korean office of a home and lifestyle brand. Oh, and don't worry, he speaks Korean better than I do. Since I can't speak a word of Japanese, he got really good at Korean."

Finally, the identity of the man sitting awkwardly in his seat was revealed.

"Johee, I was wondering when you were going to introduce me."

"Sorry! Sorry! This is Jungmin-ssi. She's the person in charge of our Instagram, the one you were wondering so much about."

Souta greeted Jungmin—it seemed he and Jihye were already acquainted.

"We finally meet! I noticed the workshop Instagram has had a complete overhaul lately. The Johee I know could never manage the account like that, or write such heartwarming posts, either. When I asked, she told me that one of the members was helping her out. I was really curious about you."

First Seungho—now Souta was singing her praises, too. Consistently awkward when it came to receiving compliments, Jungmin squirmed and expressed her thanks over and over like a parrot.

"Thank you. Pleased to meet you, too."

There was something unique about Souta. He was Johee's peer, but when he smiled, there was a bright boyishness to him. He had what looked to be natural curls, which extended in all directions. But his hair didn't look the slightest bit messy. The brand he worked at had shops in almost every city in the world, and so Jungmin knew it well, too. Maybe that was why, but he had the aura of someone with remarkable taste. The fit and pin-tucks of his chestnut-colored chinos betrayed his eye for detail.

"I've been too busy with work to stop by. But when I saw on Instagram you were starting up the one-day classes again, I hotfooted it over."

"Did you wonder what'd come over me?"

Johee handed him a belated cup of coffee. He must have been parched, because he knocked it right back.

"I wasn't worried. I know how strong you are. I just came to congratulate you."

As the pair's conversation unfolded, Jungmin learned what

the old workshop—the one she'd never seen and would never get to see—had looked like.

Soyo Workshop had once been run by a husband-and-wife pair. On one side was the potter wife, and on the now-empty table the florist husband, Hosu, worked. Following the "ceramics &" on the sign, there had once been "flowers." The hordes of pots out front were made by Johee to house Hosu's plants. The couple could discuss nonstop the sequence of flowers and vases. Hosu would ask Johee to make whatever vases she liked. Johee, on the other hand, told him to tell her what vases he needed first. Hosu enjoyed arranging flowers after being inspired by Johee's vases. Johee liked making vases to suit his flower arrangements. Yet ceramics took a long time to create, whereas flowers wilted overnight. When it came to the pair's squabbling, it was always this difference in speed that raised Hosu's arm in victory.

The previous autumn, however, at around the same time Jungmin quit her job, Hosu was hit by a drunk driver.

Drunk driving. Those guilt-inducing words—Jungmin chewed them over and over. She was reminded why the "burr" was there in Chestnut Burr Village, her past like a thorn in her side. It was like the village was a scene from one of those romance comics, where the script always stayed the same, and only the characters' faces changed. She began to suspect that the characters and scenes had been set up just to drag her past out of the cave. The shadows of her past, now out in the open air, hung thick, and she'd never be able to move on to the next scene, no matter how hard she tried. *The past always repeats itself* anyway—*give me your best shot!* She wanted to shout the words at the top of her lungs, but she didn't feel she could say even this.

After that, Johee closed the workshop. She and Hosu had always gone to work together, and she couldn't face doing it alone. Whenever she was in the workshop, it felt as if Hosu might strike up a conversation at any moment from the table across the room. Telling her what flowers he'd bought at the market in the early hours, what style of arranging he was going for this time . . . Johee stayed at home. She became a recluse, fearful of the outside world. Inside her cave, she wrapped her arms around her sadness, and Souta was the only one who could reach her.

It was Souta who'd given Johee the dogs, too. An abandoned Pomeranian and a mixed breed were living at his office, and they needed adopting. Souta thrust the pooches into Johee's arms, under the ridiculous pretense of, "They look like you, you take them." All this was possible because it was Souta who'd set Johee and Hosu up to begin with, and he was also the same friend who'd helped with every minor detail of their lives—for the wedding right through to the funeral. Souta was a living witness of the love between the endearing potter wife and florist husband. In the end, thanks to his persistent efforts, Johee was able to slowly pick herself back up again and reopen the workshop.

When Johee returned, the members were there waiting for her. Gisik had come every weekend to clean so that it'd be ready for Johee to start work whenever she wanted. He took care of the clay and the kiln, and dusted off the pieces displayed on the shelves. Jihye came on weekdays and watered the plants. She didn't know how much or when she was supposed to water each one, though, and so they all eventually withered away, leaving only the cacti. Yeri fed Hoya, and made him a name tag, too.

Then, the first day the workshop reopened its doors, Jun arrived early and waited for Johee.

Beauty, sadness, and a little mystery. Like so, Soyo was a collection of mismatched items. Jungmin choked up a little as she watched Johee and Souta speak calmly on. The sadness of being left alone, having lost the person you loved most in the world—how could you put all that into words? Jungmin gave up on trying to measure the weight of such an emptiness, it couldn't be expressed in numbers, it wasn't visible, either. Fearing the outside world—that much she did understand. The hopeless and ardent desire to instead disconnect entirely, to live as a nonexistent person and gradually disappear from people's memories. Hearing Johee's story made Jungmin feel all the closer to her.

"MORE AND MORE people are signing up for one-day classes, so I think the time has come to start using that table. There won't be enough seats otherwise."

The wooden table had been a gift from Souta when the workshop first opened. Only one year earlier, Hosu had taught flower arranging there. Now, it was the only thing in the workshop Johee had to remember him by. The logo of Souta's company on the underside of the table had long since faded away.

"As long as you're okay. Otherwise there's a wooden table that's just come out in a new design, if you want? It'll be bigger than this one, too."

"No, I like this one best. Do you remember? How he and I both shouted out, 'That's the one!' at exactly the same time."

"Hosu was particularly fond of that table, wasn't he?"

Souta drank his coffee down to the last drop. His words were to the point and didn't show any sign of pity or sorrow. Johee and Souta talked of their memories so freely—in awe of their measured attitude and the endurance of their relationship, Jungmin cast her eyes over at the table once again. She felt her face flush a little as she remembered how, not long before, she'd interfered with the "table that must not be used."

The four joined forces, and once they'd shifted the hefty piece of furniture, the space looked so much better. Everyone caught their breath before going to sit down. It was Jungmin's first time sitting at this table—the experience felt unfamiliar, yet also strangely familiar, too. Souta struck up a conversation from the seat beside her.

"Did you use to work in marketing, Jungmin-ssi? Judging by the workshop Instagram, your skills are really something. Should I call them short stories, or flash fiction, maybe? That character, Yujeong, who appears in every post—it was as if I was right there watching her heal her heart as she makes pottery. Through the story I learn just how much care goes into each piece, which gives me the itch to buy. You really know what you're doing."

"I've actually never worked in marketing. I used to be a broadcast writer. And my major was Japanese—nothing to do with marketing. Maybe it's because my profession was all about writing to grab people's attention and draw them in, but I don't find managing the social media account all that difficult."

"Of course! There's an ex-broadcast writer in our company's marketing department, too. She's also brilliant at what she does.

A few days ago, the schedule for a collaboration we're doing with another brand got messed up and we had to do everything really last minute. While we were all there panicking and shouting, 'What do we do? What do we do?,' she held her composure from start to finish. She sorted everything out swiftly without anyone else's help, and so I asked what her secret was. Then she goes, whenever something like this happens, she remembers the time they lost the entire script at six in the morning, just an hour before broadcast. She called it the most terrifying day of her life."

Jungmin laughed. Every broadcast writer had been through something similar at least once in their career. And she'd had plenty of sunbaes who'd gone on to work in marketing or advertising. "It's nothing compared to the speed broadcasting moves at," they would often comment. Jungmin sighed and said what an exhausting job it was, at which Souta laughed heartily.

Jihye and Jungmin sat side by side at their wheels, while Souta browsed Johee's pieces. The workshop, once a jumble of guests, had regained its quiet trajectory once more. Johee responded to each and every one of Souta's pottery-related questions. As Jungmin observed the pair from behind, she could picture their faces from a decade or so before. Johee and Souta, sipping coffee just as they were today, strolling across campus in their clay-splattered work clothes. Back then, perhaps, Souta would've been a bit hesitant in his Korean, still using honorifics whenever he spoke with Johee. And then there would've been Hosu, always at their side.

Souta said he'd better head back to the office. On his way out, he mentioned that he'd have a couple of chairs delivered to match the table—it was clear how much he cared for Johee. Even

Johee, who would never accept such kindness from anyone else, nodded with ease at Souta's words.

BACK IN HER flat, Jungmin soon drifted off into a deep sleep. When a thick darkness had fallen, some time after midnight, she awoke with a start. The streets were clamorous; the blunt sounds emanating from the construction sites swamped the crickets' chirping. Lately, it wasn't only her reawakening—little by little, every alley in Chestnut Burr Village was changing. One by one, the commercial units with huge TO LET signs were being renovated. Owners of cafés, each individual in its own way, teamed up with young chefs to open restaurants, while antique furniture stores and showrooms for famous Korean designer brands opened for business, too. Word of mouth spread on social media about Chestnut Burr Village as a "weekend date spot in the suburbs." Soon the streets, once dominated by cats, were filled with fashionably dressed figures and young women in pointy heels. It was good to see the streets so animated, but Jungmin was concerned, too. What would become of the little fruit sandwich place, the ice cream parlor, and even Soyo Workshop?

Jungmin scratched Hoya's head as he snored softly between her legs. She was convinced that taking him in was the best thing she'd done all year. Otherwise, who knows, maybe Hoya would've lost his way in the construction sites or in between the legs of passersby and starved. The mosquitos were unrelenting, and the saucerlike full moon illuminated the night. One heart hidden away with nowhere to go, and another heart that would always be there waiting for it—from far in the distance, the moonlight set them aglow.

My Sad Legend

SHORTLY AFTER, JUNGMIN messaged Johee to let her know she'd be taking a week off from the workshop. Maybe it was the season—the one that could make even the most resilient individual feel alone—but out of nowhere, inertia had found her once more. Alongside the icy breeze, she felt her old symptoms, though not severe, rear their heads. Posting on the workshop Instagram felt impossible. She covered her bookcase with a blanket. Good thing she'd got rid of her TV a year before. If not, she might well have smashed it to pieces. Whenever she was alone, Jungmin grew hot-tempered. She looked up at the sky and let out her anger at a god she didn't believe in, as if everything she kept bottled up in public had come exploding out at once.

Johee replied to Jungmin's KakaoTalk message.

–No problem. It's freezing outside, make sure you keep
the heating on.

Stiff letters made of pixels, displayed inside a rectangular
glass screen—did they have the power to carry emotion, too?
Johee didn't try to force her way into others' space. Rather than
ask why they were feeling a certain way, she would hand them
a warm coffee and a sweet pastry so that they could speak it
freely themselves. Coffee seemed to possess special medicinal
properties. The moment it sloshed into someone's stomach,
their tongue would loosen. Once they drank the coffee, in a few
breaths the spitefulness would escape their body, and the person
would leave the workshop wearing an entirely different expres-
sion from when they'd walked in.

Jungmin was about to lock her phone screen when another
message from Johee arrived.

–Stop by, even if you don't come to work. I've got
something for you.

Jungmin had no choice but to drag herself out of bed.

A THUMB-SIZED ARTIST'S seal, stored inside a colorful bok-
jumeoni pouch. The seal was made from clay, too. It was to
mark the name of the maker. Johee said she'd stayed up all night
carving "珉"—the "min" from Jungmin—on the smooth square
surface the size of a fingernail. Jungmin recalled how a few
weeks earlier Johee had asked how to write her name in hanja.

Gifting her a seal had apparently been Souta's idea. They'd had several candidates in mind for how to thank her for managing the Instagram account. The first was a discount on class fees, the second was to give her an official part-time wage, and the third was the seal. Jungmin was glad they'd gone for the last option. She was already using the kiln for free, and she'd told Johee more than once that this was plenty. She hadn't done it wanting anything in return, either.

Though Jungmin was only stopping by, Johee still offered her something warm to drink. The softness of her heart almost dazzled Jungmin. She knew that if she opened her mouth, she might tear up, and so she delayed her reply for a moment. For a couple of beats, she left a blank in the conversation, before at last telling Johee not to worry.

Jungmin rolled some clay out round and thin, then pressed her seal into the slab. Once, twice . . . Soon the slab was packed with hanja. The outlines protruding from the clay were small, yet distinct. She couldn't believe this tiny symbol had stood up against 1,250 degrees.

Out of the three characters in her name, *min* was naturally her favorite. It came from the word *okdol*, meaning "jade stone." Whenever she thought of the word, rather than an expertly cut gemstone, she would imagine a pebble discarded beside a pond. A stone uncut, its origin impossible to determine. Someone with a sharp eye would scoop it up and turn it over to discover the green jade dotted sparsely across it. Wasn't a stone like this far more intriguing? When she pronounced the word, too, the vibrations of her vocal cords were just like a jade marble rolling across glass.

"What made you go for 'min'?"

"I thought the word 'okdol' described you well."

Jungmin carefully placed her one-of-a-kind seal inside the bokjumeoni. Whenever she wrote for her job, she'd never once felt it to be "self-expression." This was probably because she had to write purely for others; to write what the viewers wanted. The bodiless black type shrouding the white page wasn't enough to encapsulate Jungmin. Yet through pottery, she could express herself wholly. Thoughts and concerns, hand and heart, they all existed in the physical form of a plate. And then there was the seal, which would make Jungmin's mark on the world.

Jungmin placed the little bokjumeoni inside her cardigan pocket and ran her fingers along the notched surface of the seal over and over. Suddenly, she felt like writing again. She recalled the art exhibition that had first triggered her breakdown. Back then, all she could do was collapse in a heap on the floor and burst into tears. In front of her, out of the many, many women Chun Kyung-ja had painted, one smiled benevolently. If Jungmin looked at the painting before reading the description, she couldn't remember the painting. If she read the description before looking at the painting, she couldn't remember the description. She couldn't even grasp those brief few sentences. It was this fact—that she could no longer enjoy the simple act of understanding the composition of a painting and connecting the work to the life of the artist—that made Jungmin sink to the floor. But now, she wanted to return. That place was a thread connecting unrelated events. It was as if she'd been applying random strokes of all different colors, in pointillism technique, and now that she'd finished and taken ten paces back, a single,

peaceful scene had emerged. From time to time, through the emotion of one fateful moment, two seemingly unrelated events would connect. Cause and consequence fit hand in glove, making the next step possible. Like "seal" and "writing."

JUNGMIN RECEIVED A message from Gisik asking if she was off somewhere—she was skipping workshop, after all. Jungmin's reply was brief: "Seoul day trip." As if he'd been waiting for this moment, Gisik suggested they go together, and sent an emoticon of a cat stretching its paw high in the air. This was the same person who had a severe cat allergy.

Gisik had quit his job not long before, and had begun attending the workshop on the occasional weekday, too. Once he'd finished at Soyo for the morning, he went and waited in front of Jungmin's building. Through the window, Jungmin could see him loitering outside, and flew down the stairs two steps at a time. Once she reached the ground floor, she had to catch her breath to hide that she'd been in a hurry. Gisik, pleased to see her, waved his hand in the air. The pale band of skin on his left ring finger had quickly returned to its original shade. Jungmin could tell that the book was now fully closed on his long relationship. On his right thumb and index finger, however, there were huge plasters.

"Did you hurt yourself?"

"I held the knife wrong when I was working. The plaster is so ridiculously huge that it doesn't hurt much."

Jungmin had to drop a comment about Gisik's eye-closing habit. "Are you sure you weren't dozing off at work again?"

"That's to improve the sense of touch in my hands."

"What are you talking about? You'll end up seriously injuring yourself that way."

"I don't close my eyes when I'm on the sander, now do I?"

Jungmin couldn't help but chuckle at Gisik's jibe.

"Mind if we take the subway?"

"Works for me. I didn't bring the car today—I felt like walking, anyway."

Jungmin and Gisik entrusted their journey to Line 3, all the way to Gyeongbokgung station. They relished the rewards of the weekday afternoon subway, and hung their coats freely over the empty seats beside them.

Every autumn throughout her twenties, Jungmin had visited the Deoksugung Palace stone wall path and Seoul Museum of Art just beside it. It was an important annual ritual; a ceremony to mark the change of seasons. During that time, she'd often gone by herself, but sometimes with a friend or two. Through this, she'd learned that the Deoksugung scenery, which had felt cozy and familiar when she walked alone, became awkward and uncomfortable whenever she was with someone. She'd been in her late twenties. Without wallowing in self-pity, she accepted this part of herself—there were some people who were better suited to being alone, after all. Gisik tagging along hadn't been part of the plan. She wasn't fond of spontaneity, but when it came to him, she could hardly refuse. Jungmin knew well what this emotion was, and what name she should call it by, but she did her utmost to avoid doing so.

A three-hour round trip, with three hours of sightseeing and

walking. The year before, Jungmin didn't make this brief outing of no more than six hours in total. Last year was deleted time. She hadn't wondered about the outside world, and there'd been no need to keep any promises to herself. Because of that, this year's journey, performing her personal ceremony, felt quite solemn. Despite her unexpected companion.

"The weather's gorgeous, why the umbrella?"

The sky was so clear, it might as well have stolen the color from the ocean, but Gisik had still brought a folding umbrella with him.

"Apparently it's going to rain this evening. It's not strange for autumn rain to appear out of nowhere, after all. And that means carrying an umbrella isn't strange, either."

Jungmin tilted her head. Had rain been forecast?

In fact, there was a 20 percent chance of precipitation. The reason Gisik had brought his umbrella anyway was because he wanted his day with Jungmin to be perfect. If, just to poke fun at those ambling the streets, an unseasonal rain were to fall, the pair would only need to unfold the umbrella and stroll silently on.

GISIK, HAVING PAID close attention to each and every painting, stroked his chin. "This is my first time seeing Chun Kyung-ja's works. They're so profound."

"They're difficult, aren't they? I wish I could act as if I know, but I don't have a clue. I just like them."

"What first made you like her paintings?"

Jungmin pointed to the text introducing the opening section of the exhibition, written in large type on the wall.

"Because of this."

Embedded here and there across my entire body, it seems, is the deep sorrow of a femme fatale, something that I cannot deny.

No matter how I squirm and writhe, my sad legend is not erased.

–Chun Kyung-ja, self-portrait,
The 22nd Page of My Sad Legend, 1977

"My sad legend . . ."

"We all have our own sad legend. When I read these words and look at the paintings, I can empathize with all the women depicted. I take my time to examine the portraits as I imagine the legends that the women carry."

It was a weekday afternoon, and there weren't even ten visitors to the permanent exhibition. As she looked at the paintings, Jungmin told Gisik of her own sad legend, the one about her father. How she'd made herself the villain and then punished herself for it. She spoke in hushed tones, so that no one but he could hear.

Gisik pondered what his own story—one of a similar weight—might be. Three spoonfuls of loss, two of guilt, a pinch of hopelessness, and then half a cup of inevitable exasperation. The more you mixed and the more you chewed, the more bitter the taste became. He had a story like this.

Gisik and his younger brother had been living in Goseong with their grandfather. He had congenital cataracts and lost his vision before ever seeing his own grandsons' faces. It was his

birthday, and as a gift, Gisik's parents changed all the lights. He couldn't understand why, when his grandfather couldn't see. Instead of the old fluorescent lamps caked with dead insects, brand new LED lighting illuminated the living room. The relatives each handed their presents over one by one, but in an instant, the mood shifted. Whenever they all gathered in one place, fights were guaranteed to break out. The price of care, who should pay how much, who was better performing their filial obligations . . . Grown-up legs paced back and forth over the heads of the young siblings, who lay in a huddle on the floor of the tiny living room.

"If you're going to fight, at least don't step on the kids." Restless, Gisik's grandfather tried his best to stop his children, but he was staring into empty space.

The adults were acting like his grandfather wasn't even there, and so Gisik suggested they go out for a walk. Once they'd reached the foot of the mountain trail, his grandfather let go of his hand. There was somewhere he needed to go alone, he said. This was the first time Gisik had heard his grandfather say he wanted to go anywhere—he'd never even been able to so much as leave the house by himself. Gisik couldn't stop his grandfather, who shook his hand free. That day, his grandfather's strides were loping, his footsteps swift. That was how he disappeared, and it was a few years later that his death was officially declared.

Once Gisik had started to forget his grandfather's face, his dad lost an eye in an interior decorating accident. It didn't seem like a coincidence. It was fate. If his left eye went, too, would

Gisik's turn be next? Surely it wasn't long before he'd be punished for letting go of his grandfather's hand.

GISIK HAD CHEWED up and spat out this story so many times that it was nothing but a sticky mass. But each time he regurgitated it, it was difficult to know where to stop. . . . Gisik's legend was still in progress.

"Every day I reflect on the fact I could lose my sight at any time—that in a single moment, my world could shift to black. I get regular checkups, of course, and apparently there're no problems so far. But I'm a coward and live my life in constant fear. It's easier for me that way. Burying my head in the sand makes me more anxious, and I get fed up with acting like I don't care."

That was why, Gisik said, he'd started pottery—to improve his sense of touch. Pottery would train his hands, which would become his guide later on if he lost his sight. He would make sure they were always ready to step in for his eyes.

Jungmin inspected Gisik's extraordinarily bright brown irises. At the thought that such eyes could end up seeing only darkness, she felt a tightness in her chest.

"I did notice you close your eyes a lot when you do pottery."

Gisik glanced askew at Jungmin and teased, "Oh? Looks like someone's been stealing glances at me?"

". . . I was just observing how the professionals do it. Stealing glances? Ha . . ."

Speaking with Jungmin like this, Gisik felt he'd finally found another reason why he wanted to return to Goseong. Whenever he was with her, he would discover thoughts and feelings he

never knew were there. It didn't feel overbearing or stressful, but soft, like the blanket his grandfather would lay over him on cold winter days.

THEY LEFT THE museum, and as they strolled through Deoksugung, they would repeatedly stop and start. After a lap around the palace grounds, they enjoyed an amble through the gardens, the length of their strides altering with every step. Deoksugung was big, yet small, and though for a time everything in the palace could be seen all at once, after sunset the grounds transformed into an extensive landscape impossible to contain in a single glance. The scenes before Jungmin shifted moment to moment, and each time she would halt her step and gaze off into the distance. When they sat down on a bench and waited for the sun to vanish completely from view, she suddenly erupted into tears. Like a frozen water pipe when it bursts, the tears wouldn't stop flowing. Tears she'd bottled up and up for an entire year.

Gisik patted Jungmin's little shoulders. She began to howl. After such a long time, it didn't feel all that bad to cry. It was refreshing, as if the stagnant water had gushed out, and clear water was flowing back in.

"When I looked at the paintings and read the descriptions today, I was totally fine."

"Wait, you were crying because you were happy?"

Instead of responding, Jungmin smiled brightly through her tear-stained face.

"How can I look such a mess when I'm crying happy tears . . . It's not fair."

Today, Jungmin had thought nothing of looking at the paintings and reading the words. Before, she'd simply been afraid. If her writer's block were to go away, she believed, she'd have to return to the office. Though she'd feared her mind not working as it should, she'd been even more afraid of it going back to normal. Being unwell was like being given a license to rest a little longer. Now, however, Jungmin required no permission for a "pause." It was her decision how long she would rest for and when she would get back up on her feet again. Perhaps it was only when a person became able to choose to take time off and set their own pace that they'd truly grown up.

"I'm hungry."

"Sorry?"

"Now I've cried it all out, I'm finally hungry."

"I'll take you somewhere good. Despite how I might appear, I've lived in Seoul ten years now."

Gisik pulled his shoulders right back as he spoke, but there was no two ways about it—he had the looks of a country boy. Jungmin resisted the urge to give him a good mocking.

"Listen here, I'll have you know I'm a Seoul native myself. But first, I'd like to hear what's on the menu."

"The flavors of a place where the sun shines all year round."

"Guess I'll just have to trust you."

They left and headed up toward the Sogyeok-dong area. The weather had remained lovely right through to the evening. Still no sign of rain, either. The sun, clinging on to summer, was setting extra slowly—perhaps that was why, but it felt like night would never come.

Once they arrived, Gisik boasted of just how popular the

restaurant was. It specialized in Southeast Asian food. Jungmin snorted. "We featured this place on our show way back." Gisik, who'd wanted to take her somewhere new, couldn't shake his disappointment.

"But I never ate here. We just filmed."

"How can you write so many fancy words about flavors you've never experienced?"

Jungmin shrugged off his comment. "That's generally how it is. You're so rushed off your feet, there's not exactly time to go and have a tasting menu and rate everything you eat."

"If I was the producer, I would've ordered the food for you to take away. To help you write something even better."

In an attempt to conceal her reddened cheeks, Jungmin began burying her face in the bowl as she ate. Maybe if her producer had been like Gisik, she never would've quit at all. Seemingly oblivious to how Jungmin was feeling, Gisik beamed and said how pleased he was to see her enjoying her food so much.

JUNGMIN HAD PARTED ways with Gisik and was heading back to Ilsan when without thinking she jumped on the train that'd just pulled up at the station, but turned out it terminated before her stop—yet even this couldn't ruin her mood. When she hurried to find a seat and sat on the clothes of the man next to her, he simply pulled a generous smile. That day, she felt generosity all around her. Once she caught her breath, she didn't put on any music, instead allowing the sounds peculiar to today's subway to resonate in her ears.

Direction

Jun Takes His Own Path

THE SUNEUNG, THE university entrance exam, was over for Jun, and a bitter chill had set in. In this weather, the workshop doors had to remain permanently shut. People walked the streets oozing hot fogs of breath, and pushed open Soyo's doors with reddened hands.

Other than the scarf round his neck, Jun wore nothing over his flimsy blazer. Starting with Johee, everyone—Jihye, Gisik, and even Jungmin, too—took turns to nag him affectionately about his attire. With the Suneung exam now behind him, Jun seemed to have loosened up a little, and mumbled something about having overslept.

Practical exams for art schools would kick off in January. The pottery and craft courses Jun was applying to didn't judge candidates based on their clay modeling, but on their drawing skills, just like other Fine Art departments. In preparation, Jun was

also attending after-school classes at an art hagwon, meaning there was no need for him to continue coming to the workshop. His parents' pestering, however, left him no choice. Jun's parents were both designers for a luxury ceramics brand; a prominent husband-and-wife potter pair, both active, proud ceramists, and they naturally wanted their first son to follow in their footsteps. So once Jun was in high school, they started teaching him pottery themselves, even though the entrance exams didn't require it. According to them, he needed to get a head start over the other students before he went to university. Parents teaching their own children was always a recipe for disaster, though, so they sent Jun to Soyo and entrusted him to Johee instead.

When the entrance exams had still felt like something of the distant future, Jun used to like pottery. He felt he had a natural talent for it. He was proud of his parents, and took it for granted that he would follow their same path. Everything changed, however, once he passed through puberty and started attending art hagwon. He learned to sketch and color and felt so much more freedom in painting than pottery. Jun was enthralled by the idea that you could create a whole new world on a single sheet of drawing paper. He was most captivated by the watery black ink's delicate lines and spread, and his eyes opened to the world of East Asian painting. Yet he couldn't bring himself to admit to his parents that he wanted to paint. Diverging from the path they'd laid out so carefully for him was not an option.

When Jun confessed his frustration to Johee and told her that he wanted to study East Asian painting, she handed him some colors and said he could use them on his plates. Despite her kind

offer, he flatly refused. His favorite thing was to paint on paper. Doing it on pottery was a compromise he couldn't accept. In his heart, paintings shone brightest just as they were.

Jun unwound his scarf and went to cut a slab from the pillar of buncheong clay. Another day of filling time before his hagwon class. He was being forced to do something he didn't want to—it was like chewing on a rubbery stick of gum that'd lost all its sweetness. Jun pierced his fingers right through the innocent clay. The smell had been the same ever since he was a kid; he was sick and tired of it.

JOHEE, GRINNING EAR to ear, instructed everyone to pay attention. A bowl, of a design the likes Jun had never seen before, was balanced on her palms.

"This is the nacho bowl Jungmin-ssi handbuilt today. What a cheeky design, am I right?"

It was a little bigger than a rice bowl, and also had a handle, which didn't suit its hefty body at all. Attached to its side was something that resembled a small soy sauce dish, in the shape of a waning moon. Exactly the kind of thing that'd end up gathering dust in someone's kitchen. Most concerning was that, once the piece was in the kiln, there was a high risk that a crack would form in the join. And a nacho bowl? Heavy ceramics weren't appropriate for serving snacks.

Jungmin introduced her creation. "The main section is for nachos, and you can put cheese sauce in this little dish here. You don't need to serve the sauce out separately on the table, so you can eat it in bed, too. And you won't spill crumbs when you

dip the nachos, either. You can also use it for ramyun, and serve kimchi in the smaller section. A bowl that does everything! What do you think?"

It had been an ambitious project for Jungmin, and despite the zeal of her explanation, the response from the other members was lukewarm.

"How about this then?"

What Jungmin held out next looked like a stumpy wine glass.

Hoping to come to her aid, Gisik jumped in. "Oh, is it an egg cup? You put a boiled egg in there and sprinkle some sal—"

"No . . . How could someone about to open his own trendy workshop not know what a yogurt bowl is? This design has been everywhere lately . . ."

At Jungmin's long face, Gisik tried his hardest to reassure her. Jihye and Johee widened their eyes. Ever since Jungmin had taken a break from the workshop the week before, she and Gisik had seemed a lot closer. There wasn't even a hint of awkwardness when they were together. Jihye and Johee smiled and nodded at one another. The same thought entered their minds. *Those two look so good together.*

Despite Gisik's best efforts, Jungmin's confidence had taken a knock, and so everyone picked out the strong points to compliment her with. Jun was the only one to find fault: she hadn't removed any clay from inside the stem and so it'd be way too heavy.

Whenever Jun saw people come here in the innocent desire to play with the clay, part of him was uneasy. He was worried

they'd notice how he really felt about pottery. And that was why the spiteful words—a false reflection of his true thoughts—came out.

FOLLOWING JUN'S CRITIQUE, Jungmin picked up a tool and went to sit beside him. She was going to thin down the bowl and reduce its weight. In Jungmin's eyes, Jun's natural artistic sensibility meant that any advice from him would be of help.

"Won't this be a bit light?"

"Don't ask me every single thing. The design was no good to begin with."

"I made the bowl because I need and want it, so I don't care about the design. It's just fun. Don't you think?"

"Is fun all that matters?"

Like a scared turtle, Jungmin shrunk her neck and spun forward on her seat. He was a high school senior preparing for the entrance exams—she'd expected him to be sensitive, but not *this* sensitive. Jihye, a spectator to their disharmonious conversation, butted in.

"Jun, you'd better hurry up and finish your exams, then you can come to the workshop without any pressure."

"That won't happen. After today, I'm not coming anymore."

Everyone had guessed it wouldn't be long before Jun quit. However, hearing it from his own mouth triggered an unavoidable wave of disappointment. It was Yeri who first came to Jungmin's mind. She'd be devastated when she found out.

"You're taking a break?" Jihye asked, her voice soft.

"No. I messed up the Suneung, so I need to do well at the practical exam. I'll be full-time at the art hagwon from now on, even on weekends. I got my parents' permission, too."

"I see. That's a real shame. Make sure to stop by once the exams are over, okay?"

Jun nodded, even though he was convinced that, after this was all over, he would never set foot in the workshop again. It'd been his parents' decision for him to come, not his. By agreeing, he'd created a buffer to keep the peace while he was applying to university. But he hadn't been his usual self lately, and the clay kept distorting in an unattractive manner, honestly revealing what was in Jun's heart.

LUNCH ON JUN'S last day was sushi and warming udon. Originally, the plan had been to eat at Seungho's restaurant, but the dining area was already packed with people, and there was a waiting list, too. Given it was a Saturday, people had come all the way from Seoul and Paju to visit Chestnut Burr Village. Everyone was dressed up, and they sat in twos, threes, or fours and ordered from the fixed menus for couples or families. The five members in their grubby clay-stained black T-shirts stuck out like a sore thumb. Jungmin smiled weakly at the image of her and the other members—they looked just like gate-crashers.

In the end, they took the sushi to go, and ate in the workshop like always. Jungmin was really disappointed—she'd not only wanted to use the opportunity to cheer Jun on, but it was a chance for them to have a meal out all together for once. Eating in peace and quiet in the workshop wasn't all that bad, though.

Once they'd served out the sushi onto the same plates Seungho had bought, it was no different from eating in the restaurant. Ceramic dishes really did make those sitting at the table feel like they were being "treated." The plates Seungho had chosen were a great match for Japanese cuisine, and they made the food look even more appetizing. The udon—Seungho had felt bad and thrown it in on the house—tasted even better than expected, too. The chewy noodles and the clear seafood stock were top-notch, with plentiful shrimp balls and fish cakes. As Jungmin's stomach warmed, the lingering cold on her fingertips became tepid, aligning with her body temperature. She swallowed the udon broth right down to the last drop.

Once the sushi had disappeared piece by piece from the plates, Jihye cleared her throat—she had an important announcement to make.

"So . . . I've been accepted onto the KOICA volunteer program! I'll be heading to Bangladesh next month, so I guess this'll be my last day at the workshop. I'll be there for a year. I'll try to extend if I can, too."

No one had seen it coming. Even so, everyone applauded, and congratulated her from the bottom of their hearts. Then followed the question, "Why didn't you tell us earlier?" Ready to throw on his coat and dash out, Gisik asked, "Should I go get a cake?" but Johee waved her hand. She opened the fridge and brought out a pound cake. She'd made it the day before, after Jihye had come clean to her. And besides, she'd been planning to bake one to cheer Jun on for his practical exams, anyway.

Jun seemed reluctant but got up and blew out the

candles alongside Jihye regardless. Unlike Jun, who immediately returned to his seat, Jihye made a silent wish. Perhaps she had a lot to wish for, but she kept her hands clasped together for quite a while. Johee served up the cake slice by slice and handed out coffee and tea according to each person's tastes. The pound cake had matured in the fridge for a day, intensifying the flavor. Set against the icy wind outside, being inside the workshop felt all the cozier. The sweet dessert aroma seemed to have its own color. It lingered around the members, filling the warm air with yellow and orange hues.

"I'd no idea you were interested in volunteering," Jungmin remarked, in awe of Jihye's choice.

"It might seem like a snap decision, but I've actually wanted to volunteer ever since I was young. Much like everyone else, though, getting a job was my priority. I kept telling myself that as soon as I got a job, I'd volunteer every weekend. . . . But they were just empty words. I gradually started to have doubts about this order of doing things. If there's something you want to do, why can't you just go ahead and do it? Once I started to think that way, it wasn't long before I ended up applying to KOICA. I'd never gone beyond browsing the postings—this was the first time I actually applied—and I just felt, whatever happens, happens."

All the foreign language qualifications she'd acquired while applying for jobs, Jihye added, had helped, too.

Jungmin nodded. "When a good opportunity comes along, it's the ones who're prepared who take it, right? It'll be a shame

not to see you for a whole year, but I'll be cheering you on from afar."

Jun, who was munching his cake in silence, remembered what Jihye had said to him that morning. She'd told him to stop by the workshop once his exams were over. By the time his exams were over, Jihye wouldn't even be in the country. *Pfft. She won't even be at the workshop herself.*

Jun had been quiet for a while now—Jihye, who seemed to have been monitoring his mood, slapped him on the shoulder.

"Jun, you know I really am rooting for you, right? I wanted us to all go out for a meal once your exams were over, but . . ."

"I'm not bothered."

"Blasé as always, I see. I won't get to see you at the end, but I know you're going to smash it."

Jun wasn't used to people genuinely cheering him on. He tore at the cake with his fork while he contemplated his response.

"But didn't you study chemistry, noona?" Jun asked.

"My parents said it'd be easy to get a job if I studied science, so I chose it on a whim. I was actually always interested in teaching Korean."

"Weren't your parents . . . disappointed?"

"This choice has disappointed a lot of people, not just my parents. But on the other hand, this is the first time I'm not disappointed in myself because of a choice I've made."

"I want to make my own choices, too. Whatever happens."

Jun's gaze dropped further and further toward the floor.

"Do you know what I realized about all that time I was lost,

dragging out my studies for so much longer than everyone else? That it isn't a single choice that determines our path. What you study at university now, at such a young age, won't seal your fate. It might actually turn out to be the starting point, opening up all sorts of possibilities. You'll make plenty of choices in your life. So don't be too hasty to judge the decisions you make now. Keep going, and a way will open up for you. Meanwhile, don't be afraid of disappointing anyone, and be bold when you change direction. In my experience . . . perhaps the sooner you disappoint your parents, the better."

Jun was taken aback—Jihye had seen right into his heart. She was at the workshop almost every day, after all, and she'd surely noticed the look on his face as he worked.

Gisik topped up Jun's empty cup with tea and tried his best to lift his spirits. "I studied urban engineering and I've been working at a teleshopping company. Next year I'm going to open my own pottery studio. Jungmin noona studied Japanese and then became a broadcast writer. Just because I work in a field unrelated to my major, does that mean the decision I made when I was nineteen was wrong? Of course not. It was that decision that made me who I am today. So no matter whose decision it is, go with the flow. Only then will you master how to row the boat."

It was strangely encouraging to hear that people with far more life experience hadn't always made the best decisions. Within their words—though it was yet to sink in—Jun had found a thread, one he'd lost sight of while he was so focused on the entrance exams. It was as if a pesky grain clogging the sand timer's neck had slid right through.

As Jun left the workshop to go to his hagwon class, he remembered how thoughtlessly he'd thrown together his outfit that morning. Though the snow was yet to fall, it was midwinter. A scarf was all he had to shield himself against the wind. Once he'd thrown off his sense of urgency, he only had himself to blame for stepping out coatless. Jun stood before the mirror outside the workshop and wrapped the scarf round and round his neck. Seeing this, Gisik dashed outside.

"Here, wear this. I had a spare in my car."

Gisik handed Jun a white fleece. It swamped Jun's small frame, but he no longer feared heading out into the streets as the biting gusts blew.

"Thank you."

Jun half-heartedly tugged the zip as far as his chest. Gisik came over and pulled it all the way up to his neck. "Want to know the secret of how I got into a good university?"

"How?"

"Staying healthy, staying healthy, and guess what, staying healthy!"

Though it seemed like the exams would never be over, Jun knew there was a light at the end of the tunnel. The workshop members all came out to see him off. Each one was smiling, and it seemed genuine, even. This was their act of consideration— not to pull a grave face in front of Jun, the one shouldering the biggest burden of them all.

"See you later," he said—a promise he'd be unlikely to keep— and turned around. Jihye definitely wouldn't see him later, however. Instead, Jun had bid her safe travels. Jihye had come to

the workshop almost every day—weekdays, weekends—and it wouldn't be the same once she was gone. Soyo's heat wrapped itself round Jun's body and protected him from the cold as he walked. Once he'd reached the bus stop, he turned back around. The workshop was still where it always had been, and held firm even against the icy wind, as if it'd be there forever. Soyo would gladly become a signpost: one to guide people along the alleyways of Chestnut Burr Village.

Jihye's New Start

WELL AWARE SHE wouldn't be able to fire the pieces, Jihye worked at the wheel right up until she left. Johee promised she'd finish off the cups and plates on her behalf. The two locked little fingers, and Jihye imagined herself in one, two years' time. Would she still enjoy cooking? Would she have lost weight? Would she have returned to Korea and got a job? Would she and that friend still be friends? No matter what, she hoped to have matured a little by the time that first digit of her age changed to "3." Her twenties had felt so long.

Jihye had dinner plans with Hyoseok. First to arrive at the izakaya restaurant, she was restless as she waited at their table. Telling him she was leaving wouldn't be easy. She was worried that—having failed to get a job—it'd look like she was simply running away. Being Hyoseok, there was no doubt he'd be happy for her, but she still lacked confidence. Only a little while earlier, she'd been dishing out advice to Jun as if she'd discovered the

true meaning of life, yet she still kept questioning whether she'd made the right decision.

Hyoseok soon came bounding in and perched on the seat beside her. Jihye was relieved to be at the bar, where they didn't have to sit face to face.

Once the appetizers came out, she broke the news.

"Han Jihye, huge congrats! I know we go way back, so it's not news to me, but you really are something . . ." Hyoseok stopped what he was saying and raised his glass.

"Did you tell the others?"

"No, not yet. I was thinking of maybe not telling them."

Not reading the situation, Hyoseok responded in jest. "Why not? We need to throw you a farewell party. There wasn't a single guy at our middle school who didn't have a thing for you. They'll be distraught when they find out their first love is leaving . . ."

"'First love?' Give me a break. Those good times are all in the past, and if I go to a reunion now, I'll be the number one topic of conversation for sure—but for different reasons."

Ever since Jihye had put on weight, at each reunion she was subjected to the comment, "I see someone's been enjoying themselves?" After that, she'd avoided the gatherings altogether. She couldn't be bothered to explain that she hadn't got heavier because she was enjoying herself, and she hated above all else being referred to as "the definition of going downhill" and "the girl we used to like back then."

"But you asked me out, too, and I turned you down. What was it you said when you gave me the cinema tickets?"

Hyoseok cleared his throat. "Ugh, can you erase that memory, please?"

Jihye lost herself in thought for a moment. She took a gulp of beer before continuing. "There's something I want to tell you. But if I tell you, I'm worried you'll start to doubt our friendship."

"Hey, like that could ever happen between us. It can't be that bad, whatever it is."

"It was back when you got into university and I didn't. We'd always traveled to school together—it was the first time we were apart, and our day-to-day lives changed. I followed the schedule set out by the retakers' hagwon, while you set a schedule of your own. I think that was when things started to go wrong for me."

Until her twenties, Jihye had never really experienced jealousy. And even when she did, the emotion was always fleeting—when things went well for her friends, she was genuinely happy for them. She never intentionally lined her life up against others. But then she didn't get into university. Hyoseok, whose grades were lower than hers, had breezed in. On Jihye's second attempt, she failed to make her top choice, only making her second. From then on, she was plagued by an inferiority complex, comparing every aspect of herself to other people. To make up for lost time, she signed up for classes during the holidays and tried to bring forward her graduation. Her grades needed to be better than everyone else's, too. Perhaps she'd set her sights too high, or perhaps she was out of her depth, but she got rejected for every job she applied for. For months, she hopped between internships. Not one thing—whether it was the entrance exam or applying

for jobs—had gone right for her, and she was forever consumed by the sense that she was the only one falling behind.

Soon, Jihye became the longest-standing member of the university study group for public-enterprise job seekers. Things had been getting desperate, when she and one of her hoobaes from the study group both made it to the third-round interview for the same job. But her hoobae's appendix burst and she never made it to the interview. When Jihye heard the news, her heart went out to her, and she sent her hoobae a reassuring message. As she locked her phone, however, in the black screen, a faint smirk hung across her face. She doubted whether the devious individual in the glass was really her. It was devastating to learn how petty she could be. And after all that, she was turned down for the position. She gave up on job hunting, running off to graduate school instead.

"The unhappiness of others was my happiness. And my unhappiness was so painful, too. I hated myself so much it was unbearable."

"Everyone gets a bit desperate when it comes to job hunting. It's only natural to feel that way."

Despite Hyoseok's encouragement, Jihye still despised her former self. Everyone was desperate—even more reason *not* to be that way. And, childish as it was, she had envied him, too.

"When you got into university, and when you got a job as well, I wasn't happy for you—not genuinely."

While Jihye had reached the depths of her despair, Hyoseok completed his military service and returned to university. He

found a job before he even graduated. Jihye had sent him her congratulations, but how she felt inside was different.

"I get it. When the others in my year went around boasting about how they'd found jobs, I felt like whacking them. I even threatened to do exactly that and almost got into a fight. You're nothing compared to that."

"That wasn't all. I secretly looked down on you for not getting a better job. . . . You'd always been so lucky that I thought you'd find something a cut above."

Hyoseok paused to order some skewers.

"You think the only choices in life are Suneung electives and public enterprise streams, don't you? Happiness is a choice, too. You could find happiness right now if you wanted. Here, some good food will improve your mood right away."

He placed the mouthwatering skewers—one chicken wing, one heart—on Jihye's plate.

"Isn't that just how losers try to make themselves feel better?" Jihye remarked, her tone one of self-mocking.

"Make themselves feel better? Just look at me. So that I could be happy right where I am, I decided to do things 'in moderation.' So that I can look after myself and those I care about, I work at a moderately busy workplace, earn a moderate wage, have fun in moderation. . . . People look at me and say I lack ambition. But isn't 'moderation' the greatest ambition we can have? I'm being really ambitious in trying to stay happy and within the lines of moderation. It's about choice."

"I have no option to be happy. I hit rock bottom long ago. I can't be happy where I am, like you."

Jihye recalled all those nights she'd chosen to make the most complex, time-consuming recipes, just so she could avoid writing job applications. She wasn't happy, and couldn't be happy. Happiness had escaped her. That was why she'd selected the country with the earliest departure date.

"What do you mean? You have so many options right in front of you."

"Is there really happiness right where I am?"

Jihye turned to stare at Hyoseok.

"Looking at you now . . . Nothing I say will be of any use. I reckon you'll find out once you come back to Korea."

"What if I still don't know then?"

"I'll tell you, don't worry. And while you're gone, I'll take care of the happiness that's where you are right now."

Jihye gazed at Hyoseok. Bashful, he rubbed at the nape of his neck.

"I'm so glad to have a friend like you, Hyoseok."

It was always weird to say such things between friends. Feeling the awkwardness, Jihye glugged down her beer. Hyoseok followed suit and poured the remainder of his glass down his throat, too. The pair contorted their faces in unison and belched. They left a pause, before bursting out into laughter and ordering more beers. "Excuse me, can we get a top-up?"

Emerging from the Cave

JIHYE LEFT THE country at the beginning of December. Jun didn't visit the workshop after that. Everyone had expected as much, but now that he wasn't there, they missed his look of utter disinterest and his stiff manner of speaking. And in no time, there were new members occupying the spaces where Jun and Jihye used to set up their wheels.

A number of women a little older than Johee had signed up to the workshop. They generally belonged to one of two groups. The first came to let off steam. Once their husbands left for work in the morning and they'd sent the kids off to school for the day, they had the afternoons to themselves. Through the clay, they could release their pent-up energy. Wedging the clay until their shoulders went numb felt like a more productive use of time than café-hopping with the other mums. They were making the

most of their youth, and so they enjoyed activities like pottery. What's more, here they weren't addressed as "so-and-so's mum," but "so-and-so-ssi."

The second group came for an energy boost. Office workers would arrive, exhaustion plastered across their faces, and by the time they thrust open the door to leave again, they'd forgotten all about having to return to work in the morning. Their voices grew shrill with the gratification of finding a new hobby and the yearning for a challenge, but Jungmin believed that Johee's coffee and baked goods played a big role, too.

Today was the weekend, however, and when lunchtime came around, they all left to spend time with family and friends. Today, again, Johee and Jungmin were the only ones without plans.

"Guess it's just us. Anyway, I'm glad you're here, Jungmin-ssi. My Saturday lunchtime would've been lonely otherwise."

"Don't mention it. I would've been at home all weekend if it wasn't for you, Seonsaengnim."

On the menu today was ramen. The previous summer, their lunch options had been limited, but in a matter of months, all sorts of restaurants had popped up. Johee and the members had fun trying out all the new places. Of course, when it was just the two of them like today, they felt the absence of those who weren't there, but it felt cozy, too. Jungmin peeled open the lid of her takeout ramen and when she stood up to get something, she almost tumbled over. She'd lost all feeling in her legs. Concerned the clay might dry too quickly, they'd moved the heater, and her legs had gone numb as a result.

"I think you might be our workshop's savior, Jungmin-ssi.

When you first came, it was the same week I ended my life as a recluse and started going out again."

Jungmin, too, remembered that day vividly. She'd left the house for the first time in months, wanting to escape life as a nonexistent person. Perhaps the rays of the summer sun had whispered something to the two of them? People with entirely separate lives had left their homes at a similar time. The two lines, at first nonintersecting, had curved toward one another and made a couple of points of contact. It wasn't clear whether their paths were always fated to cross, or whether an amalgamation of choices had led them here. But it was a good thing, regardless. Most important was that the lines continued to form connections. Lines that were once stationary rode the wave of fate—or of choice—and pressed on ahead. Johee screwed her eyes shut, as if sensing the motion of this great wave, before opening them once more.

"As I watched you drinking your coffee, I wondered whether you and I were alike. People who clasp their coffee cups with such care are usually hiding a story somewhere deep within their hearts. And so before I knew it, I'd suggested you try pottery. Being confronted with death made me fear people. Only five minutes before, I'd been saying to Jihye that I didn't want to take on any new members for a while. . . . The fact that I'd say such a thing when we'd only just met—it made me laugh. No, I was intrigued. But ever since you took over the social media account, the atmosphere in the workshop has changed. New people have started coming, and lots also came back after a long break, wanting to remind themselves of forgotten memories."

Jungmin had also felt a mysterious pull when she first saw

Johee. *Why not fire one yourself?* Was that what she'd asked? That day, the word "fire" had rung pleasantly in Jungmin's ear.

"I'd never thought of doing pottery before, but I really changed because of it. There were plenty of moments that moved my heart, but if I had to choose the most memorable, it'd be a conversation I had with you, seonsaengnim. I think it was when we were handbuilding together, before I'd begun throwing. I'd used way too much water, and so my clay was sopping wet. But then you told me to wipe away its tears. It was just a passing comment, but those words really got to me. Caressing, touching, wiping away tears . . . As I wedged the clay, it felt as if I was embracing myself."

Jungmin twirled the remaining noodles with her chopsticks as she ruminated. When life got tough, people made it through by leaning on old memories; Jungmin, however, had often worried that she didn't have a single one. Finally, through her time at Soyo, she'd gained a memory of her own, ready for her to open up one day when the exhaustion got too much.

"Firing pottery is like lighting a fire in your heart. There might be something inside that you're trying your best to ignore, but it's only by turning your gaze toward it that you can see it clearly."

It wasn't the ramen broth—Jungmin could tell—but Johee's words that were warming her heart. The heat spread fast, right down to the frozen tips of her toes.

"'Firing pottery is like lighting a fire in your heart.' I can't explain it, but the words are so lovely."

"Sometimes it's the things we can't explain that leave the most distinct echoes."

Shooting stars and auroras—things people come to love without the need to interrogate what makes them beautiful. Their beauty requires no explanation.

"Johee seonsaengnim, sometimes I find myself worrying that I smiled less than I did yesterday. I think I've started to get greedy."

"Be even greedier if you want. Happiness is enjoyed by the ones who've already experienced it. So make the most of it. The more you train yourself to notice your happiness, the more it becomes yours."

Even if she hadn't been born happy enough or loveable enough, she could make up for it instead. Here, eating lunch with this person she was so fond of, Jungmin chose to believe this.

IT WAS SATURDAY evening, and Hyoseok turned up at the workshop before the adult education class began. Without even putting down his bag, he passed on what the members' ears were burning to hear: news of Jihye.

"I saw her safely off at the airport. She said to make sure to let you all know, too."

Johee and Jungmin felt a little emotional.

"It's laudable what she's doing, but I'm also concerned. We'll be able to get in touch, won't we?" Johee asked, warily.

"Of course. We live in the twenty-first century, after all! We have a video call right at our fingertips!"

Hyoseok shrugged his shoulders in an exaggerated manner.

"How come it's just the two of you? Oh, Gisik hyung is leaving soon, right?"

Hyoseok turned to look at Jungmin. At some point, people had naturally begun to direct any questions about Gisik to her.

"Sorry? Oh, yes, Gisik-ssi is leaving soon. He quit his job and I think he's just about ready to leave his place in Seoul."

"Gisik-ssi . . . ? Do you two still use honorifics with each other?"

"Uh . . . Yes, we do."

"Really . . . ? I thought you were pretty close. Anyway, such a shame he's leaving, huh?"

Jungmin had been thrown into a daze by Hyoseok's persistent questioning, and simply nodded. He pulled a look, apparently unsatisfied by Jungmin's response.

"The members will be here soon—we'd better get ready."

Johee clapped her hands to lift the energy again, and rolled up her sleeves. Thankfully, Jungmin was thus able to dodge Hyoseok's question.

"Oh, Jungmin-ssi, Hyoseok-ssi, if you have time today, would you mind helping out with the lesson? Christmas is coming up and we're going to make trees, but the students are finding it a bit difficult. I'll treat you to BBQ in exchange!"

The instant he heard the word "BBQ," Hyoseok readily agreed. Jungmin remembered that she had no plans that evening, and nodded, too.

EACH OF THE eight students had sat down in their seats, and the lesson began. Today's activity involved cutting designs out of the tree-shaped pieces that the three, including Johee, had made in advance.

"Jungmin-ah, mind giving me a hand, too?"

Jungmin was startled—it'd been so long since she'd heard Gyuwon, Juran's father, call her name.

"Oh, of course."

She sat beside him and examined his tree. He hadn't controlled his grip on the tool properly, and the surrounding clay had crumbled away, leaving jagged edges.

"First we'll smooth out the parts where bits have fallen off."

Jungmin took a new finger-sized lump of clay and moistened it with plenty of water.

"We stick on the clay like so. . . . Good as new, right?"

"I thought I'd gone and ruined it, but now you've stuck on more clay it's like it never happened."

Jungmin rested her hand on Gyuwon's to demonstrate, then froze.

"I think this is my first time holding your hand," Jungmin murmured.

For a moment, they were silent. Both were reflecting on a hazy past.

It was a struggle, but Jungmin finally opened her mouth. "I'm sorry . . ." She'd never sought his forgiveness before. Since the accident, she hadn't had the reason, or the nerve, to show her face in front of him.

"It wasn't your fault. Don't talk like that."

He removed his hand and placed it gently on top of Jungmin's.

"Is this about right?"

Gyuwon smiled, wanting to put Jungmin's mind at ease. His forgiveness was more wonderful than a tight embrace. Jungmin was on the verge of tears, and she lowered her head before nodding.

"It's been really tough on you," said Gyuwon. His hand gently tapped Jungmin's, his skin thick and coarse.

WHEN THE LESSON was almost over, Juran arrived to pick up Gyuwon. She was more than a little surprised to see Jungmin perched beside him. Regardless, she quickly sauntered over nonchalantly and made small talk.

"Appa, was Jungmin a good helper?"

"Of course, thanks to her I made this beautiful Christmas tree."

Juran's dad proudly held up his creation.

"Jungmin-ah, thank you."

"What for . . . Oh, er, by the way, you can put a light inside the tree."

Unsure of what to say, Jungmin revealed the hollow inside and said the first thing that popped into her head. "It'll be even prettier that way. He said he hasn't decided what color glaze to go for yet, though . . ."

Juran scoffed and cut Jungmin off. "I see being thanked makes you as awkward as ever. Just take it. He said it because he was genuinely grateful, there's no hidden meaning in it."

". . . All right, I get it."

"Everyone, tomorrow I'm going to put your trees in the kiln so that they're ready by Christmas. Good job today."

Thanks to Johee, whose timing had been spot-on throughout the day, Juran and Jungmin's uncomfortable conversation was cut short. Jungmin went alone to the back room, removed her apron, and slumped down into a chair. She could still feel Gyuwon's heavy, rough palm on her hand.

Soon after, Jungmin went out to help load the wheelchair into the car, when Juran suddenly grabbed her arm.

"You must've loathed the sight of me."

"What?"

"I was jealous. It was a shock seeing you and Appa sitting side by side like that. It was like you'd got all close while I wasn't looking. You must have hated seeing me hanging around your mum, going 'Umma, Umma' like that."

"Yeah, I couldn't stand it." Jungmin's words came out unexpectedly sour.

"We were so young."

The chatter of a gaggle of passersby conveniently filled the silence between them.

"Were we just young? We were sensitive. Fragile, too. But Juran-ah, I'm okay. I'm better." Now when Jungmin looked back on that time, everything was so vivid, but there was something unnerving about it all. She wasn't sure whether it was really her it'd happened to. After all, so much time had passed.

"I'm glad you're okay."

"I'm going back inside now," Jungmin called to Gyuwon. She hesitated a few seconds before continuing, "Juran-ah, I already know how to leave the cave. I wanted to delay going out, that's all. It was to protect myself—I was worried it'd wear me down. I'll come out when I'm ready. I'm not doing it alone, so don't worry."

Jungmin remembered everyone at the workshop. At times, she would rub her hands together, but the clay caking her fingers would only cling on all the more tenaciously. It was then that the

members, their hands sparkling clean, would take her palms in theirs and wipe away the clay.

"Guess you've got a lot of people looking out for you, not just me?" A mischievous look landed on Juran's face.

"Guess I do. I want the opportunity to talk properly next time, apologize to you. Let's grab dinner or something?"

Juran agreed without a moment's hesitation. "Sounds good. It's cold, go back inside."

Jungmin watched on for a while, until Juran's car had vanished completely from view. Meanwhile, she promised herself that when they did meet for dinner, she would speak those final words, the ones she'd never been able to say.

BY THE TIME they left the BBQ restaurant, stomachs full to bursting, it was dark. Despite Johee's protestations, Jungmin returned to the workshop to help clear up. Once they'd finished, Jungmin stepped outside, and for the first time in a while, she noticed the sign.

소요 SOYO
ceramic art &

Johee came out to see Jungmin off. She'd been wondering whether to redo the sign, she said, given so much time had passed. Jungmin followed Johee's gaze. In the midst of this unprecedented cold, the leaves had long since returned to nourish the soil. The sign stood out much more than it once had. During that time, it'd been the flowerpots, cacti, and ivy that

made Soyo's presence known—now, it was the sign performing this role.

"I like that there's a blank after the ampersand. It makes me think of all the things you'll do in the workshop from now on." Jungmin hoped that when Johee went back inside, alone, she wouldn't feel even a tinge of sadness.

"I think I like the sign how it is, too. I doubt I'll be able to change it any time soon. It's like a guardian watching over the workshop."

In their minds, they went through all the changes they'd experienced in just three seasons. The causes and consequences of these changes weren't fully clear, and it wasn't enough to simply line them up in order. For a moment, they put the deep thinking to one side, and decided to consider how they could better savor and celebrate the changes. Time was too short to simply go with the flow. The sun was already setting on the year, and no one knew how long they'd be together. For the rest of winter, they would align their temperatures with one another and fire hearts with all their might—this was how Jungmin envisaged the year's conclusion.

There was a practical reason, too, why this winter would see an end to Jungmin's vision of a shared future at the workshop. When she'd left her flat that morning, she ran into her landlord, who asked if she could vacate the property earlier than her contract's summer end date. For the past year, Jungmin had been eating away at her savings, and she couldn't afford the hike in the Jeonse lease price. She would have to move in the coming spring. What's more, her restricted budget made shouldering

the workshop fees tricky. She was beginning to feel the pressure. And now that she had Hoya, she felt an even greater sense of responsibility. Changes were underway, and Jungmin had to go with them. She needed to choose a future for herself.

DEFLATED, JUNGMIN AMBLED home. When she reached Gromit, she paused. Chocolate chip cookie frozen yogurt was no longer on the menu.

"Excuse me, was the chocolate chip dough . . . Greek yogurt flavor discontinued?" Jungmin stumbled as she did her best to recall the longwinded name.

"Oh, you mean the chocolate chip cookie dough frozen yogurt? It's not on the menu, but it's still available," the owner enthused, delighted to meet a customer who knew about it. "There's one particular gentleman who keeps coming back for it. He said he's moving away soon, so I'm keeping it on the menu until then. He's a regular, you see."

The image of Gisik coming here and blabbering on about his new business was endearing.

"Can I get a tub to go?"

Relieved, Jungmin returned home carrying a tub full to the brim with that sickly sweet ice cream. She no longer wanted plain and simple vanilla. At first, she'd thought the yogurt and chocolate chip cookie were Ara and Gisik. No, that was what she'd wanted to believe. That the two weren't a match. But now she realized that the two unmixable flavors were in fact her and Gisik. Jungmin felt like crying. There were choices she had to make: one was about her relationship with Gisik.

First Snow

CHESTNUT BURR VILLAGE's shopping area had burst to life, and the streets were inviting. Wherever you went, you could hear the hum of friendly conversation, and each person's step followed a different rhythm. There was a thrill to be found in searching down the alleyways for the little espresso bar or the restaurant run by a single chef. A new story was ready to begin at any time.

As Christmas drew near, the shops decorated their trees as if in competition over whose lights shone the brightest. Cafés played foreign pop songs, while bars blasted out Korean ballads. When Jungmin went food shopping, when she went for a run, and even during her brief journey to the workshop, she heard Christmas music. Thanks to this, she could feel that the festive season was here. Couples eagerly pondered what gifts they

would hide behind their backs for their partners; husbands and wives played Santa and purchased toys for their children, and kids bought little cards with pictures of Rudolph on them to compose messages for their friends.

Flea Market 12.24 (Sat)

2–7 p.m.

The workshop was also busy preparing for Christmas. On Christmas Eve, Chestnut Burr Village's park would host a flea market. Soyo would be taking part, too, and in the leadup Johee had spent every day engrossed in her work. It was Jungmin's first time seeing her create her own pieces. It was an even more impressive sight than she'd imagined. No, "impressive" didn't quite capture it—she was a marvel to behold. As a potter, rather than a teacher, Johee looked content and at peace. Her calling was making its presence known. Whenever Jungmin took a break, she would sit and observe Johee from a distance. The strength in her arms, attached to such a slight frame, was incredible.

"What are you making today?"

"I'm focusing on ornaments. There'll be lots of young people, so cuteness will be our winning ticket, don't you think? A cat-shaped spoon and chopsticks rest, a jewelry box in the shape of a turban snail shell, those kinds of things."

"Sounds adorable. I guess you can make all sorts of things with clay, not just plates."

"Of course. By the way, how about selling some of your work, too?"

Jungmin waved her hand in dismissal. "Me? I'm about as much of a novice as it gets. I'm not good enough to sell my work."

Gisik egged Jungmin on, too. "At the end of the day, pottery is all about ideas. You come up with unique designs that no one else does, Jungmin-ssi, just like the nacho bowl. Put them up for sale, even if it's for cheap. You never know who might be on the hunt for a dish like that."

He was planning to sell his vases at this year's flea market, too. Johee had floated the idea to him a while back, saying it'd be a good experience before opening his workshop. Jungmin muttered that she didn't have Gisik's same expertise. Gisik fixed his eyes on hers, as if doing so would be enough to persuade her.

"All right, all right. I'll do it. Happy now?"

Jungmin waved her white flag. Only once Gisik had got the answer he wanted did he beam and nod. The greater variety of pieces they had on sale, Johee claimed, the easier it'd be to draw customers in, and she happily announced that Jungmin could use the clay and kiln free of charge.

Jungmin decided to sell a small number of coffee cup and filter cone sets, as well as nacho bowls. She'd made adjustments to the designs after giving her original pieces a test run at home. The flea market was right around the corner, and everything had happened so quickly—none of this suited Jungmin's planner personality, but doing it alongside Johee and Gisik, she felt reassured. It was fun, even. She fine-tuned the join on the nacho bowl, and made coffee cups of various sizes. By the time she'd finished putting the holes in some tea strainers, too, it was dark outside. The days were shorter and the nights were longer, but

Jungmin liked it this way. She welcomed the winter evening scenes, displayed through the workshop's glass front.

The trio were exhausted after a long day of work. Johee had been too busy to bake, and so brought out some snacks instead. The ceramic piece in the shape of a wicker basket was full to the brim with tangerines and rice crackers. On the radio, the DJ was reading out a story submitted online by a listener, a tearjerker that was somehow also laugh-out-loud funny. The person's username, which elicited great sighs and chuckles from the listeners, was "my_solo_acapella." My_solo_acapella—the name itself enough to evoke pity—had booked a stay at a pricey hotel overlooking Seoul Tower as a surprise Christmas present for her boyfriend. Getting a room on Christmas Day had been a battle, but she put the skills she'd refined as a young girl snagging tickets for idol concerts to good use. Just a few days before the big event, however, her boyfriend broke up with her. In parentheses, she noted: "It was less of a breakup and more of a ruthless dumping." The problem was, she'd made the reservation in November, and the free cancellation period had passed, meaning all that money she'd spent was out the window. Yesterday, however, her ex-ex-boyfriend—to be honest, she couldn't remember how many boyfriends back he'd been—who she'd ended on good terms with, had called. And so, she asked listeners, "Should I give things a go with him, to stop my money going to waste?" After then clarifying that she'd deleted his number and would have to re-ask his name because she couldn't remember it, the laughter the three were stifling finally came bursting out.

Once the break ads started playing, Gisik commented, "I don't think anything can top that."

"I've got an even more depressing story." Jungmin glanced comically askew before fixing her gaze. "Way back I dated this guy I worked with, but he broke up with me on Christmas Day."

Johee shuddered in disgust. "What an awful man."

"But of all the guys I've dated . . ."

Jungmin opened up her hand to count her past boyfriends but thought better of it when she met Gisik's eyes. "I've been dumped every single time. Just like that."

"Those guys are the weird ones. What on earth were they thinking dumping you?"

"They all said that no matter how long they spent with me, I always kept them at a distance. They said it wasn't like being with a person. What did they call me? A bookcase, wardrobe . . . that I was more like a piece of furniture. Not an animal, even."

You don't tell me anything. Jungmin thought she'd been pretty chatty, but she was always given the same response. She had a rough idea of what they wanted her to "say." But she hadn't seen it as a problem—she hadn't lied to them, after all. They never asked the question straight up, so what point was there in saying it? It wasn't as if she'd deliberately hidden anything—she simply left blanks between the lines, like in a novel. Jungmin believed every couple needed blanks.

"Jungmin-ssi, you've got muscle, skin, and though you can't see it, blood flowing round inside, and look, I can feel you, like this." Johee grabbed Jungmin by the shoulders and scanned meticulously here and there with her eyes.

"Phew. I'm glad I'm still a person, not a piece of furniture."

"You sure are. You're one of our workshop's precious members. I'm telling you, I'm afraid you might leave me."

The word *leave* hit a sore note for Jungmin. And likely for Gisik, too.

Jungmin clasped Johee's hands in hers. "I'm not going anywhere. Don't worry."

As the second half began, the DJ forced his voice into a high pitch in an attempt to impersonate a woman. ". . . *I want to have a bit of innocent fun, just for one day.*"

Next, my_solo_acapella's request played out. Kelly Clarkson's "Underneath the Tree." The DJ jokingly changed it to "Underneath Seoul Tower," and whispered in a deep baritone his hope that as they looked out over the tower together, their hearts would flutter.

As she listened to the song, Jungmin reflected on her last Christmas alone, as well as the many Christmases before, spent with boyfriends whose names she—like the caller—couldn't remember. There'd been good moments, sure, but none had left a lasting impression. Her favorite day of the year wasn't her birthday in April, but Christmas Day. Yet she hadn't had a single memorable Christmas, probably because she'd always hyped it up so much.

Meanwhile, Johee would've been reminiscing on her final Christmas with Hosu; while Gisik would be reflecting on his four Christmases spent with Ara. The music had mesmerized them. As soon as the last verse drew to a close, they all jolted up and began cleaning as if nothing had happened. They were in a

daze, returning from a brief trip through time. This Christmas, however, was just around the corner, and they couldn't get distracted by the ones of years gone by.

"Jungmin-ssi, stamp your seal before the plate hardens."

"Can I? It's a piece by an unknown artist, wouldn't it be better if it had no mark at all? Like the ceramics they sell in supermarkets . . ."

"Not at all. A seal isn't just for letting people know who made the piece. The seal will help whoever buys it remember that day better. Who they spent their Christmas Eve in Chestnut Burr Village with; what they bought at the flea market; why they bought this particular piece. A seal is a helpful way to keep the day vivid in the owner's mind. No one entrusts such a precious memory to unbranded supermarket ceramics."

After hearing this, Jungmin had a change of heart and decided to stamp her seal. She didn't want her pieces holed up in a corner of someone's kitchen cupboard without containing a single memory. She wanted to play her part in giving someone a Christmas to remember. So, on the side of the nacho bowls and the base of the coffee cups, she stamped her seal. The soft, squishy clay. Jungmin's "珉" made its mark on the bowls. She hoped that someone's special day would make a clear, crisp echo, too, like a jade marble as it rolls across a hard surface.

POTTERY TIME WAS over, but Jungmin and Gisik still had work to do. They'd decided to post about the flea market on Instagram each day in the lead-up to Christmas. Hopping on the "blogmas" and "vlogmas" trends, every day they made a

record of their Christmas preparations. Jungmin's Heart Series had proved more popular than anticipated, and they'd recently passed the three-thousand-follower mark. Thanks to that, online orders had shot up. Customers also came to buy in person, and restaurants made bulk orders. Jungmin sometimes helped package items for delivery, and though before she'd taken the seal and free use of the kiln in exchange for running the Instagram, she'd now started accepting an official part-time wage. She was finally seeing a response to her regular posting, and she became even more motivated. "Your pictures and text really evoke the senses." "The captions strike a chord." Checking the comments and DMs became part of her bedtime routine. Most were, of course, left by either the workshop members, Hyoseok, or Souta.

While Gisik photographed the ornaments Johee had made that day, Jungmin debated over the concept for the post. The content had to be more concise than her previous story, but it also needed to excite the reader.

Gisik, who'd already taken all the photos and uploaded them to the laptop, checked in on Jungmin. "Looks like it's taking a while this time."

Jungmin's page was still blank, and she was considerably tense. Gisik liked the look of concentration on her face whenever she wrote. He gazed at her with admiration—even for such short text, she didn't write just any old thing, thinking it through meticulously instead. And, in turn, that look of absorption stimulated his own imagination. He pictured the broadcast-writer version of Jungmin, one he hadn't known.

"What should I write? I want to spark the readers' curiosity."

"I know how you feel, but the more ambitious we become, the more it stunts our creativity, so don't put too much pressure on yourself."

Gisik sat beside Jungmin and suggested browsing through the photos to stimulate her imagination. He opened up the folder containing the files for upload. The images captured each day's creations in an unembellished manner. As Gisik sorted through the photos—A-cuts for posts, and B-cuts for stories—he had the real look of a new business owner. He'd begun the product photography as practice for his own workshop, but he was quick to shake off the amateur vibes.

Handmade ceramics—unlike mass-produced ones—were all one of a kind. As was the nature of being made by hand, there would always be small differences in the shape or size, even for the same design. The color, too, came out differently depending on the weather conditions and humidity the day the piece was glazed. Such variations could appear insignificant to those not in the know. That was why the promotional text and photographic composition needed to highlight these differences. And so Gisik and Jungmin had to constantly rack their brains over how best to "promote." When Jungmin wrote, the two would make small talk about a range of topics, and as they did, she would occasionally have a lightbulb moment. Gisik wanted to do whatever he could to help this time, too, and so chattered about all manner of things—but it was no use.

"All right, okay then. Let's go back to square one. I'm talking way back, though. They say that when a wolf has an unsuccessful hunt, it goes back to where it first spotted its prey and retraces

its steps one by one. Let's go back through the topics one at a time, too. Okay, Christmas. What does Christmas mean to you, Jungmin-ssi?"

Jungmin, who was scrolling aimlessly through the photos, paused to consider. "It's my favorite day of the whole year. I like it even more than my birthday. It's the time I most look forward to, and I want so much to be happy on that day."

"I've never heard anyone say they prefer Christmas to their birthday before."

"My birthday is just about me. It's like I'm having fun all on my own. But on Christmas it's as if everyone has their birthdays all at once. Everyone's the main character! We celebrate with each other and have a blast—just because. I like that kind of gratuitous fun."

"I guess you might be right . . . A Christmas where everyone's the main character. A Christmas where it's everyone's birthday. And Soyo's main focus is bowls and cups. Bowls for serving food. Cups for serving drinks."

Jungmin clapped her hands. "That's it, you've got it." Then, like a spring bursting to life, in a single breath she listed all the thoughts that came to mind.

"A Christmas birthday meal for everyone. Roast chicken, lasagne, stollen, soup, mulled wine—we'll recommend dishes to serve all the different food and drink people have at Christmas! And with simple recipes alongside. One of the special features of ceramics is that you can use them both in the microwave and the oven, right? We can highlight that they stay strong under any temperature."

Gisik swiftly typed out everything on his laptop. Ideas were volatile, and therefore needed to be recorded without delay, Jungmin would often tell him.

Jungmin's face lit up with pure delight, and Gisik couldn't tear his eyes away. It was a look of innocence that she revealed only sporadically. This was how Gisik knew Jungmin's love of writing was genuine.

Once all the ideas were written down, Jungmin held out her hand to Gisik. The small palm met the big palm with a slap. Her hands weren't exactly slight, but they were tiny next to his.

Jungmin returned Gisik's laptop. "What does Christmas Day mean to you, Gisik-ssi? I got all overexcited and rambled on about myself."

"To be honest, Christmas has always been the definition of depressing for me. I'd think to myself, 'I started off this year with so many resolutions, but in the end it turned out to be nothing special.' The monotony of the everyday gets me down and I just end up going through the motions. I'd still be in the same job I was in at the beginning of the year, meeting up with the same people, living in the same neighborhood, eating the same food. And even drinking the same beer that I occasionally drink. There's nothing to look forward to, and so I can't help but feel depressed."

With his upturned mouth, Gisik always appeared to be smiling, but at times he wasn't actually pulling any expression at all. At Christmas, he said he always felt uneasy around people. As they saw in the year's end with good cheer and looked forward

to the one to come, he struggled to relate. He always felt like an outsider.

"But this Christmas feels different. Next year is going to be different from this one, after all. I feel kind of excited. Goseong is a new place, and I'll meet new people there. I used to hate all the hype around the festive season—it's only now I'm starting to get it."

The woman whose favorite day of the year was Christmas, but who spent it like any other day; the man who disliked Christmas more than any other day, but who now finally got the hype. They weren't exactly hoping for anything interesting to happen. All they wished for was a little more fun and laughter compared to any other ordinary day—a little shimmy from a set of slumped shoulders.

"It's snowing." Jungmin led Gisik outside.

The first snow. It had come unusually late this year, keeping everyone on their toes. In search of an enthusiastic reception, the cold white flakes had waited until every last person on the street was on tenterhooks, before finally falling in great piles. The first snow must've selected this day carefully, knowing that its arrival meant something.

Jungmin and Gisik held out their hands. The brief, subtle chill of the flakes grazed their palms. When Jungmin looked over at Gisik's hand, the snow had already melted to clear water.

Wanting to Speak

MAKING HER COME all the way from Ilsan! Her body sandwiched into one of the Gangnam-bound M-bus's tiny seats, Jungmin felt faintly nauseous. The bus was making its way along the Gangbyeon Expressway and had still only made it as far as Wonhyo Bridge, though Jungmin was sure they'd passed it way back. Thanks to a single DM that'd landed in the workshop Instagram's inbox the week before, she'd sacrificed her peaceful weekday afternoon for this hellish three-hour-plus round trip to Gangnam and back. A publisher—one not exactly well known, but one that released a steady stream of books nonetheless—had got in touch.

Perhaps thanks to the increased volume of posts in the runup to the flea market, the workshop Instagram account had gained

five hundred new followers in two weeks. One of those was the publisher Antarctic Fox, whose profile picture was a cute illustration of the animal. They'd been very aggressive in the DMs, saying they wanted to offer Jungmin a book deal. The so-called editor-in-chief's messages were relentless, like a steam train that never stops.

Jungmin, however, was baffled. All her captions were short, and she couldn't begin to fathom what kind of book you might make out of them. Despite her reticence, the editor-in-chief arranged a meeting the following week, during which he would show her the official proposal. Something felt off—she wasn't sure whether to see his behavior as passion, or considerable bad manners. Even so, he'd sparked her curiosity. At this point in time, Jungmin was sure that she'd keep writing, though she had no idea what exactly. At a time when everything else in her life was uncertain—clouds bobbing aimlessly across the sky—being sure about anything was, for her, extraordinary.

THE BUS REACHED Gangnam, and here it joined the suffocating lines of traffic. Jungmin had sweated through her many layers. She made it off the bus, just about. The ambushing gale dried her sweat, and instantly stole her body heat, sending goosebumps all over. A foreshadowing of how the day would unfold.

In amongst the tall square buildings, identical from all angles, the publisher's office was on the twelfth story of the oldest of these. The open-plan office occupied the entire floor. Jungmin was hit by the new book smell as soon as she stepped out of the elevator, and she almost relaxed her guard. Surrounded like this

by the scent of paper—one she preferred to perfume—her spirits lifted and her movements became lighter.

"Hello. Are you here for the ten a.m. meeting by any chance?"

"Yes, I'm Yu Jungmin."

"Thanks for coming all this way. I'm Kim Jitae, editor-in-chief."

The man looked tired, though his thick, round frames seemed to be doing their best to conceal it. He was wearing a casual red corduroy checked shirt and navy blue trousers—a look that jarred against his online tone. His aura was one of disinterest, and it was hard to imagine this was the same man who'd said: "We *strongly* encourage you to publish with us." He led her to the small meeting room at the far end of the office. For the past few days, he explained, he'd been trawling through every one of Soyo Workshop's old posts. As they walked, he told Jungmin how he'd found himself looking forward to the new posts, and for the first time in a while, he'd felt a renewed passion for publishing. Without pause, he continued.

"I read so many manuscripts, but for a while I've struggled to find anything I really love. But as soon as I came across your writing, I felt a thrill and satisfaction—maybe I'd discovered a budding talent within the barren publishing landscape . . ."

He didn't seem to be hoping for a response from Jungmin—he was essentially having a conversation with himself. There was a hint of pretense to his tone, too. His rambunctious monologue went on, right until Jungmin sat down in her chair. She wondered whether the editor-in-chief might've been a playwriting major, one of the many she'd come across at her old job.

A young member of staff came in and poured hot coffee into a plastic cup—an illustration of that same fox across it—before setting it down in front of Jungmin. She then perched beside the verbose editor-in-chief, but introducing her seemed to have slipped his mind. The woman remained unintroduced and nameless, and simply smiled awkwardly. She kept putting down and picking back up the business card in her hand as she tried to calculate the right time to jump in. Obviously, she was well accustomed to her boss's inconsiderate nature.

"Here's the proposal I told you about. Would you like to take a look?"

Underneath the title, *1,250 Degrees*, was the subheading, *Proposal for an essay collection by Yu Jungmin*. The word *essay* had already got Jungmin furrowing her brow.

"With all my experience, I get an immediate sense of how to write up any given publishing proposal. To be honest, your writing needs a lot of polishing. I understand you used to be a broadcast writer, but the writing style of TV narration is miles apart from literature. I'm talking about spoken form and written form here. This might offend you, but you need to consider relearning how to write. The content, however, is great. Your book would be in the style of a diary, noting down how you feel as you put your time and energy into crafting ceramics. A rumination on what 'heart' means for the modern person. For the ordinary individual, 'pottery' brings to mind a hobby reserved for the rich, something from the art world, and not for them. But that's not actually the case. A worn-out office worker heals her heart as she works with the clay. We're flooded with essays about engaging

in self-care through similar pastimes, but lately I haven't come across any reference to pottery in bookshops. And this is exactly the opportunity we're going to seize."

Despite having been instructed to read the proposal, the editor-in-chief's constant blabbering made it impossible for Jungmin to concentrate. Not only did he have a lot to say, he had a booming voice, and her ears were ringing.

"Oh, you're probably wondering why I went for '1,250 Degrees.' It's just a working title, of course. We'd need to consult you first. 'Only in the kiln does clay become pottery. No matter how much heart we put into the making process, it is up to the piece itself whether it can stand the heat. Much like human relationships.' You wrote this in the Heart Series, right? That's when the feeling came to me. Temperature, that's it! I'm generally pretty speedy when it comes to writing up proposals, but it's been a long time since I've knocked one out in a single night. Having a clear title in mind makes the planning far easier."

He threw out words like *sense* and *feeling* all over the place, unaware that this betrayed his lack of expertise.

Jungmin finally managed to get a word in edgeways. "I'm no expert when it comes to pottery, though. I wouldn't feel comfortable going with that title."

"Anyway, it's your first book, so the advance and royalties..."

On the one hand, the editor-in-chief seemed to be deliberately ignoring Jungmin, but he may genuinely not have heard her in all his excitement. Bullish, he laid out what he had to say regardless. The unknown staff member—was she from the marketing team or the editing team?—grinned uncomfortably,

revealing a set of braces. Her gaze seemed to say: *Please forgive our editor-in-chief. I hope you'll look favorably on our proposal.*

Unable to stand it any longer, Jungmin straightened her posture and cut the editor-in-chief off. "Hang on a minute. There's something I need to tell you first. I'm interested in publishing my own work, but I don't want to write essays. You'll know from Instagram, but I generally write my posts like stories. I've never even considered doing nonfiction. More than that, I don't have the experience or wisdom for it."

"Isn't the story's protagonist, Yujeong, based on your own experience? Your writing took the form of a novel, but contentwise, I saw it as no different from an essay. And essays sell like hotcakes in bookshops these days. It's also the easiest inroad for new writers."

"You're right that it's my story. Yujeong is essentially me. I don't have the courage or confidence, though. I'm just about able to write, but only by hiding behind a protagonist with a different name."

The force in Jungmin's tone seemed to catch the editor-in-chief off-guard.

Jungmin never had been a fan of reading essays. She regarded these books as trophies, written by those who'd broken through the wall of inertia and depression, a hurdle that she herself would never be able to overcome. Back then, she'd hit such a low that recovery was out of the question. Stories of those who'd come out the other side gave her no encouragement, and instead sent her confidence plummeting. They even triggered an ugly jealousy in her. She used to wonder whether one day

she might recover and write something like that herself, but the answer was always a resounding "no." Considerable courage was needed to share your story with the masses. For Jungmin, who couldn't even tell her own friends how she was doing, it seemed an impossible feat.

Jungmin gulped down what was left in the plastic cup. The bus here had cost 3,000 won—making it 6,000 won both ways. After the editor-in-chief's bulldozing, she tried to reassure herself that it was basically the same as going for a coffee at an expensive franchise. The coffee was—of course—stale and bitter. No different from any big chain's, which made her "basically the same" ruse all the more convincing.

The editor-in-chief didn't try to stop Jungmin as she walked out, but he did tell her to get in touch if she changed her mind. It was then that he finally handed over his business card. Even in that moment, he still looked to have more to say, and his mouth twitched in impatience. Just then, the woman beside him scrambled to offer her card, too. Jungmin felt a strange solidarity with this woman, who never did manage to insert herself into the conversation.

MISSING THE ILSAN-BOUND M-bus, she had to wait at the stop for a good half hour. Gangnam was quiet this weekday afternoon—everyone was presumably safe inside their toasty offices. The cars seemed to be the only thing moving. Back and forth they went, rousing dreadful gusts of wind, and Jungmin felt an even fiercer chill burrow inside her coat. She didn't want to remove her hands from her pockets even for a second. The

sound of her ear-splitting ringtone, however, left her no choice. Floating on her phone screen was a name she hadn't seen in a while: Writer Gu.

"Hello?"

"Hey, it's me."

Gu was the main writer who she'd worked with for two years on the documentary series, and they'd been through thick and thin together. This was the first time she'd contacted her in a personal capacity since Jungmin went against their boss that fateful day.

"Gu jakkanim, hello, it's been a while. Sorry I haven't been in touch . . ."

"Forget it. The reason I called—I was wondering if you were working at the moment. You said you were going to take some time off."

Had she got in touch for work reasons? For a moment, the reminder of that oppressive atmosphere sent Jungmin's head spinning, as if she'd put on a thick pair of glasses that didn't match her prescription.

"Yes, I'm still taking time off."

"I just called to ask something."

Her nuance suggested this wasn't anything to do with the office. Jungmin breathed a sigh of relief. The instant Writer Gu had said *I just called . . .* she knew instinctively that the conversation would easily spill over the ten-minute mark. She'd detected the pattern a while back. Writer Gu always called out of the blue, and always got straight to the point. But it was generally for something un-urgent that could've been covered by text.

Jungmin kept switching her phone between hands to try and make it through the call, but the problem was her feet. Despite getting extremely cold hands and feet every winter, she always forgot to wear more than one pair of socks. In the end, she gave up on the bus and headed for the subway. The bus went direct to her home, while the subway involved the slog of multiple transfers.

"Here's the thing, a while ago I produced a trailer for the essay platform 'Different.' It was for a competition shortlist. I heard they're running the prize again this year, too. While I was making the trailer for last year's contest, I was surprised that none of the essays that made the shortlist were anything special. I called because I thought you should give it a go. They get loads of entries, but anyway . . . Um, are you sure you're all right to talk now? It's really loud all of a sudden."

Jungmin was now inside the express bus terminal under-ground shopping center, which was swarming with people. Near-identical shops selling remarkably similar women's clothes, for as little as 5,000 won—prices that made you doubt your own eyes. Getting lost here was inevitable.

"Oh, I'm in the subway now. It's a bit noisy, isn't it?"

Jungmin had privately been hoping that Writer Gu would end the call, but there was no chance of that. As Jungmin trailed off, Gu continued, "I'll be quick," and Jungmin's faint hopes were quashed.

"The competition is fierce, but I've worked as a broadcast writer for fifteen years now. I'm a little embarrassed about this, but I'm throwing my hat in the ring, too. I've got some essays I've been working on in bits and pieces for the past year, kind

of like a detailed confessional, dishing the dirt on corruption in the broadcasting world. The secrets of viewer ratings, how little writers get paid, poor working conditions. I wrote under a pseudonym but there are parts I'm worried one of the producers I know might read. Half of it is me badmouthing them, you see. Anyway, I'll send you the link—do you mind voting for me? I'd be grateful if you could share it with your friends, too."

Jungmin was swift to select the words Writer Gu wanted to hear. "I remember you saying you wanted to write a book. I'm rooting for you. If you send me the link I'll share it around. And I'll vote myself, of course."

"Thanks a lot. If you could vote twice on two different accounts I'd appreciate it."

The call was finally over. Writer Gu hadn't called because she'd been thinking of Jungmin—she'd wanted to speak about her essay. If Jungmin had been somewhere less noisy, she probably would've been given a preview of parts one right through to four. Her head felt woozy: the result of going from the cold outside to the warmth of the station, combined with that unexpected phone call. Meanwhile, Writer Gu had presumably forwarded her the link, because her KakaoTalk notifications were chiming.

Responding to Writer Gu's onslaught of messages took up Jungmin's entire journey, and when she looked up, she was in front of her building. She'd been staring into her tiny phone screen the whole ninety minutes on the subway—her eyes were dry, and she felt a weariness rising from the pit of her stomach.

—I'll read your piece this evening.

Jungmin was simply paying lip service. Perhaps because it'd been so long since they last spoke, Writer Gu was even more talkative than usual, so Jungmin decided to put a stop to the conversation. Today, there was a lot she wanted to say, too. She got on the phone to Gisik right away.

Gisik picked up on one of the first rings. "You'll never guess what happened to me today . . ." Jungmin began. Gisik, who'd been lounging on the sofa in front of a run-of-the-mill comedy show, got the sense this was going to be a long one. In preparation, he shifted into the most comfortable position possible so his legs wouldn't go numb halfway through—he didn't want to interrupt Jungmin's flow. He lowered the TV volume to zero so he could concentrate. The now muted comedians on the screen spoke to each other and laughed on repeat. Gisik was ready to hear what Jungmin had to say.

There are days when all people want is to tell their story. Just like the editor-in-chief, who'd be tearing his hair out right now about searching for another debut writer; just like Writer Gu, who'd be frantically calling round her other hoobaes; just like Jungmin, who was now on the phone to Gisik. Today, they wanted to let it all out.

Christmas Flea Market

THE DAZZLING BLUE of the Christmas Eve sky put December twenty-third—when it'd rained until late into the night—to shame. At odds with clouds floating languidly above, Chestnut Burr Village's park was bustling. Johee, Jungmin, and Gisik all moved swiftly, and Souta lent a hand, too. A few people trotted here and there across the park, scarves wound round their necks, and soaked up the Christmas Eve atmosphere.

At two o'clock, crowds poured out of the restaurants rubbing their post-lunch stomachs. Soon, they were flocking to the park. Soyo's booth was right beside the entrance, where those entering and those leaving crossed paths. It was an ideal location: every customer would cast an eye over their stand at least twice.

The booth had made its first successful sale. A newlywed

couple who'd just bought their first home nearby chirped about their decoration plans. The man squeezed the hand of the woman, her arm linked through his, and explained his wish to fill the apartment with items they could use for years to come. Johee's round rice bowl matched well with the home they described. A simple, honest bowl, which wouldn't have looked staged, but would always be there in its rightful place. The marks revealed it'd been made by hand: it was where the eye landed most during making that such traces remained. A loving gaze that left its tracks—it resembled how the couple looked at one another.

Jungmin packaged up the bowl and slipped one of the cards inside. This was Johee's idea. Each little card had the title of a Christmas song and the reason for its recommendation. Johee, under the influence of Hosu—a music-lover who'd collected hundreds of LPs in his time—had her own opinions when it came to music. The cards were folded shut, and so Jungmin had no idea what song the couple would get, but she hoped it'd be a jazz piece to complement the newlywed atmosphere. She hoped, too, that the bowl and card would become yet another winter memory for their new home.

The second customer was a woman with hair white as snow, tied back into a long ponytail. It was her slender neck that first captured Jungmin's attention. Judging by the wrinkles on her face, like life's relics, Jungmin guessed she must be in her sixties.

"Do you have an ovenproof lasagne dish?"

Her voice was measured and low. Gisik gave Jungmin a gentle poke with his elbow and whispered, "I think you'd better

take this one." She swiftly moved the lasagne dishes in front of the customer.

"Here are our lasagne dishes. They're all in the same turquoise and there are three different sizes."

The woman examined them carefully, even though they differed only in size, and pointed to the largest of the three. Quick to respond, Souta reached under the table and pulled out the biggest box they had before passing it to Jungmin. She wrapped it twice in newspaper and stuffed in some Bubble Wrap.

"Did you find out about us on Instagram?"

"So that's what you call it. My granddaughter's coming back to Korea for the first time in years, and for the past few weeks she's been saying how she's craving my lasagne. When she was young, my granddaughter and I lived in Prague, and on Sundays we'd go to mass and often have lasagne for lunch after. I guess she misses the taste. But it turns out I don't have an ovenproof dish. So I asked her to give me a link of where I could get one, and she sent me a photo of this. Seeing I could buy it at the flea market, I stopped by on my way back from the shops."

The woman pointed to a tote bursting with ingredients. Jungmin could sense the woman's excitement in the produce that peeked out from the bag.

"I'd like to try that lasagne myself!"

Jungmin's mouth watered at the thought of piping hot lasagne in a bitter winter.

"I don't have any special recipe like other grandmothers do. It's not much different from the recipe you posted. Maybe what my granddaughter wants to remember isn't the taste of the

lasagne, but winter in Prague, and her middle school years, her grandma as a younger woman! This is the dish I need to serve it in. It looks so much like the dish I used back in Prague. Seeing this faded turquoise, I understand why my granddaughter recommended your workshop."

The "ideal dish for lasagne" that Jungmin had uploaded on Instagram had reminded this woman of her precious time back in Prague. It was mysterious how old memories would poke their heads out at the most unremarkable of things.

"Our teacher was set on making these dishes in turquoise, so I guess it was because of you."

Jungmin held out the carrier bag with the dish bundled inside to the woman. She'd been the dish's rightful owner all along. Before she left, the woman added, "I'll still be able to recognize her after all these years, won't I? Or maybe I've aged so much she won't be able to recognize me . . ." Her granddaughter's parents had joined them in Prague the year she started middle school, and the woman, who'd been suffering from homesickness, had then returned to Korea, she said. She wouldn't have seen her granddaughter for more than a decade.

"Of course you'll recognize each other. Your granddaughter will certainly recognize you, at least. She remembered the dish her grandmother used to serve lasagne in, after all."

Finally, the woman smiled with ease. "Goodness, I went on a bit, didn't I? She'll be on the plane by now. . . . I'd better start preparing before she arrives."

As she went to leave, the woman turned back around and said to Jungmin, "Have a lovely day."

She could've said "Merry Christmas," but these everyday words felt all the more genuine. Jungmin smiled back at her and replied, "Have a nice time." For the woman, it wasn't important that it was Christmas Eve; what was important was that she would spend this day with her granddaughter. She clutched the carrier bag in her left hand, and on her middle finger was an old rosary ring made of gold. Jungmin hoped the song on the card would be a tranquil hymn written in some unknown language. One that would transport the grandmother and granddaughter back in time like a magic carpet, to winter in a land far away.

GISIK'S VASES WERE a big hit with all the customers. His shallow plant pots were in high demand, too—with the black diamond pattern set against a red background, they burst with character. A scruffily dressed man, who exuded a potent odor of sweat, had been staring at the plant pots for quite a while.

"After a plant pot?" Gisik asked.

The man was unresponsive. Gisik waited for him to start talking first.

"This pattern . . . how did you . . . add it?"

His stumbling words fell in dribs and drabs, and he didn't even use honorifics.

"It's brushed on with black paint before firing. The paint is special in that it maintains its distinct color even through the heat of the kiln."

The man buffed his index finger against the pattern, as if to confirm that it wouldn't rub away. His fingernails were caked with dirt.

"Can . . . anyone . . . learn this?"

Gisik leaned ever so slightly toward the man. Next, he opened up his hand.

"Of course. Even ham-fisted people like me can manage it."

The man quietly pulled some cash from the inner pocket of his lightweight padded jacket. One 50,000-won note, two 10,000-won notes, one 5,000-won note, and five 1,000-won notes. He ignored Gisik's offer to wrap the pot, and went away with it held close to his chest.

Most customers were only interested in how they'd use the piece; they weren't curious about how it'd been made. This man, however, had first asked, "How did you make this?" just as Gisik had done when he'd first bought a piece from Johee. Gisik believed that, as this mysterious customer scrutinized the piece with care, he would discover its heart and appeal. When the man planted something precious inside the pot, this itself would be an act of creation, even if he wasn't crafting ceramics. It made Gisik feel good to imagine the changes his pieces might bring about in people.

The booth wasn't overrun with customers, but there was a consistent trickle of people coming in. About a fifth said they'd come because of Jungmin's "Christmas, Everyone's Birthday" post on Instagram. Jungmin felt a fullness that couldn't be described in words. That people had been moved by her post and come all the way here—it was nothing short of a Christmas miracle.

Johee's dishes and ornaments, as well as Gisik's pieces, went one by one, ready for the customers to place their own memories

inside; Jungmin, however, hadn't sold a single one of her nacho bowls or coffee cups. Despite their bargain price tags—15,000 and 10,000 won respectively—no one had gone for them. She couldn't conceal her disappointment.

"Red bean or pastry cream?"

Souta offered her a sweet fish-shaped bungeo-ppang pastry.

"I'm saying this as a homeware designer, but your pieces really are marvelous," he commented, in an attempt to raise her spirits. Jungmin, however, had known for a long time that Johee and Souta's "marvelous" was code for "I want to give you a compliment, even though it's not all that marvelous." Jungmin and Souta were in the middle of a petty squabble over which part of the bungeo-ppang you should eat first, head or tail, when a young boy came over.

"What's the cheapest thing you have?"

He had dark skin and big eyes with unusually deep double lids—the boy reminded her of someone.

"The cheapest is this coffee cup for ten thousand won. And this nacho bowl here is fifteen thousand."

Presenting her pieces not based on their suitability for the customer's purposes, but as the "cheapest"—it was mortifying.

The boy scanned his saucerlike eyes left and right over the dish.

"You're not selling it cheaply because it has a crack or there's something wrong with it, are you?" The boy's voice was pointed, and he looked Jungmin straight in the eyes. She crouched down to meet his eye level—only then did she realize who he reminded her of.

"Not at all. We're only selling sturdy, crack-free dishes. It's cheap because a novice made it."

A shadow fell over Jungmin. When she looked up, there was Yeri.

"Unnie, this is my little brother. Our mum's birthday is on Christmas so he's choosing a gift."

The two looked so similar, they could almost be twins. Yeri, however, was tall for her age, while the boy was small and scrawny for his.

"Yeri-ya! Long time, no see. Your mother's birthday is on Christmas? Must be double the fun, then."

Yeri shrugged and replied with a disinterested, "It's just like any other day." She'd recently moved far away, and rarely came by Jungmin's flat or the workshop. Yeri remarked that their new home was no bigger than their previous one, which meant she couldn't come and get Hoya yet. Jungmin wanted to give Yeri's brother the bowl for free, but seeing the seriousness with which the siblings inspected the dish, she couldn't bring herself to suggest the idea.

The shrewd Yeri questioned the practicality of the bowl on her brother's behalf. "What's it used for? And what's this random bowl on the side?"

"It's a bowl for both nachos and cheese sauce. When you use it for ramyun, you can serve kimchi in this little side plate. Or if you use it for mandu you can pour soy sauce in for dipping. It might not look that elegant, but it has plenty of uses."

"It's so you, Unnie. Means less washing up, so that's good I guess."

Yeri persuaded her brother to buy the bowl. She was the one

doing the washing up for their busy mother, after all. The boy didn't look utterly convinced, but he acquiesced nonetheless.

While Jungmin was packaging up the bowl, Yeri exchanged happy greetings with the other workshop members. Jungmin's fears were realized—Yeri found out that Jun hadn't been coming to the workshop recently. Yeri tried to act nonchalant, but Jungmin caught her pouting out of the corner of her eye. Even so, Yeri agreed to come along to the little Christmas party they were holding at the workshop after the flea market. Johee handed Yeri and her brother both some candy, and said in a spooky voice that if they came to Soyo at 7 p.m., there they would find a feast of delicious food. "Seonsaengnim, Halloween was ages ago." Yeri acted coy, but she still promised to come along.

After Yeri and her brother stopped by, Jungmin's pieces finally began to sell. Other children also buying gifts for their parents, a university student wanting to decorate their studio with a little money from their part-time job, and a husband and wife trying to use up their local business vouchers. No matter the reason, Jungmin felt good picturing her dishes quietly performing their roles in these people's kitchens. When the last of her dazzling white coffee cups was gone, Soyo Workshop's stand was left bare. Sold out. That moment felt freeing, but it left a hollow aftertaste. For Jungmin, it felt like all the heavy things occupying her heart had flown out.

"As a potter, I feel this every time, but I never get used to it. It's odd—a bare stand makes you feel good, but empty, too."

"Same here, Seonsaengnim. It feels empty, like all our hard work has gone to nothing."

Souta swung his arms round Johee and Jungmin's drooping

shoulders. "I guess that's a reflection of how much heart you both put into your pieces."

The fact that when you'd poured all your whole heart into something, a feeling of emptiness was inevitable, reassured Jungmin. Unlike a year before, when she'd fled from this same emptiness in fear, without facing it head on, she now wanted to put in the time and effort to really lose herself in her work. She wanted to once more relish the act of taking each day as it comes.

ONCE THE FLEA market was wrapped up, everyone headed back to the workshop to help tidy away. Inside the workshop was as bitter as outside. Even with the heat of four additional bodies, cold air still lingered in every nook and cranny. Johee announced that it was time for the day's highlight, and whipped out the food. As she heated the roast chicken, cheese pasta bake, and pizza, which she'd preordered from a restaurant nearby, finally the nip in the air began to ease. Souta lit up the little Christmas tree he'd prepared the day before, and Gisik and Jungmin meanwhile laid the table.

"I got a couple of bottles in to celebrate. I'm not sure whether they'll be to everyone's taste, but the shop owner recommended them highly."

Gisik presented two different bottles of red wine.

"It has to be red wine on Christmas. Goes with the food, too. Gisik-ssi, I didn't realize you had such good taste?" Johee cheered and pulled out some wine glasses.

"I wanted to celebrate a successful flea market, as well as my last day at the workshop. So I reckoned a drink was in order."

Gisik explained that he was planning to head down to Goseong early to get things ready before the workshop's official opening. Jungmin was hunched over laying the tablecloth when she heard his announcement, and for a moment she thought she might burst into tears. What last words should she say to him? She wasn't at all prepared.

Jungmin put on a cheerful face and took out the cake she'd hidden in the workshop early that morning. "This is my gift. Apparently it was made by a famous pâtissier. Eating a bright white cake topped with strawberries on Christmas is my personal tradition."

Johee, touched, clasped her hands together. "Jungmin-ssi, you too? Thank you. And there was me wanting to be the one to treat you all . . ."

The plates overflowing with food were served, and the cake—complete with Santa-shaped iced cookies as decoration—was set out on the table, too. It finally felt like Christmas Eve. Just then, a familiar face came through the workshop door.

"Jun-ah!"

"I was wondering when you'd get here!"

"Come on in!"

Jun pulled an awkward smile as everyone said their piece. "I forgot to give Gisik hyung back his fleece. I didn't realize you were having a party."

Jun's visit was unexpected—he was still preparing for the entrance exams, after all. But here he was! Johee pulled Jun into an embrace. She praised him for his hard work and began by asking whether he'd eaten. He'd had an early dinner but told a white lie for Johee's sake. Gisik and Souta dragged the two-person sofa

out from the corner of the workshop so Jun could take a seat. By the time Yeri arrived, all the seasoned members (other than Jihye, of course) were present.

When Yeri caught sight of Jun, she smiled and blushed. Since the summer, Yeri had been lamenting the age gap between her and Jun. She wanted Christmas over quickly so she'd be another year older in Korean age. Jungmin made sure to leave Yeri the spot on the sofa next to Jun.

Souta played the role of a fancy restaurant waiter and poured wine into each person's glass with poise. Everyone chuckled at this out-of-character performance. Each time—and making no exception for when he served out pulpy orange juice for Jun and Yeri—he said "Enjoy!" in English. Though they all booed and told him he sounded like a broken record, they still busied themselves capturing his ridiculous display on their phones.

The "Christmas birthday banquet for everyone" was served. What with Souta's show, the candle kept on melting. At the critical moment when it looked like the wax might drip onto the cake, they all took a deep breath and blew. While the adults boomed "Merry Christmas!" Yeri drew her hands together and made a silent wish. Everyone's faces brimmed with mischief as they waited in silence for Yeri. When she eventually opened her eyes, she protested, "Hey, what're you all doing?" but that just made them break into laughter all over again.

"EVERYONE, I HAVE something to say."

They were chattering about the flea market's most memorable customers, when Jun suddenly opened his mouth to speak.

This was a rare event. Naturally, all attention turned toward him. He withdrew a little from the table.

"I never expected this, but I got into the ceramic art department at my first-choice university. Now I'm forgetting all about the exams and just hanging out."

Everyone applauded, overjoyed for him, while Gisik ruffled Jun's hair and remarked that it was no surprise.

"At first, I wasn't sure whether to be happy or not, and that's why I didn't come to the workshop. To tell the truth, I wanted to paint. When I told my parents, as expected, they completely lost it. We're still in a standoff now. But I'm thinking of giving it a go. Being part of the ceramic art department doesn't mean I can't paint—I can paint pottery, and I can do a double major. What I really want is to choose my own path. I think Jihye noona's words brought me to my senses. Even though she's not here anymore."

Jun hurried his last words before downing the orange juice. He clearly didn't enjoy having five sets of eyes on him.

"Jun, we have plenty of paints, so if the workspace over there isn't suitable, come whenever you like! There'll always be a space for you here."

At Johee's reassurance, Jun's nerves eased and he pulled a grin. In awe, Jungmin cupped her face in her hands—she'd never seen him smile so peacefully. Even the robotlike Jun was capable of displaying emotion! And he wanted to paint? Her doubts about the persistently moody boy melted away, and she was grateful he'd opened up like this.

Jun's news heated up the atmosphere of this little Christmas

party. Gisik cut the cake and served a slice to Jungmin, before dropping in a comment. "Jungmin-ssi, don't you have something to share, too?"

Jungmin's eyes widened and she shot him a look, but Gisik was unfazed.

"A good opportunity came your way recently. When something worth congratulating happens, you need to share it."

This time, all eyes were on Jungmin. "Unnie, what is it?" Yeri urged her, and Johee meanwhile stared intensely at Jungmin's lips. She was flustered—she'd had no intention of telling everyone at the workshop about last week's publisher incident. As she tried her best to worm her way out and play down the situation, Gisik sent her a secret wink. *You can do it*, it said.

"Actually, a while ago I received a DM on the workshop Instagram. The message said they liked the posts and wanted to make them into a book."

This was as far as she'd got when rapturous applause broke out.

"Hang on a minute! It's too soon for congratulations. In the end, it fell through."

"Just the fact you got an offer is a huge deal! There are so many writers out there these days. Seems you've got potential. No, loads and loads of potential!"

Souta boasted of having been the first to notice Jungmin's talent. Johee pressed down on his shoulders and snapped, "Quiet, you! This is her moment. Jungmin-ssi, can I ask why it fell through?"

"The publisher wanted essays. But I want to write a novel,

you see. That's why I turned down the offer. I didn't know what I wanted to write before, either. But during the meeting with the publisher, I realized. I want to write a novel. So I'm planning to reorganize all the posts and write an actual book. Enter it to competitions and submit it to publishers. I never imagined I'd start writing again. I got so discouraged in my early twenties after never having any success at the literary contests. I thought I'd given up on my dream, but I guess not. Seems I know myself least of all."

"Jungmin-ssi, I think I might cry." Johee wiped away her imaginary tears. "I'm such a silly old fool."

"It's all thanks to you, Seonsaengnim. You believed in me and entrusted me with the shop's account. Then this opportunity came along."

Johee raised her glass to Jungmin. "With each new post, I couldn't help thinking how heartfelt your writing was. To think it might become a novel . . . Can I be your very first reader?"

"Of course! I haven't published anything yet, though."

Gisik swooped in and raised his glass, too. "Wait a minute then, let me be your very first fan."

Souta, Jun and Yeri followed suit and joined the toast. "Here's to a successful flea market; to Jun getting into university; to Jungmin-ssi's book offer; to Gisik's workshop . . ." Johee paused, before condensing the congratulations into a brief "To all of us!" The clink of glasses followed, though no one had yet processed all the changes of that year. Anxious the happiness might soon slip through their fingers, they sensed just how precious this moment was.

IT WAS LATE into the evening, and only the adults remained. The conversations flowed on until the cheese pasta bake was stone cold. Everyone was feeling a little tipsy thanks to Gisik's wine. Johee had now brought out the finger food, and they were on to the second round of drinking. Before long, Gisik had slunk over to the seat next to Jungmin.

"Jungmin-ssi, would you like to come to Goseong with me?"

Gisik scooped up a canapé and dropped the bombshell. Johee and Souta, meanwhile, were too engrossed in their trip down memory lane to overhear. In a flash, Jungmin felt herself sober up. Looking at Gisik's face, it was impossible to tell whether he was drunk or fully in his right mind. As always, he was white as a polar bear. The same scenario she'd daydreamed about as she was home alone petting Hoya had become a reality. *If he asks me to go to Goseong with him . . .* Jungmin had secretly imagined various saccharine endings to this sentence—she now felt a subtle shame, as if she'd been exposed. She thought she'd been waiting for him to say these words, but now he actually had, she was conflicted.

"You can take charge of the café, and work on your book with the sea as your backdrop. The café looks right out over the water. It's way too cold right now, but in summer lots of people go surfing, too. And if you feel like doing some pottery from time to time, you can come over and join me in the workshop. The café and workshop are joined by a corridor. Cafés are where people go to talk, so maybe it'll be helpful for your writing? Of course, those aren't the only reasons . . . I'm speaking without a filter right now . . ."

The high spirits in which Gisik first made the suggestion

The Healing Season of Pottery 233

had fizzled away, and at the lack of enthusiasm in Jungmin's response, his voice had shrunk smaller and smaller.

"This is sudden, I need some time to think. It's a bit overwhelming."

She pushed out the words one by one, trying not to expose the alcohol lingering in her system. At thirty years of age, she couldn't decide to up and go to Goseong just because she had a thing for him.

"You're right. It was out of the blue. It's always been on my mind, but it must've come as a shock to you. You're right. I got ahead of myself . . ."

Gisik kept shifting this way and that on his chair.

"What's all this here? Are you trying to headhunt her?" Souta, having picked up bits and pieces of their conversation, swooped in.

"Oh, well, I guess you could say that. Jungmin-ssi is a talent in high demand, after all."

Thanks to Souta, Gisik just about managed to dodge an uncomfortable situation.

"Exactly. I wanted to get her for our company at first, too. But Jungmin-ssi shot me down, saying how she hates being tied to anywhere. I almost felt a bit hurt, but when she said she wanted to write a novel, it made sense. When there's something in your heart that you really want to do, you can't tie yourself down to anything else . . ."

"No one likes being tied down . . ."

Gisik echoed Souta's final words. His expression hardened, but only enough for Jungmin sitting beside him to recognize.

Though it wasn't his desire or intention, Gisik feared that

Jungmin might see things like Souta had said. For Gisik, Goseong was a new challenge and a new start, but he began to wonder whether it might be more of a claustrophobic no-man's land to Jungmin. His mood plummeted deep underwater. He thought of how he'd proposed the same idea to Ara and been rejected. Back then, Ara had said, "You always did see every-thing through rose-tinted glasses." Maybe he was the only one painting a rosy picture inside his head. Writing while gazing out over the ocean, making coffee, doing pottery on weekends . . . Gisik regretted his inconsiderate words. He was infuriated at himself for being so rash. As an apology, he raised his glass to Jungmin in a toast. For the first time, the sweet wine tasted bit-ter. He didn't dare kill the aftertaste with cheese. Though he car-ried on drinking, he stayed as sober as anything.

After Jungmin's lukewarm reaction, Gisik sat with his back to her, and talked with Souta instead. Or really, he simply listened.

Jungmin glanced at Gisik out of the corner of her eye and realized that he'd sobered up a long time ago. Whenever she'd secretly pictured her life with him in Goseong, a grin would float to her face. But remembering the things she'd have to give up, her smile soon wiped away. This was a crucial time of her life—she didn't want to embark on a reckless adventure when she was trying to pursue a new dream. She needed to drag herself back down to earth. While Jungmin had been dilly-dallying, Gisik had tried to draw one step closer to her heart. But she couldn't open the door right away. Perhaps she didn't have the space to let her guard down. She grew anxious, as if her heart might soon crumble to pieces.

A RATHER MERRY Souta rested two hands on Johee's shoulders and slurred, "Leave this one to me, you all be on your way." He looked very much to be the drunker one. Johee squirmed and shook off his palms. She asked Gisik and Jungmin whether they could stay behind to clean up—it looked like she'd have to see Souta home. Jungmin had wanted to avoid being alone with Gisik, but given Souta's current state, she was left with no choice. In silence, Gisik began to tidy things away.

Neither uttered a word as they cleared the leftover food from the table. Breaking the awkwardness felt too overwhelming. Jungmin had stuffed the last rubbish bag and was about to leave, when Gisik stopped her.

"There are still things left to sort."

"Haven't we finished most of it?"

Gisik headed toward the back where the kiln was. Jungmin followed, and there she saw the mound of dud pieces that'd accumulated since the workshop had reopened its doors the previous summer. It was the "dochong": the pottery tomb. In the month leading up to the flea market, it'd doubled in size with all the plates and vases that, for various reasons, couldn't be sold. They'd been chipped, cracked, or in serious cases, even shattered, and there were mangled pieces that'd never made it as far as the kiln.

"At the end of the year, all of these need to be broken. Makes it easier when it comes to throwing them out."

Before he'd finished his sentence, Gisik picked up one of the small plates and chucked it into the drum. There was a clang as it shattered. Without the slightest hesitation, he destroyed all

his failed pieces. Jungmin flinched at the piercing noise and her head throbbed, but it was also strangely cathartic. There were definitely far more of her pieces than anyone else's. She picked up one of her coffee cups with a ballooned base—the kiln's heat must've been too much for it. Apprehensive, she tossed it in. The cup rode a small arc before tumbling, crashing into another piece with a thud and breaking nicely apart. One after another, she flung her work into the drum. The slightest force from her hand made light work of the pieces—ones ruined during glazing, or ones that'd never become pottery at all.

Jungmin released her stress through the hammer—sending spiderwebs of cracks through her pottery—and soon she was having fun, even. *All this time I'd been hoping for my pieces to turn out flawless. Now look at me, destroying them with my own hands!*

"Looks like almost all your vases are here."

Gisik held up one of Jungmin's distorted vases. It'd been her poor attempt at mimicking his.

"Basically, every one of mine cracked or broke. The half-decent one I gave away . . . Vases make excellent gifts, after all. Maybe that's why I still don't have a single one in my flat."

Jungmin smashed the nacho bowl last of all. This one had turned out a total flop—the sauce dish had fallen off completely. A fragment bounced back and tumbled all the way over to her feet. It'd broken off cleanly. She picked up the scrap—of which not one part had been left untouched by her hands—that'd once housed her hopes, and her devotion.

"You don't feel empty after smashing everything like this?" Jungmin asked.

"You just need to make them again, and again. That's why I'm not bothered when my pieces crack or break. Because I'm going to keep on making more. Whether it's pottery or life, it takes more than one attempt for them to come out right. And all that effort makes the end product more valuable, too."

While Gisik hammered a large fragment into tiny pieces, he ruminated over his hasty comment earlier that evening. He hurled those words alongside the pottery, and they made a clamor as they shattered. This he did in order to fire his heart for Jungmin, again and again.

Jungmin held out the shard in her hand to Gisik.

"Can you ask me again later?"

Entwining herself in a new relationship was one of the painful things Jungmin had to endure. Dating had always ended badly for her. She'd long since got in the habit of thinking about the end and expecting the worst before the relationship had even begun. She hoped this occasion would be different. She needed a little more time.

Gisik took the fragment and nodded his head. Next time, he promised himself, he would move Jungmin's heart with something much better worded.

Soon, it was past midnight. No matter how she ultimately looked back on this Christmas, Jungmin wanted to remember it for a long, long time to come.

Chestnut Burr Village, of All Places

WHEN THE LUNAR New Year holidays were long gone, and "Happy New Year!" became somewhat of an awkward greeting, Jungmin and Juran went for lunch. When Jungmin had first suggested the idea, Juran was the one who asked if they could hold off until she was "feeling better." Two weeks later, Juran got back in touch. She'd quit her job, she said, and now had all the time in the world.

Juran was receiving outpatient treatment at a hospital in Ilsan, and suggested they meet for lunch the following Thursday around Baekseok station. Jungmin longed to probe her item by item—which hospital, what was wrong, why she'd suddenly left her job—but then she recalled Juran as a young girl, and

how when it came to long conversations like these, she'd always preferred speaking face to face. Each time, she would spill tidbits, like a film trailer for the next time they spoke in person. Jungmin knew well not to press her.

They met at a mandu hotpot restaurant near the station. Juran was wearing several layers of thick winter clothing, but even this couldn't conceal how gaunt she was. She must've lost all that weight in a matter of months.

"Remember how we used to save up our pocket money and go buy wang mandu? Now look at us, adults eating mandu hotpot. Weird, huh?"

Juran warmed her hands around the bowl of steamed rice as she spoke. Her fingers, spindly like winter branches, were crimson.

"I know, right?"

When the server brought out their food, Jungmin dished out modest portions of mandu, meat, and soup onto Juran's plate. She noticed how much more comfortable she felt around Juran now.

"Oh, by the way, I see the story you're posting on Instagram is doing well?"

"You read that?"

Jungmin was at a loss. One of the characters from Yujeong's past in the novel had been inspired by Juran. She couldn't have picked up on that, right . . . ?

"Yeah, Hyoseok told me. Read it all, start to finish. I'm a huge fan—even set an alarm to remind myself when the next part

comes out. But shouldn't I get an appearance fee if you're going to feature me . . . ? Listen, hotpot's on you. I'm normally more expensive, but let's just call it even."

"Er, nothing got past you, then?"

"Course not. Seems it's really popular. Lots of comments, too."

Johee, Jihye, Hyoseok, and Souta always left comments, and there were a few from unfamiliar accounts. That was the extent of it. And the ones from unknown accounts were clearly Gisik's work. He'd been sloppy—even the tone and spelling mistakes were identical.

"The same people read it every time, that's all. Do you leave comments, too?"

"Nah, I'm just a lurker. Oh, but I do give the posts a like."

Jungmin wondered whether Juran would read her book if it came out. And what might she say after? When Juran said she didn't leave comments, Jungmin realized she was still a long way off.

Juran pushed the food around her plate, picking at a few bean sprouts and slivers of cabbage. She dodged the mound of mandu and meat entirely. Jungmin began to worry that Juran had come all the way to Ilsan to eat food she didn't even like.

"I wanted to ask. What are you going to hospital for?"

"Don't get me started. I've been so busy. Up until last week, I was at the office on weekdays, then I had to come all the way to Ilsan on weekends for fertility treatment. My husband was recommended the hospital by a doctor he knows. That was why

I quit my job, too. Being a secretary is hard on the body—even though it might look like all we have to do is sit there all day looking pretty. My boss travels on business all over the country and I have to accompany him everywhere. I've always got my phone in my hand to keep an eye on flight tickets, and I have to keep the clients happy, too. It's so draining. I thought it might be work stress that's keeping me from getting pregnant, that's why I quit."

Juran's husband was six years her senior. She confessed that her in-laws were putting pressure on them—their son wasn't getting any younger, after all. But that wasn't much of a problem. It was Juran who most wanted a child.

"You don't know the reason?"

"No. My in-laws say they're worried about my husband's age, but to be honest he's still young, and there's nothing wrong with either of us. At the hospital they just repeat the same thing: minimize stress as much as possible. Guess there's nothing else the doctor can say."

"Must be stress. I know it's always been your dream to have a big family."

Jungmin knew Juran had wanted to be a mum ever since she was young, which made it all the more heartbreaking.

"Maybe it's an insecurity. I know divorce is common these days, but I . . . It's just how I feel. I want to be part of a complete family for once. One with a mum, dad, and kids. I know how up myself this might sound, but I've got a really good husband. He's a decent guy—wise, genuine, and always has my back. I

felt confident we'd have a happy life together, that we wouldn't split up like my parents did. But when I had the miscarriage . . . I was so angry at God. I thought I'd lived a decent life, not really doing anything bad. All I wanted was an ordinary family, the type some people are born with—is that too much to ask?"

Juran's eyes reddened. She was doing all she could to hold back the tears. Jungmin passed her some tissues. She always had been more of a listener than a speaker. As her friends let out their pain, she'd be there quietly listening and handing them the tissues. Though it might appear cold-hearted, this was Jungmin's own method of listening—without sympathy or pity—to the stories of others.

"I didn't want to get like this, but it always happens when I'm with you. With everyone else they share their own experiences and try to do all they can to encourage me, or else they try to tie up the conversation with a hopeful message. But you're not like that."

For a while, Juran allowed the tears to flow. Once she'd let it all out, she sniffed and pulled an embarrassed smile. Fifteen-year-old Juran always used to do the same. . . . As Jungmin looked back on the past, she found her nose tingling, too.

Once Juran's bloodshot eyes had returned to white, and the two had filled their stomachs, Jungmin pulled out the carrier bag. Now seemed the right time.

"Here. This was why I wanted to meet up. I wasn't sure what dish you needed, but then I remembered how you used to like the pajeon side at my mum's jokbal place. You can use the plate for jeon, or whatever, really."

Jungmin handed Juran the dish, which she'd even wrapped up. It was a broad, round plate in the shape of a shallow basket. She'd made it the day she first centered the clay on the wheel. Two pieces had come out intact, one of which was the vase she'd gifted her mum. Jungmin had wondered whose face would come to mind next, and floating right there in front of her was Juran. In the end, Jungmin's second piece entered the possession of her old friend.

"Did you make it? You were struggling at the one-day class—when did you get so good? I've never received such a heartfelt gift before! Thank you."

Though Juran's signature fuss made Jungmin uncomfortable, she knew the words were genuine.

THE PAIR HEADED toward Chestnut Burr Village in search of a café. It was near Jeongbalsan station—they would need to walk a good thirty minutes to get there. On their slow amble, they scattered silly memories on the streets. Like how Juran's father would always give Jungmin a black toothbrush whenever she stayed over. The last of this year's snow lived on as a thin layer of ice on the pavement. In a few hours, even this would've melted. Spring was on its way.

They were in front of Chestnut Burr Village when Jungmin asked the question. "Do you remember that day?"

Juran took her time to reply. She was retracing her past.

"Yeah, I do. Out of nowhere, my dad suggested we go for a drive. That day was my first time riding the delivery van, and it was a bit depressing. It was like he was locked up in that tiny

space day after day distributing people's happiness and sadness. To be honest, I don't remember much of what happened next. Other than seeing you and your mum at the police station. Over the years, I've pieced together the events of that day through my conversations with my dad."

"After that day, my dad disappeared without a word, so I never got a chance to hear his excuses. There was so much I wanted to ask him, so much I wanted him to tell me. There was something I wanted to ask you, too."

Jungmin halted her step and turned to face Juran.

"I wanted to ask if you were okay, but my dad's shirt was covered in blood and, that night, I was more worried about him, that piece of shit, when you and your dad were right there in front of me. Awful, right? In part, I was still angry about what you said in the film club that day. . . . But also, I believed I was the same breed as him, that I couldn't escape it. . . . And so I believed I shouldn't be around you. I didn't want to cause you more hurt, so I needed to stay as far away as possible. That was how much I cherished you as a friend."

Jungmin had said what she'd never been able to, and a wave of relief came over her. Juran, meanwhile, took her time to mull over her friend's confession.

"Not just a friend, but a cherished friend—I can't tell you how much I wanted to hear you say that. . . . But isn't it normal to worry about your dad? He's your family—it's exhausting trying not to care."

Jungmin felt the tension melt away from her clenched fists. In

the past, she used to explode in anger—calling the world cruel, violent even—but in the end, she realized, she'd inflicted the worst of it on herself. Was there anything as cruel as neglecting her own emotions? Was there anything as violent as betraying your own heart? Now, however, it felt like she'd scooped out her heart and washed away all the foul-smelling stains coating it. Her life felt impossibly lighter.

"I'm sorry, Juran-ah. I'm really sorry about what happened to your dad."

This was the first time she'd ever apologized to Juran. All that time, she'd suppressed the urge. She hadn't wanted Juran to misunderstand her, to think she was simply longing to be told, "It's okay."

"Forget it. Your apology is enough."

Juran didn't say that she forgave her. After all, Jungmin wasn't the one who needed forgiving.

"By the way, how come you were so pleased to see me again?" Jungmin asked.

"Not sure . . . At first, I found you unbearable. Even running into you at school was enough to give me chills. But ten years down the line, I was at church on Sunday like any other week, when I suddenly remembered that day. That one time you came to our church and ran out halfway through the service. We needed to pray 'Our Father, in heaven,' but you couldn't bring yourself to say 'father.' How could I keep holding it against you . . . It would've been easier if you were a bad kid, then I could've hated you."

A tepid breeze wafted through the space between them. The chestnut tree branches, their sprigs sprouting from beneath the bark, quivered against the gusts of early spring.

Juran made a *hmm* and pretended to be deep in thought. "Why do you think we met here, of all places?"

At Juran's words—more said to herself than in hope of a response—a grin spread across Jungmin's face.

"Juran-ah, do you know where Chestnut Burr Village gets its name from?"

CAMERAS WERE SET up all over Soyo Workshop. When preparations were almost complete, Writer Gu arrived.

"Jakkanim! Long time no see. How've you been?" Jungmin trilled.

"I've been good. Thanks so much for today. I don't know what I would've done without you!"

It'd been a year since Jungmin had last seen her, but Writer Gu hadn't changed a bit. She went to greet the camera operator and the producer before chiming a sunny hello to Johee.

The producer called out to Johee. "Filming starts in ten minutes. Have one final look in the mirror before taking your seat."

Johee kept fiddling nervously with her hair in front of the mirror.

A buoyant Hyoseok did his best to calm her nerves. "Seonsaengnim, you look beautiful. Lovely. You'll make your hair greasy like that. Just leave it as it is." Hyoseok, who'd come as a spectator, took on the role of Johee's PA and fixed her hair.

"There, okay! Don't touch it any more. It's perfect."

Jungmin handed Johee a bottle of water. "Seonsaengnim, it's time to take your seat."

She smiled and went to sit down. Even though Johee seemed her usual self, Jungmin was a little on edge. A while before, Writer Gu had got in touch. She was producing a YouTube video series sponsored by the Office of Education that introduced a range of professions, when she remembered that Jungmin had been taking pottery classes. She'd asked Jungmin whether the potter at her workshop might be interested in taking part.

At first, Johee had refused. Seeing the troubled look in Jungmin's eyes, she'd asked, "Jungmin-ssi, you don't like asking favors of people, do you?"

"No, I don't. If they don't want to, they don't want to. . . . My sunbaes always criticized me for it. They said it was a writer's job to convince the guest even if they didn't want to do it."

"If I refuse, will it put you in an awkward position?"

"No! It's not that. It's not my job, just a close sunbae of mine asked . . ."

Johee thought hard and finally accepted—she'd do it for the memories, she said. Jungmin, meanwhile, felt ill at ease. She didn't want to cause Johee hassle.

WRITER GU AND the producer signaled to one another.

"Right, clap your hands, please. Then filming will begin."

With the sound of Johee's clapping, filming commenced. The questions weren't difficult. How to become a potter, the ups and downs of the profession, what kind of students she'd recommend the career to . . . As soon as the camera was rolling,

Johee's nerves evaporated, and the interview went by without a hitch. She joked around, her gestures were natural—she was made for broadcast!

Hyoseok slunk beside Jungmin and whispered, "She's incredible!"

"Yes . . . I wonder where she learned to do that?"

"Remember that she was a famous potter. She was interviewed all over the place. She got used to it."

Had the fretting all been an act? Jungmin was blown away.

Thanks to Johee's flair, the interview was over in a flash.

"This is my last question. Could you tell us what your upcoming plans as a potter are?"

"I like teaching people. That's why I enjoy running the workshop and spending time with all the members so much. But I'm thinking about going back to my work again. And to doing exhibitions, like before."

"Okay! Thank you. You were so eloquent, we got through everything in no time. We'll wrap up the interview here, and after a twenty-minute break we'll start filming the insert shots."

At Johee's answer to the final question, for a moment, Jungmin froze. Did that mean she wouldn't be teaching classes at Soyo anymore? Surely, she hadn't agreed to filming so that she could leave one final memento? Jungmin was about to interrogate Johee when Writer Gu blocked her path. She suggested they go grab some coffee. It was clear she had something to talk about, and Jungmin had no choice but to follow her.

On their way back to the workshop, each clutching a

cardboard carrier of coffees, Writer Gu stretched out her neck and scrutinized Jungmin.

"Yu jakka, you look way healthier."

"Sorry?"

"You're not skinny like you were . . . Yeah, you look well. There's no escaping it—quitting this work is the only way to get back your health."

Thinking about it, she'd definitely put on weight. Not unwelcome weight from over-indulgent snacking, but healthy weight. It was probably because of the extra cooking she'd been doing since starting pottery.

"By the way, jakkanim. Are you not working in TV anymore? What you filmed today will be going out on YouTube, right?"

"Gosh, Yu jakka! How can a young person be so out of touch . . . The trend these days is toward YouTube and live commerce, not TV. That brings me to my question . . . How about working with me again? I'm thinking about starting my own YouTube company. Nothing big or anything, just a group of like-minded producers and writers."

"Oh . . . thanks for thinking of me, but I'm planning on leaving the field entirely." Jungmin looked a little uneasy.

"Is it because of what happened back then . . . ? If it is, I'm really sorry. For not having your back. I was a terrible sunbae."

She'd wanted to apologize before, she said. That even as she used to babble away for so long over the phone, there'd always been an uneasiness deep down. Jungmin felt a twinge at her sunbae's heartfelt words.

"I forgot all about that ages ago. I didn't get anything right myself either. Actually, I'm going to try something different."

"What is it? News producer? Advertising? IT developer— that's a trendy job these days, right? At your age, you're still young, you can make a new start whenever you want."

Writer Gu was straight-up as always—she never could curtail her curiosity. If Jungmin were to put her in a box, she was Johee's polar opposite. But that didn't mean she disliked her. And so, though it was difficult for Jungmin to say what came next—she could predict exactly what Writer Gu's response would be—she knew she had to.

"It's not that. . . . I want to write a novel."

The look on Writer Gu's face was, naturally, skeptical.

"Plenty of broadcast writers want to pursue their own writing, so they give novels and essays a go. But the result is never . . . I tried making use of my experiences to write, too, but I was rejected by the competition I entered. It hurt my pride! Being a good writer isn't enough to make a success of yourself. It's not easy. And there's no guarantee you'll be able to make a living out of it."

Her final words were like a punch in the gut for Jungmin. But now she'd made up her mind, there was no going back.

"Jakkanim, do you remember how I used to print out the whole team's scripts to read?"

"Sure I do. I used to call you the 'script thief' to the other teams. I told them how hard you were studying. That you had a real love of writing."

"Once I made my debut as an assistant writer, I printed out

everything I wrote. It's easier to check for typos on paper and I just like the rustling sound it makes, too. But I think it was last summer . . . I collected everything I'd ever written and put it in a suitcase. It fitted perfectly inside that twenty-four-inch carrier. I was impressed by how much I'd written, but there wasn't a single sentence I properly remembered."

Writer Gu, who'd been listening in silence, spoke with a bitterness. "Broadcast scripts fade away so quickly. That's because you only ever hear them spoken out loud, and never see them written down. Once the show is over, that's it. Change channels, and *poof*, gone."

"Jakkanim, from now on I want to write things that'll be remembered."

"Yu jakka, you know you're a good writer, right?"

She didn't know what to say. This was the first time one of her writer sunbaes had ever complimented Jungmin to her face. Her heart was racing.

"February's freezing," Writer Gu mumbled, shuddering. She pushed open the workshop door, unable to stand the cold any longer.

"You're not coming in?"

"Oh, yes, I am!"

ONCE THEY'D FILMED Johee throwing on the wheel and placing pieces inside the kiln, as well as teaching "student" Hyoseok, who'd made a special appearance, shooting was complete. The crew withdrew, and the workshop settled back into its usual atmosphere. Utterly drained, Hyoseok and Jungmin exhaled

and collapsed into their chairs. Johee was the only one who seemed completely fine.

"Seonsaengnim, I was only in front of the camera ten minutes, and I'm so, so exhausted. You really are impressive."

"It's no big deal. You both look tired, let's get something nice to eat."

Jungmin remembered what she'd been wanting to ask Johee.

"By the way, Seonsaengnim, are you not going to teach classes anymore?"

"I wanted to tell you first, Jungmin-ssi, but I didn't expect that question to come up in the interview. I'm sorry . . . I should've told you before. I'm going to focus on my work as a potter for a while. Not right away, though. I'll gradually close up Soyo and head over to the workshop where my father is. It was always his dream to do a father-daughter exhibition. I've broken my promise to the members that there'd always be a place for them."

"You have nothing to be sorry for. Make sure to let me know when the exhibition opens, though." Jungmin tried her best to sound cheerful.

Hyoseok jumped in, too. "Me too! Promise, Seonsaengnim?"

"Of course."

For some reason, Soyo's end didn't feel sudden. Each time another member left, Jungmin had been preparing herself to say goodbye.

"Jungmin-ssi, hold on a minute."

Johee's smile was full of meaning, and from behind the kiln, she pulled out a vase.

"I think it's time to give this to you. It's not from me—

Gisik-ssi made it a couple of months ago, before he left. He told me to give it to you if you still didn't have a vase by the time spring came around."

"When did he do this . . ."

How did he know she didn't have a vase? Jungmin guessed it must've been that day they smashed all those pieces. The vase—with its two elegant curves—fitted perfectly in her hand. Its shape almost reminded her of the waves of the ocean. And unlike his usual black decoration, there was a soft layer of warm matte green all over. The balmy sea. She recalled parts of their conversation on that late-night walk. Even the expression on Gisik's face as he asked what color the word *sea* brought to mind. He'd said he gifted his pieces to those people whose faces popped into his head as he worked. Hers would've been there in his mind ever since winter. It'd been the same for Jungmin. The pieces she'd made with Gisik in mind had piled up without her ever giving him a single one.

He'd asked her the question once more, as per her request, but she'd never expected him to do it quite so subtly. This way was the most "him." Her answer this time was decided.

"Seonsaengnim! Hyoseok-ssi! I think I need to go to Goseong!"

Emerald Green Sea

AFTER JUNGMIN STEPPED out of the taxi, she spent thirty minutes loitering in front of the workshop, though she was shivering from head to toe. Wasn't it supposed to be spring by March? The cold had eased off in Ilsan, but with the sea breeze, the winter chill was holding firm in Goseong. She'd often come to the East Sea on holidays, but it was her first time at Gajin beach. Unlike Gangneung's Anmok beach, with its famous café street, here it was secluded and the waves were a little rougher. Coming as no surprise, the water was an uneven blue. Far from emerald, it was as if slender slices of sapphire, like flaked almonds, had been sprinkled all over the sea. There wasn't a speck of green to be found. But if Gisik were to stand here beside her and say it was green, Jungmin would wholeheartedly agree.

다음 DAUM
ceramic studio & café

That was where Gisik would be, in the café facing the sea. He'd sent the location on the group chat, and Jungmin had read it again and again, learning it by heart. The ivory building was right on the beach. It was exactly where he'd said it was. The workshop didn't show up on her phone map—it wasn't open yet, after all. Did he say two weeks from now? But "Daum"? What did it mean? Jungmin rolled the questions over her tongue before finally taking a seat on the bench in front of the workshop. The sun was still bright, and she reckoned it'd be all right to stay like this a little longer.

"What are you doing here?"

Gisik had snuck right up on her. He still hadn't hung a shop-keeper's bell at the entrance, and so Jungmin didn't notice the door swing open behind her.

"March is still cold in Goseong. You should've let me know you were coming."

Gisik handed Jungmin a blanket and plopped down on the bench beside her.

"I saw you through the café window. I guessed you were taking a walk so I left you, but then you just slumped down on the bench, which made me wonder if something was wrong. That's why I came out."

To think that he'd seen her hanging around like someone with nothing better to do—Jungmin hoisted the blanket right over herself in shame. She felt her body curl up against the cold.

Beneath the blanket, she pulled her knees together and wrapped her arms around them.

"You never tire of looking at the sea, do you?" Jungmin asked, her shoulders hunched right over.

"I don't. I think that's why this is where I need to be. This is the place where I'm most myself. And that's why the workshop's name is 'Daum,' as in 'na-daum.'"

"Oh!" Jungmin let out a little exclamation. *Na*, meaning "me," and *daum*, as in "just like." Just like me. It occurred to her that he had a better sense for names than she, the writer, did.

"Let's go inside. I'll give you a tour."

Gisik opened the door. "Jungmin-ssi, you're my first visitor." Every first had a meaning. Jungmin felt something special as she stepped inside. A toasty air lingered, as if he'd been warming the space since early that morning. Gisik's affectionate hand had left its mark here and there across the café area. Six or so tables. They were of all shapes and sizes: from a four-person table to a one-person bar-style seat overlooking the sea. The kitchen behind the espresso machine was neat and tidy. It had a homey vibe—Gisik hadn't followed social media trends, which made Jungmin warm all the more to the place. She felt so proud just imagining him going back and forth between Seoul and Goseong and doing it up, and she almost felt like ruffling his hair.

Through an archway from the kitchen was the studio. There, in front of a messy desk, was a window, which had a clear view of the bench where Jungmin had been sitting. He must have seen everything from here.

"The café and workshop are so lovely."

"Take your time to look around. Here, coffee."

He must've made it while she was browsing the studio. A cup of hot black coffee. As she held the cup in her hands, she was back in Soyo Workshop for the first time. *Right, this was how it felt.*

"Tastes good. Suits the pale pink cup, too."

"Glad to hear it. I'm still not really sure how to pair the cups with the beans. I'm also considering letting customers choose their own cups."

"Now I've come all the way here, I might as well help you with some taste testing."

"It'd be an honor."

Gisik pulled his signature grin and made a show of bowing right down at a ninety-degree angle. Jungmin still found his distinctive smile intriguing every time. He was wearing a long puffer coat over his work clothes, and the green apron poking out was dirty as always. One of the pockets was in tatters, its stitches coming undone.

"Thank you for the vase. I really love it."

"I'm glad. You said before you didn't have any vases. It's weird that you still struggle with them, even though your pottery skills are improving all the time. And the ones that turn out all right, you give away."

"I set my sights high after seeing your vases and tried to use techniques well above my skill level. That's how I ruined them. What I really wanted was a vase made by you."

"You should've told me before. I made so many vases with you in mind . . ."

"I have plenty of pieces for you, too. But what you make is

so much better—I'd be mortified to give them to you. Instead, I really wanted to give you this."

Jungmin handed over the poorly wrapped gift. "It's a bit late, but anyway."

"It's an apron."

"At the start, you lent me yours, right? I think it's time you had a new one . . ."

"Exactly what I needed!"

Straight away, Gisik removed his coat and put on the new apron. The denim with its leather trim suited him well.

"Wear that and make even more pottery. And make people delicious coffee, just like Johee seonsaengnim."

But Gisik pulled a sour look, as if something was weighing on his mind. "To be honest, I'm a bit worried. Will I be able to make this space as welcoming as Soyo? I'm not used to a workshop where there's no Johee seonsaengnim, no Jihye, no Jun, no Yeri and no Jungmin-ssi. I don't feel at home here."

Gisik swept his eyes over the workshop. It'd been so lonely making pottery here these past three months. Though he'd put his heart into decorating each part of the space, his gaze never rested anywhere long. Each time, the faces of the Soyo Workshop members would float before him. Those faces—which made his chest expand like candy floss—passed by, and then finally, he saw Jungmin's. In this new workshop, where no one had yet left their fingerprints, he longed for Soyo.

"There's no sandwich shop here and no ice cream parlor, after all. . . . You'll have to search out the good local spots," Jungmin

sniggered. Gisik could tell this laugh wasn't the one she made when she was most at ease. It was clear she was still hiding what she really wanted to say. He reckoned he should show her the water from closer up.

"Let's go take a look at the sea."

THE SAND CRUNCHED beneath their feet. Bit by bit, they shared what'd been going on in their lives. That Soyo would soon be closing its doors, that Hyoseok was really feeling the absence of his drinking buddy, Jihye, that Hansol and Yeri had stopped by, and they'd had a sudden growth spurt, that newly turned university student Jun could hold his drink surprisingly well, that Hoya was alive and kicking . . . Jungmin had a lot to tell Gisik, but he didn't have a lot to tell her.

Since arriving in Goseong, he'd done nothing, he said. He woke up late, worked on his pottery, and visited other cafés for market research while he still debated over which coffee beans to use. That was the sum of his day-to-day. But he spoke— breathlessly, like someone who'd never had a lie-in in his life— of how good it felt to wake up around lunchtime.

Jungmin was used to seeing Gisik in Chestnut Burr Village's little workshop. His face was the only familiar thing in this unfamiliar environment. Maybe that was why her gaze kept returning there, even with the picturesque sea right in front of her. It felt like they were surrounded by water on all sides, on their own private island.

"How's the novel going?"

"I'm working hard at it. But it's not easy."

"I like your writing, Jungmin-ssi. I still read the posts you upload to the workshop Instagram."

Jungmin cracked up. She managed to rein in her laughter and showed a bemused Gisik the list of account IDs she'd noted down on her phone. Though he did his best to feign ignorance, he couldn't meet Jungmin's eyes.

"Thank you. I felt really supported."

"I used all different accounts, but guess I got found out. You're scary, that's what you are. There's no fooling you."

Gisik hid his face in his hands. His ears were red.

"But Jungmin-ssi, if you knew I was leaving the comments, why didn't you get in touch . . ."

He looked a little hurt. He'd been hoping so much for her to contact him. Even for something trivial—it didn't need to be the answer to his question. If he contacted her first, he was worried she'd feel pressured, and so time and time again he restrained himself. Gisik knew well how to wait for people like Jungmin, but he couldn't help but be a little upset.

"I told you that I'm a *reeeeeally* slow burner, right?"

Though she hadn't intended to test his patience, it was true that she'd taken her time, and for that she felt sorry. She couldn't drag it out any longer.

"You know the ice cream parlor. The chocolate chip cookie dough frozen yogurt flavor. Thankfully it hasn't been discontinued."

Jungmin didn't stumble—at some point, she'd learned that lengthy name by heart.

"Really?"

"Looks like there were a few people cheering on the yogurt and chocolate cookie pairing."

As she spoke, a sweetness filled her mouth. She had no idea how many times she'd gone to buy that ice cream on Gisik's behalf, hoping to keep it from meeting its end in the graveyard . . .

"Were you one of those people, Jungmin-ssi?"

"Of course! At first, I had no clue why you liked it. But something kept coming to mind. As I ate it, it wasn't just sweet. Just as my tongue started to tingle from the chocolate, the plain yogurt balanced out the sugariness."

"You finally recognize the true value of the taste. I'm kind of proud."

"But maybe it really will get discontinued now. Its last remaining fan is about to leave Chestnut Burr Village. Chestnut Burr Village, Residential Complex Four, Flat Two-oh-One . . . My contract has finished. I'm thinking about spending this spring in Goseong."

Jungmin looked at Gisik's profile. He turned his head and gazed quietly at her. They were face to face. Jungmin felt a twinge in her chest. She was selecting her next words, when Gisik took her hand in his. He seemed to be whispering: *Go on, keep talking.*

"The novel I'm writing. I think the story will take place inside a pottery workshop looking out over the tranquil East Sea."

"I reckon there's probably a café attached to the workshop, where they serve coffee in the cups the man made, am I right?" The corners of Gisik's mouth lifted into a pleasant curve.

"Yes, you're right. There's a little cat, too. But . . . what should we do about your allergy?"

"I'll work something out."

The two burst out laughing.

JUNGMIN WANTED TO welcome in the coming spring here, by the sea. Finding the reasons they ought to be together wasn't hard. Their next challenge would be to create this new world together, a promise that belonged only to the two of them. Before night fell, the sun made one final push and sprinkled its brightest light across the water. A path opened—tracing the glittering ripples over the warm green sea—to their island. Two overlapping hands: even against the icy winds, the space where they met was hot. Like the waves, the seasons flowed in, and flowed out.

AUTHOR'S NOTE

I LOVE ALL the "soyo"s of the world.

소요(所要): a thing needed or requested
소요(逍遙): the act of ambling freely from place to place

Whether with objects or relationships, did I ever take my time? Did I take walks to admire the things that retain their true heart, even amidst the big and small changes of each day? These soyos force me to ask myself such things—how could I not cherish them?

And then there's the soyo (塑窯) of wedging clay and firing it in the kiln.

I ask another question: Is my texture that of tender clay, or of hard ceramics? To find the answer, I guess I'll have to make more pottery. The moment I accept that nothing can be done once the door to the kiln closes, the strength flows out from my

fingertips, and a refreshing powerlessness spreads through my body—right now, this is all I can know.

I want to thank my seonsaengnim for allowing me to set the novel in Soyo Workshop. Like scooping up smooth, round pebbles in my hands, I carefully collected the names of the neighborhood and the workshop, but what remains of the backdrop was of my imagination. I send my thanks to the two people who allowed me to use their names. The precious words from those around me—who always welcomed me with open arms, no matter how awkwardly I waved hello—can be found scattered across the novel.

I hope that you, like soft clay, will embrace each other's shabby handiwork with gladness. Learn to cherish, without fear, that which is precious. Discover the deep bowl that will contain each of "us" completely. I send this novel to you: you who will, like pottery, fire your life slowly, and yet with great passion.

—Yeon Somin, Spring 2023